THE SCULPTURE OF HENRI MATISSE

Isabelle Monod-Fontaine

THE SCULPTURE OF HENRI MATISSE

With 162 illustrations

THAMES AND HUDSON

Published on the occasion of the exhibition "The Sculpture and Drawings of
Henri Matisse" (1984–85), organized by the Arts Council of Great Britain.

Edited by Catherine Lampert
Isabelle Monod-Fontaine's text translated from the French by David Macey

First published in the USA in 1984 by Thames and Hudson Inc.,
500 Fifth Avenue, New York, New York 10110

Library of Congress Catalog Card Number 84–50422

Printed and bound in Great Britain by Balding + Mansell Limited, Wisbech, Cambs.

CONTENTS

FOREWORD TO THE EXHIBITION

When the Matisse retrospective exhibition was planned for the opening of the Hayward Gallery in 1968 his work in sculpture, drawings and prints was not included. These areas were saved for a future exhibition which has taken rather longer than expected to realize. Meanwhile, Matisse's popularity has continued to grow and his art seems not to date; indeed, like Picasso, his sculpture especially appears fresh to succeeding generations.

The cross-references between Matisse's achievements in various media figure extensively in the two catalogues accompanying this exhibition. The literal depiction in his still-life painting of his sculpture is one example of Matisse's searching consideration of the ambience belonging to each image. The merging of ideas culminates most profoundly in the series of *Blue Nude* cut-outs which at the Hayward Gallery will end the exhibition. Like the other works on paper, these drawings will be shown adjacent to the sculpture. In contrast, previous exhibitions have demonstrated the equal value and beauty of displaying the sculpture on its own. This was done by the Arts Council in 1953 at the Tate Gallery and in the 1970s in New York (1972), Nice (1974) and Paris (1975). Through the generosity of lenders it has been possible to arrange to extend loans and to show Matisse's sculpture for the first time in Edinburgh and Leeds (meanwhile, the drawings alone will travel to the Museum of Modern Art in New York).

In addition to selecting the drawings, the painter and art historian John Golding has kindly devoted much time to directing the installation at the Hayward Gallery. At his suggestion we asked Isabelle Monod-Fontaine to write the catalogue text. Aside from offering knowledge gained through keeping an active 'dossier' on Matisse – partly in relation to her work as curator at the Musée National d'Art Moderne, Centre Georges Pompidou – Mademoiselle Monod-Fontaine has in this catalogue introduced new questions about Matisse's intimate relationship with the clay and plaster figures kept in his home (mainly editioned posthumously) and has related his work to the art of his contemporaries. Her lucid writing and general support throughout have been invaluable and are deeply appreciated.

Because there is no single source for the sixty-nine sculptures, they have become progressively harder to gather together. After Judith Collins completed initial research, we turned to Alicia Legg at The Museum of Modern Art who generously shared her experience. Numerous people have assisted in the search for loans. To these and

all the private and public collections who have lent works we are extremely grateful, particularly Matisse's immediate family including his daughter the late Madame Marguerite Duthuit. Pierre and Maria-Gaetana Matisse have given invaluable assistance. Likewise Madame Marie Matisse has a special interest in the sculpture, as had her late husband Jean, Matisse's eldest son and himself a sculptor. The Musée Matisse in Nice-Cimiez, endowed by the children, has lent generously. This is a particular favour, for their beautiful but small collection is a place of pilgrimage for admirers. Other museums which are famous for their Matisse sculpture have been equally co-operative, including the Cone Collection in Baltimore and North Carolina, the Hirshhorn Museum and several more. It would have been impossible to represent Matisse's sculptural thinking without the two imaginative series, the four bas reliefs called *The Backs* and the five heads of Jeannette; we are grateful to the Tate Gallery and the Los Angeles County Museum, respectively, for sparing these magnificent groups from their collections.

The enthusiastic collaboration of the Edinburgh International Festival and the City of Edinburgh Museums and Galleries and of the Leeds City Art Gallery has made the additional showings possible. In addition to the lenders, we would like also to thank the following people who have contributed in different ways: Mrs Rachel Adler, Mlle Colette Audibert, Mr Alan Bowness, Mr Lars Rostrup Bøyesen, Mme Lydia Delectorskya, Dr John Elderfield, M. Dominique Fourcade, Mr William S. Lieberman, Mr and Mrs Rodrigo Moynihan, Mr Earl A. Powell III, Lady Stewart, Mr Robert Stoppenbach, Mr Nikos Stangos, Mme Dominique Szymusiak, Mme Marie-Thérèse Pulvenis de Seligny, Mr James E. Tucker, Mr Germain Viatte, Mr Leslie Waddington.

To these and to all the private and public collections who have lent works we are extremely grateful.

<div style="text-align: right">

JOANNA DREW
Director of Art,
Arts Council of Great Britain

</div>

LENDERS TO THE EXHIBITION

	Canada
Toronto	Art Gallery of Ontario
	Mr and Mrs David Mirvish

	France
Le Cateau-Cambrésis	Musée Matisse
Nice-Cimiez	Musée Henri Matisse
Paris	Musée National d'Art Moderne, Centre Georges Pompidou

	Switzerland
Geneva	Galerie Jan Krugier
Lugano	Thyssen-Bornemisza Collection

	United Kingdom
Cardiff	National Museum of Wales
London	The British Rail Pension Fund on loan to the Tate Gallery
	The Trustees of the Tate Gallery
	Waddington Galleries Ltd

	USA
Atherton	Mr and Mrs Harry W. Anderson
Baltimore	The Baltimore Museum of Art: The Cone Collection
Chicago	Dr and Mrs Martin L. Gecht
Greensboro	The Cone Collection, Weatherspoon Art Gallery, University of North Carolina
Los Angeles	The Los Angeles County Museum of Art
Minneapolis	Minneapolis Institute of Arts
New York	The Metropolitan Museum of Art: The Alfred Stieglitz Collection
	The Museum of Modern Art: A. Conger Goodyear Fund and Abby Aldrich Rockefeller Fund
	Dr Ruth Bakwin
	Mr and Mrs Walter Bareiss
	Collection of Mr and Mrs Sidney E. Cohn
	Mr and Mrs Lee V. Eastman
	Mr and Mrs Benjamin Weiss
Philadelphia	Philadelphia Museum of Art
San Diego	San Diego Museum of Art
Washington DC	Hirshhorn Museum and Sculpture Garden, Smithsonian Institution

	USSR
Leningrad	State Museum, The Hermitage

	Venezuela
Caracas	Pedro Perez Lazo

Private collections

THE SCULPTURE OF HENRI MATISSE

I · Painting and Sculpture
1903–10

More than half of Matisse's sculpted *oeuvre* (sixty-nine works) was executed between 1900 and 1909, at the beginning of his career as a painter. During these years of apprenticeship and development, there is a constant dialogue between his painting and his sculpture. But the partners in the dialogue are not equal, and painting always takes precedence. As Matisse put it, 'I sculpted as a painter. I did not sculpt like a sculptor.'[1] The straightforward way he expresses it makes this remark highly significant. He does not in fact put the same energy into the two activities: all his conviction and inventiveness go into painting, with sculpture occasionally intervening to vary, confirm, complete or shed light upon discoveries which have usually already been made. This is why one has the impression of a time-lag, the feeling that Matisse's sculpture is 'behind' his work as a painter. At the very beginning, during the period of *The Serf*, for example, the time gap is minimal, but it increases as his vocation as a painter becomes clearer. There is no such time-lag in the work of Picasso, where painting and sculpture advance hand in hand, with now one and now the other taking the lead. With Matisse, however, from 1905 onwards, there are occasional moments of confluence between the two means of expression, but sculpture never leads the way.

The appearance of Fauve sculpture was very belated: it finds its full expression only in 1907 with *Reclining Nude I*, two full years after Fauvism was launched at the Salon d'Automne of 1905. An interval of two years represents a considerable timespan in the brief but crowded history of the Fauve explosion which, as far as Matisse's painting is concerned, was over by 1907. In painting, Fauvism constituted an attempt to break with both the deliquescence of Impressionism and the scientific rigidity of the Divisionist system. Pure colours are juxtaposed and at the same time separated from each other by the violence of the individual brush strokes and by the white of the canvas, which acts both as a unifying light and as a disruptive element. Unlike Cubism which, although it fragments objects into minuscule facets, reshapes the painting into a whole, a solid tissue, Fauvism works towards discontinuity, emphasizing the violence of disruption and separation (of light from shade, for instance) rather than continuity. The principle is applied to both landscape and to figure painting, with the figure often being seen as a spot or system of spots within a discontinuous space. In Matisse's paintings of 1905–07, red may signify shadow, and the relationship between mass and void in a face or body

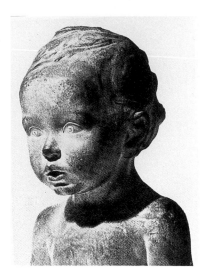

1 Albert Marque, *Portrait of Jean Baignères*, 1905.

may be inverted or thrown into question by colour (as in *Portrait with Green Stripe*), but when it comes to his sculpture, the figure is still seen in traditional terms as a block, a compact kernel whose shell can to some extent be handled roughly (lighting or modelling effects creating an unfinished, rough or fragmented impression), but never pierced or broken.

In this context, the presence of Albert Marque's small Italianate sculpture in the famous 1905 Salon d'Automne is doubly symbolic. It was seen as 'a Donatello amongst wild beasts [*fauves*]'; but what sculpture could have looked really at home in that exhibition? Ultimately, one wonders whether this little sculpture might not be an accurate witness to the fact that sculpture lagged far behind painting in the early years of the century.

How does this time factor affect Matisse's sculpture? How do the links between painting and sculpture affect it? An examination of the *Reclining Nude* theme will enable us to analyse these questions in detail.

The theme first appears in painted form in 1904 with *Luxe, calme et volupté*, an ambitious canvas depicting five principal nude figures in poses which provide an index of the future themes of Matisse's paintings and sculptures. For our purposes, the first sketch is more interesting because it is already a Fauve work and is much freer than the definitive version, in which Matisse forced himself, not without some difficulty, to work within the framework of Divisionism. Both the nude lying on one elbow in the background and the half-seated nude in the foreground are painted in broken dots. This treatment is particularly marked in the foreground figure, which is surrounded by light and shade, appears to be completely disjointed, but is still definitely located in space. In 1905, a small sculpted figure adopts the same pose (*Woman Leaning on her Hands*), but the emphasis is placed upon the continuous arabesque, on the smooth transitions and the polished roundness of the shoulder, which echoes that of the chignon and the knees. Only the deformed hands, which look like the paws of an animal, introduce a violently discordant note.

In addition to paintings and drawings, the preliminary work for *Bonheur de vivre* (1905–06) includes one truly transitional sculpture: *Reclining Figure with Chemise*. It both represents a volumetric treatment of the figure placed in the foreground of *Bonheur de vivre* and accurately prefigures *Reclining Nude I*, which was modelled slightly later, in the winter of 1906–07. The time-lag is once more obvious: in *Bonheur de vivre* the rhythms are greatly simplified and the expression is clear and purified of emotion, whereas the sculpture gives an impression of clutter. The extremely classical pose is heavily allusive: it is that of *Ariadne Sleeping*. Matisse may have seen Poussin's transposition of it – a painter's sculpture *par excellence*. The floating folds of the chemise are also cluttered: they introduce an element of tactile sensuality, but make it impossible to see clearly the interplay of counterpoints and twists.

Finally, in 1907, we have the 'pair' formed by the sculpture *Reclining Nude I* (*Aurore*) and its painted version, *Blue Nude* (*Souvenir of Biskra*). Here,

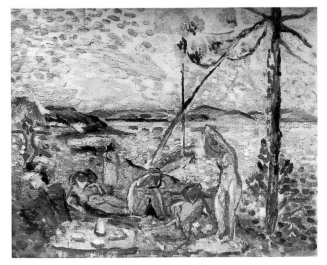

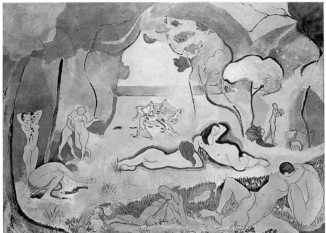

2 Study for *Luxe, calme et volupté*, 1904–05.

3 *Luxe, calme et volupté*, 1904–05.

4 *Bonheur de vivre*, 1905–06.

5 Study for *Reclining Figure with Chemise*, 1906.

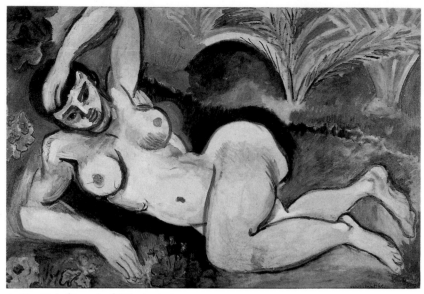

6 *Blue Nude (Souvenir of Biskra)*, 1907.

there is no longer any time-lag; these two works represent one of the rare moments of confluence between painting and sculpture. (We know that the sculpture came before the painting, that *Blue Nude* replaced an earlier sculpture which had been broken, and then served as a model for the definitive version of *Reclining Nude*.) They also typify Matisse's constant preoccupation with 'organization'; 'it was done for the purposes of organization, to put order into my feelings, and find a style to suit me. When I found it in sculpture, it helped me in my painting. It was always in view of a complete possession of my mind, a sort of hierarchy of all my sensations, that I kept working in the hope of finding an ultimate method.'[2] On this occasion he did indeed find a method. In *Reclining Nude*, Matisse succeeded in preserving the violence of his feelings and in expressing them with an energy equal to that lavished upon the painting. The energy does not lie at the surface, in the lively, but not particularly innovatory, modelling; its intensity is felt in every element of a displaced and distorted body which is placed at the service of a 'hierarchy'. In the painting, the arm extends beyond the frame. In the sculpture, the monumental effect is created by the same curve, which is now both complete and grandiose, and by the way the arm touches the helmet of hair. Each joint is handled separately and is enlarged, but the whole process is constantly held in check and unified.

 In order to understand this period in Matisse's sculpture, we have to take into account the important role of the photographs which provided him with themes. Matisse used photographs, not only for famous and already published sculptures such as *Two Negresses* (1908), *Small Crouching Torso* (1908) and *The Serpentine* (1909), but also for many

others whose origins we have been able to trace. Photographs were definitely used for *Seated Nude with Arms on Head* (1904). According to his daughter Madame Duthuit, photographs were also used for other sculptures in the same series (*Upright Nude with Arched Back*, 1904; *Standing Nude*, 1906; *Torso with Head, La Vie*, 1906) and for certain paintings dating from the same period (*Standing Nude*, 1907). Matisse used specialist magazines which published collections of poses, supposedly for artists. The magazine he used most often was entitled *Mes modèles* and appeared at a rate of three instalments a month between 1904 and 1910.

This fairly systematic use of photographs may seem surprising at a time when Matisse had a wide choice of subjects. His wife was quite willing to pose for him (she was the model for most of the paintings of his Fauve period) and, as can be seen from countless life studies, he also used professional models. A note published by Matisse in *Camera Work* in 1908 may help to explain why he used photographs. (It is particularly interesting, being contemporary with the series of sculptures we are dealing with.) In reply to the critic Georges Besson's question, 'Do you believe that photography can produce works of art?', Matisse wrote that 'Photography can provide the most precious documents existing, and no one can contest its value from that point of view. If it is practised by a man of taste, the photograph will have an appearance of art. But I believe that it is not of any importance in what style they have been produced; photographs will always be impressive because they show us nature, and all artists will find in them a world of sensations.'[3]

Matisse's comments appeared in the review created by Alfred Stieglitz, who saw himself as an 'artist' rather than a photographer and who published only 'fine art' photographs (which Matisse never used for inspiration) in *Camera Work*. They explain his interest in these documents and their rudimentary and often almost obscene exploitation of female bodies which were apparently unsuited to the affected and contorted poses they were forced to adopt and which were crudely revealed for what they were (the bodies of factory girls and seamstresses) by the scantiness of the accessories they wore.

Quite apart from their striking authenticity, Matisse may have been interested in such photographs because they provided him with a vast number of motionless models who had been deliberately chosen because they represented very different physical types. The photographs did not prevent him from having recourse to models to study poses, but they did provide him with a starting point and during his work served as lay figures much as those used in traditional art studios for the study of light effects. The range of poses available to him facilitated his work: rather than forcing his model to take up a preconceived pose to which she might not in fact be suited, he could browse through the pages of the magazine until he found both a model and a pose capable of triggering the 'monde de sensations' that might give birth to a work of art. Even at this early stage of his career, he was convinced that he had, in the female figure, found the essential theme of his work. He wanted to collect as much material connected

7 Photograph from *Mes modèles* used as basis for *Standing Nude*, October 1906.

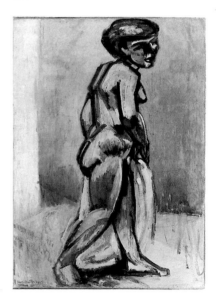

8 *Standing Nude*, 1907.

9 Page from *Mes modèles*, September 1906.

11 *Upright Nude with Arched Back*, 1904.

12, 13 Photographs used as basis for *Upright Nude with Arched Back*.

10 Magazine photograph used as basis for *Two Negresses*.

with the figure as possible: academic drawings, life drawings, painted and drawn studies of all kinds. The mediocre photographs of *Mes modèles* played a far from negligible role in this exhaustive search for material. Before long, however, Matisse established his independence from photography as source material. In any case, his reflections on the model and on the figure were to mature and to lose the almost compulsive tone that characterized them until 1908.

We can see the process of development quite clearly if we compare the group of sculptures made in 1904–06, which are directly based upon photographs and use them almost untransposed, with the works of 1908–09, which are much more elaborate, even though they were originally based upon the same material. *Seated Nude with Arms on Head* and *Upright Nude with Arched Back* are typical of the first group: in both cases, the pose seems to have been chosen because it allows a clear but artificial vision of the various axes, masses and articulations of the female body. There is no real transposition of the motifs of the photographs, but simply an exploration of the possibilities for a continuous arabesque (like that which connects the torso with the arms and then the thighs in *Upright Nude with Arched Back*) and of the points that break the arabesque (knees, elbows). Matisse also seems to show little interest in the artificial continuity of an enveloping epidermis and emphasizes, on the other hand, the mobility of the light, which allows him to suggest a face or a knee without describing it. Thus, we are dealing here with a somewhat hasty search for a rhythm within a given motif, with a reading of lines of force, a summary exploration, with a personal and energetic use of material that is to hand but which has not yet been fully internalized.

The second group of sculptures, which are also based upon photographic material, represent the culmination of a very different process. It is worth analysing them one by one. The original source of

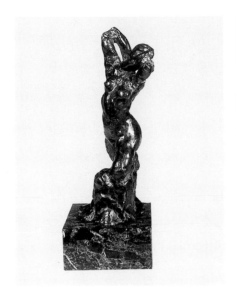 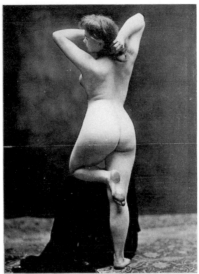 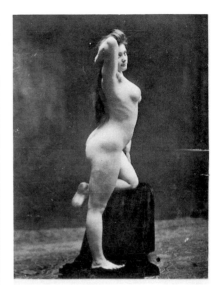

Two Negresses (1908) is a document entitled *Deux jeunes filles Targui*. But the ethnographic pretext is less important than the fascinating reversibility of the two figures: both women are of the same stature and their common air of exoticism makes them look almost like twins. They are visually connected in such a way as to provide a solution to the eminently sculptural problem of combining front and back views. Matisse moves skilfully from the flat image to the three dimensions of sculpture and accentuates the ambiguity (are we looking at two symmetrical and identical views of one body or at two bodies which are at once similar and different?) by reducing the differences between them. Despite the primitive references (in 1908, neither the starting point nor the title of the sculpture itself were neutral) and the archaic references (the frontality of each figure, their edges which form a cubic block in which the arms and legs read as the armature), *Two Negresses* is an affirmation of an extraordinarily modern and complex vision. As Meyer Schapiro pointed out as early as 1932,[4] the sculpture represents an attempt to transcend three-dimensionality and to achieve a total representation of a figure which is seen simultaneously and fully from behind and from in front, a play between wrong side and right side, between mass and void, between opening and closure, an ambition which goes far beyond the exploitation of a pose.

Another series of sculptures dating from 1908 deals with the crouching nude pose: *Small Crouching Nude with Arms, Small Crouching Nude without an Arm* and *Small Crouching Torso*. The *Small Crouching Nude with Arms* is a fairly faithful transposition of a photograph and we can take it as a starting point. The version with only one arm (which was broken off by accident, but as so often in Matisse's sculpture, led to a new departure by allowing him to begin the work again) and with no base, is quite obviously a small object to be caressed, an autonomous form which expresses compactness. There are no longer any obvious empty

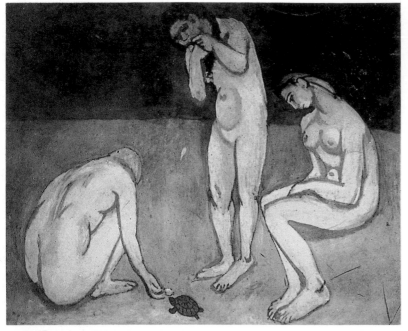

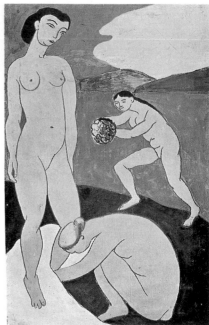

14 *Bathers with a Turtle*, 1908.

16 *Le Luxe II*, 1907–08.

15 Photograph used as basis for *Small Crouching Nude with Arms*.

spaces in this second version. The arm joins the chin to the leg, the thighs touch and the foot touches the knee. Even more so than in the version with two arms, in which the right arm rests upon the ground and breaks the continuity of contact, the whole body is closed in upon itself and caresses itself voluptuously. Finally, *Small Crouching Torso* is even more closed in upon itself, the egg-like effect being reinforced by the suppression of the head, the arms and the legs. This sculpture is almost abstract, stripped down, yet its tactile quality and subtle

16

rhythms give it considerable sensual power. It also represents a moment of confluence and plays a part in Matisse's work as a painter. As early as 1904, echoes of the pose appear in *Luxe, calme et volupté*. More definite echoes can be found in *Bonheur de vivre* (1905–06), in both versions of *Le Luxe* (dating from 1907 and 1908) and in *Bathers with a Turtle* (1908) – where the effect of simplification, abstraction and elongation provides a real equivalent to sculpture, although, as in *Blue Nude* and *Reclining Nude I*, there is still a tension between painting and sculpture. The difference in scale is obvious (the sculpture is very small and the painted nude is monumental) but the vision is the same.

This brings us to *The Serpentine* of 1909. Matisse remains faithful to the details of the photograph, even down to the somewhat sentimental detail of the finger in the mouth. A drawing and Steichen's photographs of Matisse working on the sculpture in 1909 show that he initially respected the rounded, almost solid physical appearance of the model. It was only later that he made the limbs so slender that they look like flexible cords. As he told Alfred Barr, 'I made the forms more slender and related them to one another in such a way that the movement could be completely comprehensible from every point of view.'[5] He thus conceived the paradoxical structure of a sculpture which seems to be based upon a precise arabesque cutting through space and determining equally precise spaces (which, in quantitative terms are more important than the solid mass). But the empty spaces are, so to speak, contained within the sculpture. They are active only within the confines of the sculpture, and its confines are those of the initial block. On the other hand, Matisse succeeds in transposing volume into *lines* which are so subtly modulated that they themselves can evoke a third dimension. This labour of elaboration and transposition has definitely to be related to his work on *The Dance* (1909), in which Matisse was once again to flatten the most elementary tools of painting in a deliberate manner: three flat tints – blue, green and the 'vibrant vermilion' of the bodies – are enough to express their movement and the landscape in which they are set.

This period gave birth to a new relationship between Matisse and his models as well as to vital explorations and discoveries. Matisse was no more able to do without models than he was able to restrict himself to them: he used his models to discover a reality that lay beyond. As he explained to Aragon thirty years later, 'When I see that my work has become more and more obviously detached from reliance upon the model, I do think that I have made some progress. . . . One day I would like to be able to do without models altogether. . . . I do not think I will be able to do so because I have not developed my memory for forms sufficiently. . . . I know perfectly well what a human body looks like – for me, a model is a springboard, a door I have to break down so as to get into the garden in which I am so alone and so happy.'[6]

Were not sculptures based upon photographs, models or paintings, springboards, ways to enter what Matisse saw as the true solitary garden of painting?

17 Photograph used as basis for *The Serpentine*.

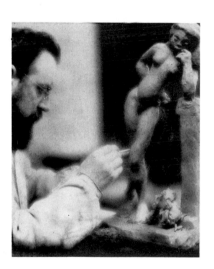

18 Photograph by Edward Steichen of Matisse working on *The Serpentine*, autumn 1909.

2 · Matisse and Cubist Space
1910—14

No discussion of Matisse can avoid the question of his relationship with Cubism, yet that relationship has never been analysed closely, rigorously or even accurately. It is particularly relevant here in that, from the outset, Cubism represented an even more radical exploration of sculpture than Matisse's work of the same period. As Daniel-Henry Kahnweiler stressed in 1948 in his preface to a collection of Brassaï's photographs of sculptures by Picasso, 'It was only natural that an undertaking which set out to make a new plastic inventory of the external world — and that was the original goal of Cubism — should turn to sculpture in order to overcome painting's relative inability to represent volume.'[1] Conversely, Matisse's attitude as a painter to sculpture may help us to understand the various ways in which he reacted to Cubism at different times.

Even though they are superficial and unsympathetic, contemporary press reports do provide a clear picture of the irresistible rise of Cubism to the forefront of new developments from 1910–12 onwards. We can imagine what this must have meant for Matisse who, since 1905, had been the unchallenged leader of the rebellious young Fauve painters, the representative of all that was avant-garde. One movement drove out the other. According to some sources, Matisse himself may have helped to baptize the new movement by describing the work Braque submitted to the 1908 Salon d'Automne as 'a painting made up of little cubes'.[2] There is, however, no proof of this. Even so, Matisse inevitably took an interest in the experiments of Braque and Picasso right from the start, and we can assume that his interest was real, understanding and favourable as well as critical. Discussing Cubism in a conversation with Tériade in 1952, he said that 'It was a period in which we did not feel that we were trapped inside uniforms; anything audacious or new that could be found in a friend's painting belonged to everyone.'[3] At this time he was in personal contact with Braque, Picasso and Derain. They all frequented the same collectors, namely Gertrude Stein, Shchukin and Morosov. Braque and Picasso spent the summer of 1911 in Céret and quite naturally visited Matisse in Collioure.[4] We know that Matisse was on friendly terms with Juan Gris after the outbreak of war: they spent the summer of 1914 together in Collioure and, as Gris told Kahnweiler, we 'talked relentlessly about painting'.[5]

Madame Duthuit often recalled that Matisse paid frequent visits to Picasso in the boulevard Clichy at this time and bemoaned the fact

that no record was kept of their extremely frank and intimate conversations. Matisse was then very well informed about the initial period of Cubism (1907–10). He was in almost daily contact with the Cubists, and the climate was one of generosity and shared discoveries. It was only later that he broke with Cubism and distanced himself from both the individuals involved and from their work. There was a widespread feeling that something snapped in 1914: a whole artistic climate and a whole international network (the Russian and German collectors) disappeared for ever. Even during the period of his 'exposure' to Cubism, Matisse was alternately drawn to it and repelled by it. What interested him was the precision of Cubist drawing, the similarity between what he called 'the battle against the deliquescence of Impressionism' and his own battles. What repelled him – and this takes us back to the problems posed by sculpture – was 'the investigation of the plane' which 'for the Cubists . . . was based upon reality' whereas for Matisse 'it had to appeal to the imagination.' This is the important point. In his conversation with Tériade in 1952, Matisse went on to say that 'it is the imagination which gives the painting its space and depth. The Cubists forced a rigorously defined space between objects upon the imagination of the spectator.'[6]

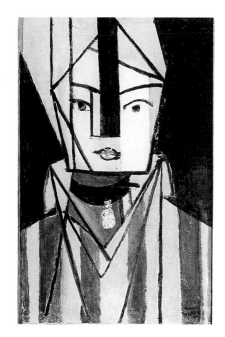

19 *Head, White and Rose*, 1914.

Thus, although he did sometimes try to adopt a roughly orthogonal grid (as in *Head, White and Rose*, 1914), Matisse never succeeded in breaking down space into superimposed planes which fold and unfold within precise and predetermined limits. He was neither willing nor able to do so. Cubist space (in both the Analytical paintings of 1911 and more conclusively in the Synthetic period) is never indefinite. It is a regular, calculated space which is full of surprises, but it is always measured in advance. Compared with the crystalline compositions of Picasso and Braque, the space in Matisse's paintings of this period appears to be disproportionate and gives no sense of scale. In *The Red Studio* of 1911, for instance, it is impossible to measure the quantity of space between the objects: they are suspended in a milieu which is at once dimension and light and which is truly limitless.

Hence, I believe, Matisse's inability to get away from the definition of the block in his sculpture and his inability to suggest space in an *open* object, not to mention in a combination of objects or an assemblage. Matisse sculpted figures which make no noticeable impact upon the space around them. It is as though he could only produce such effects in paint, as though his personal feeling of space could only be expressed in colour. Cubist paintings, in contrast, are in a sense paintings of sculpted space and give the impression that space has already been translated into the language of sculpture.

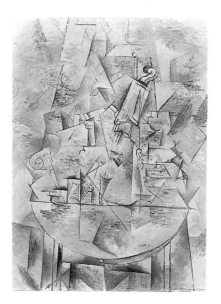

20 Georges Braque, *Le Guéridon*, 1911.

All the experiments carried out by Braque and Picasso after 1912 on collage and relief (adding sand or dust to pigments, making collages from pieces of paper, paper constructions, etc.), and above all Picasso's move towards making real assemblages, are the logical continuation of the so-called Analytic paintings and their calculated space. Daniel-Henry Kahnweiler's account of the period 1910–14 confirms this view:

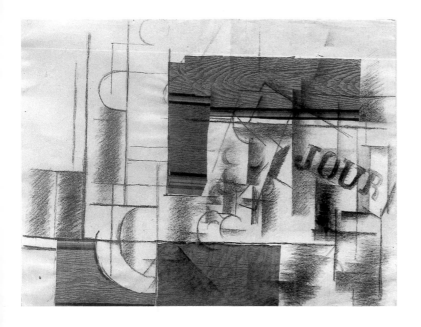

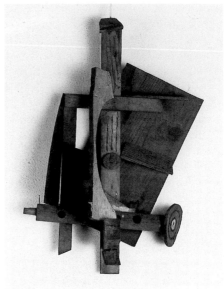

21 Georges Braque, *Composition*, 1912.

22 Pablo Picasso, *Mandolin and Clarinet*, 1914.

23 *Girl with Tulips*, 1910.

'The change which begins to appear in 1910 simply accentuates the use of eclectic materials. Initially, sculpture dominated this development. Between 1911 and 1913 Picasso's paintings once more become copies of imaginary sculptures.'[7] Imaginary sculptures which were to material- ize in 1914; could it be argued that Matisse's sculptures are simply copies of imaginary paintings? Perhaps we should look at the five *Heads of Jeannette* from this point of view.

Before we compare them with contemporary sculptures by Picasso, we have first to look at how the series developed and to recapitulate what we already know about it. The five versions of *Head of Jeannette* (Jeannette Vaderin, the model for *Girl with Tulips*, 1910) appear to have been executed in plaster at Issy between 1910 and 1913: the first four in 1910 and 1911, the fifth in 1913. They are of course distinct and autonomous works. But, significantly, they can also be seen as so many stages in a process of formal elaboration, or as so many states of that process. Although Matisse did not do so at this stage, he later kept systematic records of similar processes in his paintings: after about 1934, almost all of Matisse's paintings were photographed as they progressed day by day. The starting point is a portrait treated in relatively conventional style. The first two versions, for which Jeannette Vaderin actually does seem to have posed, are realistic points of departure. The head and the crown of hair are treated as a single homogeneous mass whose expressive modelling catches the light. The second version, in which the effect of a simplified mask is stronger (the neck is suppressed and the integration of details such as the eyebrows is improved), is even more like a drawing, a global unity with the emphasis on the frontal view. In the last three versions, the starting point is displaced in spectacular fashion and the series culminates with the impressive figure of *Jeannette V*. In *Jeannette III*, the hairstyle is

20

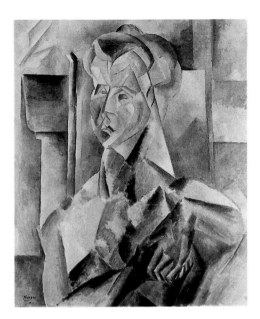

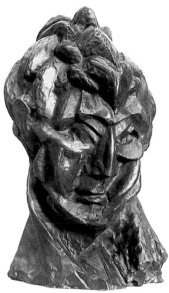

altered: the hair is redistributed into four unequal and separate masses which echo the prominent nose, the heavy eye sockets and the swollen, deformed cheeks. The initial impact of the unity of visually contrasting elements culminates in *Jeannette IV* (completed in 1911), with each part developed independently. The convex modelling of the eyes (the left eye appears to have been added later) and the subsequent alteration of the proportions of the face add to the impression of rupture. It should be noted that for the fifth version (executed two years later in 1913) Matisse worked, not from *Jeannette IV*, but from the third version. He went back to a plaster cast of *Jeannette III*, cutting through the mass of hair at the back and on the side of the head and hollowing out the left eye. He then added clay to the plaster cast, remoulding the nose, the forehead and the hair above the forehead into a single form. Although he had started out from the same original elements, he arrived at an alternative solution to the 'rupture' effect produced by *Jeannette IV*. *Jeannette V* produces a new synthesis: the integration of dissymmetry, as opposed to a classically harmonious rounded figure. In a sense, *Jeannette IV* represents a move towards decomposition, towards a sculpture which is on the point of splitting and allowing the space around it to intervene. *Jeannette V* represents Matisse's final choice: it both refers to a new interpretation of the human figure (the African sculpture he saw in 1906), and is also linked with the classical image of the figure as the true measure of space.

Two important sculptures by Picasso, *Head of a Woman (Fernande)*, 1909, and the *Guitar* of 1912, are contemporary with the *Heads of Jeannette*. Picasso's *Head of a Woman* is an accurate volumetric transposition of the facets in his paintings of 1909: the object is seen from several angles and as if from within. Paradoxically, the facets form a continuous surface, an enveloping epidermis, like a shell around a kernel, and we find

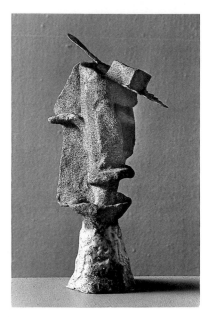

26 Pablo Picasso, *The Glass of Absinthe*, 1914.

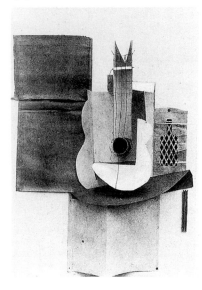

27 Pablo Picasso, *Guitar and Bottle*, 1913.

ourselves in the presence of what seems to be an Impressionist sculpture that has been taken to almost absurd extremes, a direct descendent of the work of Rodin or Medardo Rosso. As Daniel-Henry Kahnweiler remarks, 'The surface is no longer simply rough: it is gouged into hollows and moulded into protruding bulges, as though Picasso wanted to give his bronze the created light of a painting. He is no longer depicting the form of the head, but the objectification of light upon the head.'[8] Picasso did not in fact pursue his research along these lines any further, as it seemed to be leading nowhere. The dislocation of form remains superficial and produces a much weaker effect than the paintings of the same period.

With the first sheet-metal *Guitar* (1912), the paper and cardboard constructions which came before and after it, the first *papiers collés*, the *Glass of Absinthe* and the reliefs of 1914, Picasso does, however, enter a completely new field in which the object is central. As Pierre Daix notes, 'Up to that time, Picasso had upset traditional figuration, that is, the means whereby perceptible reality had been represented in painting. He had now got to the point of destroying even the *figura*, the collected elements which constitute the shape of a body, the image. . . . But what happens in the space when the image is no longer there, when the shape of the figure has disappeared? Well, it still works. The brain re-establishes the essential correlations.'[9] Picasso demonstrates that forms can radiate in space, that space can be organized in terms of open forms and above all that empty space can be used to express mass. 'These reliefs', wrote Daniel-Henry Kahnweiler, 'introduce something startlingly new into European sculpture: "opaque" volumes (if I can put it that way) are split open. The forms of the glasses and musical instruments are never *described* in their continuity; they acquire continuity only in the creative imagination of the spectator'.[10]

At the very moment when Picasso was discovering and exploring all the implications of the fertile ambiguity of the assemblage – material discontinuity/mental continuity – Matisse returned in 1913 to the monumental figure known as *The Back*, the first version of which dates from 1909. The four versions of *The Back* are the most ambitious of all his sculpted figures and, being bas reliefs, are more like blocks than the others. They may also be more closely related to his paintings. It seems in fact that Matisse worked on each of the last three versions (1913, 1916–17, 1930) by using a plaster cast of the previous state, hence the constant dimensions of the rectangle within which the figure is inscribed, as though it were a canvas or a sheet of paper.

The first state (1909) takes its inspiration directly from reality, from a model. The left arm is raised above the head, causing the right shoulder to rise too. Both legs are clearly defined: the left leg is stiffened to support the weight of the body, the right slightly flexed. The general schema is structured by a vertical axis from which the other lines radiate. The first state is the best known, as a plaster cast was shown as early as 1912 and again in 1913 at the Armory Show. In the second (1913) state which he 'forgot' in 1951, Matisse concentrates upon

a purely formal combination, and the expressiveness is less pronounced. (A small pen and ink sketch of the second state figures on the back of a letter from his son Jean to Madame Matisse.) The spinal column has been straightened and provides a more stable vertical axis. The various elements of the body tend to merge; the right shoulder is rounded, the line of the neck is extended by the plait, and the plait in turn merges with the vertical fissure of the spinal column. The legs become thicker and resemble pillars.

Albert Elsen has quite rightly compared the third state (1916–17) with *Bathers by a River*, a canvas which was begun at the same time.[11] The earlier formal combination is thrown into question, but certain of its implications are at the same time developed. The inverted fissure of the plait has become an explicit vertical axis in relief. Like the canvas of the *Bathers*, the sculpted rectangle is divided into parallel vertical zones of unequal width in accordance with a rhythmical pattern that will become even more pronounced in the fourth state (1930), which gives an impression of clarity and equilibrium. In this state, the body is treated as a single unified form.

States II and III of *The Back* series are, then, a startling demonstration of Matisse's inability to break the unity of the figure and to internalize the problem of space *within* sculpture. In both his paintings and his sculptures, what matters most to Matisse is the figure and the assertion of its indivisibility. Perhaps the whole process which led to the materialization of Cubist sculpture in 1912–14 – a process which begins with painted still-lifes, Braque's 'tactile space' and the use of pieces of imitation wood-grained paper and sand to reinject both reality and colour into painting, and which anticipates the fragmentation inherent in the assemblage – is connected with the emphasis on the exploration of the still-life. It is as though Braque and Picasso chose objects in 1912, whereas Matisse opted to remain with the figure.

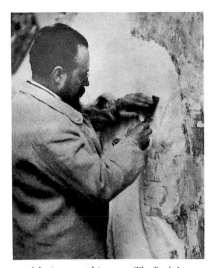

28 Matisse working on *The Back I.*

29 *Bathers by a River*, 1916.

30 *The Back*, 1909–10.

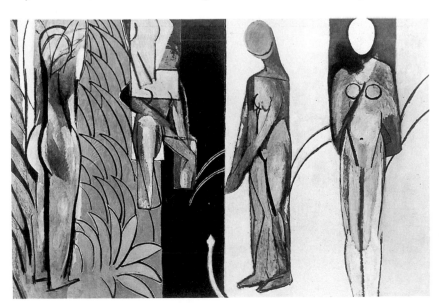

3 · The Sculpture in Matisse's Painting
1911—17

On the basis of the current state of our knowledge and in the absence of a *catalogue raisonné* of Matisse's paintings, it appears that all the known paintings (some twenty in all) which depict sculptures date from before 1916—17, from before the Nice period and the return to 'an intimate painting'.[1] In view of the lucid nature of Matisse's approach and his self-awareness, it seems to me that this observation, which might appear to be purely quantitative, has a number of implications and merits systematic exploration. I will therefore ask a number of questions: Why did Matisse fairly often depict his own sculptures in his paintings? Which sculptures did he choose and what is their function in the composition? Does his use of sculpture evolve in any way? Which problems common to both painting and sculpture are raised by these questions?

The sculptures, and especially the small statuettes which are designed to be handled, are coloured objects and can become formal elements in a still-life composition, just like bouquets of flowers, bowls of fruit or multicoloured carpets. They do, however, introduce a certain ambiguity: a sculpture is a small object which can be placed at a given point in the still-life and, like the other elements in the arrangement, it is an immobile object, but it is also a *figure*, an evocation of the living human body and, in that sense, it is truly different from the other elements. Painters have played on this ambiguity for a long time. It will suffice here to cite only certain still-lifes by Cézanne, notably the Courtauld Institute's '*L'Amour en plâtre*', which depicts a cast of an *écorché* similar to that owned by Matisse. In 1903, Matisse produced a sculpted version of this *écorché* and he also included it in two paintings dating from 1911: *Interior with Aubergines* and *Still-life with Aubergines*. They exemplify the way in which Matisse's paintings take painting itself as their subject: the reflective movement which informs any true work of art and gives it its depth. They also serve as a reminder of the constant link between Cézanne and Matisse and of Matisse's exploration of Cézanne.

The sculptured figures which appear in Matisse's paintings are, however, usually his own, and the interiors are normally the rooms in which he painted. In them space is treated in perspective terms, sometimes dizzyingly so. The spectator is invited to enter into the painting as it is being produced. Thanks to the device of 'the play within the play', of a painting which represents itself, we eventually

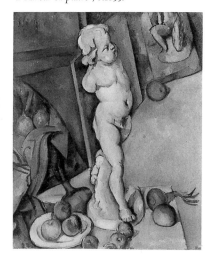

31 Paul Cézanne, *Nature morte avec 'L'Amour en plâtre'*, c.1895.

24

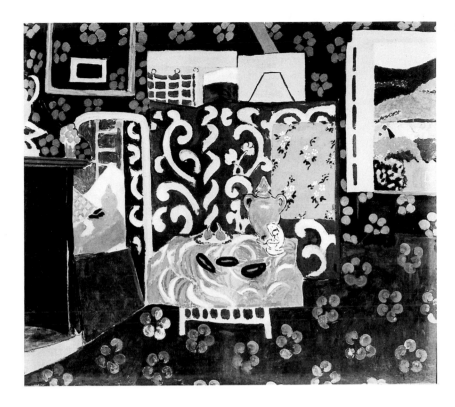

cease to make any distinction between the 'real' space in which the painter and his model are set and the 'less real' space of the painting on the easel. At the same time, we realize that this composite space is that of painting, that it is the only real space. Finally, the site of creation – the studio as workshop, as storehouse of materials, as repository for all the achievements that are required if work is to go on – merges with the subject of the painting itself. Within this space, the sculptures seem to have the same status as the paintings.

Thus, in the two great paintings of 1911 – *The Pink Studio* and *The Red Studio* – Matisse depicts a large number of works in the context of his day-to-day life. Chairs, tables, carpets and frames are shown in apparent disorder, thus giving two 'pictures' of the work in progress, two 'states' of the place in which the work was produced. There are paintings on the walls and on easels. We can, with some difficulty, recognize the sculptures: on the table in *The Red Studio*, the *Upright Nude with Arched Back* and, standing against the wall in *The Pink Studio*, a plaster cast of *The Back I*. They are indeed difficult to distinguish: the outlines are painted without any shadows or in such a way as to become almost transparent, and they have no depth. In *The Red Studio*, the *Decorative Figure*, which is in fact quite solid, becomes a threadlike figure with the lightness of an insect and looks somewhat reminiscent of *The Serpentine* – a sculpture which, to my knowledge, Matisse never painted, perhaps because it is so perfectly sculptural. But is not lightness characteristic

of all the objects which fill the two *Studios*? They are all bathed in the glorious light of the painting and suffused with red or pink; they are no more than painted substances. In these and certain other paintings, the sculptures lose their specific weight, their material substance and thus add to the clarity of the representation. Light, air and thought circulate with complete freedom, complete fluidity. In *The Red Studio* we move with a euphoric feeling of weightlessness from *Large Nude with Necklace* (a lost painting) to the small sculpture on the table (*Upright Nude with Arched Back*, an orange-coloured terracotta, seen here from behind), which is also entwined with flowers, and then to the *Nude* nestling amongst the flowers on the plate. Although these three figures are in fact very different in terms of their weight and presence, within the space of the painting they breathe in exactly the same fashion. The *Decorative Figure* in *The Pink Studio* appears to have escaped from *Le Luxe*, the painting hanging above it, and has no more weight than the landscape seen through the window panes. But is the landscape real or painted? The simultaneous presence of the Greek *Kouros* (which is obviously a white plaster cast) and *The Back I* produces a similar effect: at first sight, it is impossible to be certain whether *The Back* is another cast or a drawing. What is certain is that each figure is affected by the presence of the other in a space which, in this case, is undoubtedly that of painting.

Normally, Matisse only painted his sculptures once (some are painted twice, one on three occasions), but *Reclining Nude I* (1907) appears in his paintings on nine occasions. This sculpture always had a particularly close relationship with Matisse's painting. As we have seen, *Blue Nude* (*Souvenir of Biskra*) is the most obvious example of the interpenetration of the two modes of expression, as it both replaced a sculpture which was broken, but on a much more monumental scale ($36\frac{1}{4} \times 55\frac{1}{8}$ in.), and served as a model for the surviving sculpture.

Over a period of more than ten years, this sculpture appears again and again in Matisse's paintings in a number of very ambiguous and therefore, for our purposes, highly significant guises. In 1908, the sculpture is placed horizontally and becomes the subject of *Bronze With Carnations*. Set upon a stand, slightly larger than life size (the painting measures $23\frac{3}{4} \times 28\frac{3}{4}$ in.), and clearly defined as a sculpture, it still bears a curious resemblance to the painted *Blue Nude*: its position in the two-dimensional space of the painting is identical, the contours are even more heavily outlined, and the distortion is the same. The visual tension is very high and the ambiguity is total: we cannot tell where the painting begins and where the sculpture ends. A later group of three paintings (1911 and 1912) combines the motif of a bowl of red goldfish with that of the *Reclining Nude*, but this time the sculpture is positioned vertically. The *Reclining Nude* is reduced to very schematic lines and is not to scale, being always either too large or too small in relation to the bowl of goldfish. It visibly escapes its status as sculpture.

This is particularly clear in the Museum of Modern Art version of *Goldfish and Sculpture*. This is the earliest of the three versions and is contemporary with the two *Studios*. Only a band of colour which

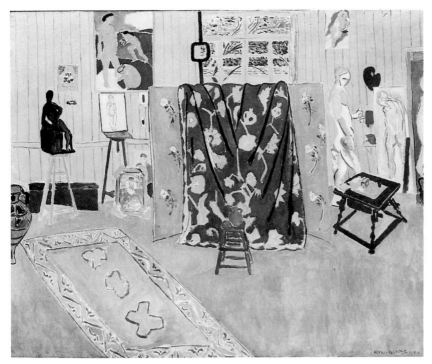

33 *The Pink Studio,* 1911.

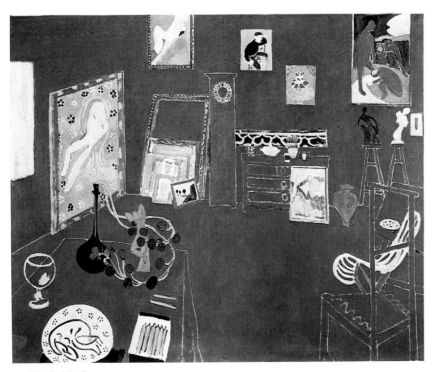

34 *The Red Studio,* 1911.

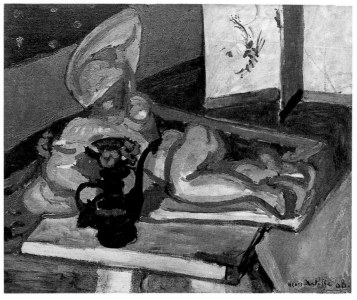

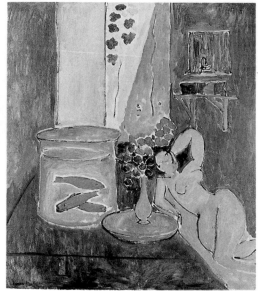

35 *Bronze with Carnations*, 1908.

36 *Goldfish and Sculpture*, 1911.

extends beyond the frame connects the *Reclining Nude* to the sculpted plinth from which it should be inseparable. The colour itself heightens the ambiguity. The reclining figure is painted in a pink which suggests the flesh tints of a body rather than the true colour of terracotta and it seems to be looking at the fish, just as many of the female figures in the paintings and engravings of the 1920s were to do. Although the title refers to the figure as a 'sculpture', it seems likely that it has in fact become a model once more, a representation of a human presence alongside the vegetable and animal elements of this tripartite still-life. In terms of colour alone, it signifies 'body' or 'figure': against the dominant blue and green, the pink becomes a faded echo of the 'vibrant vermilion' of *Dance* and *Music* (1910).

Two slightly later works invert the elements once more: *Terracotta, Water-cooler and Fruit* (whereabouts unknown), and *Still-life With Ivy*. Here, there is no longer any ambiguity as to whether or not the figure is a model: it is an object which is formally related to the other elements (the brutally schematized thigh echoes the handle of the water-cooler, the breasts echo the fruit). During this very brief period, Matisse came close to Cubism. He was trying to find geometrical co-ordinates and also to treat the figure itself geometrically (cf. *Head, White and Rose*) but did not really succeed.

Finally, we will see the *Reclining Nude* reappear in *The Music Lesson* (1917). In this painting, the figure is definitely not to scale and its presence – in every sense of the word – is, for a variety of reasons, quite astonishing. But before we analyse this important painting, we have to return once more to the question of scale. In order to do so we must examine other paintings depicting other sculptures. It will then become apparent that the representations of the sculptures are never proportional to the real space they take up, that they play the role of

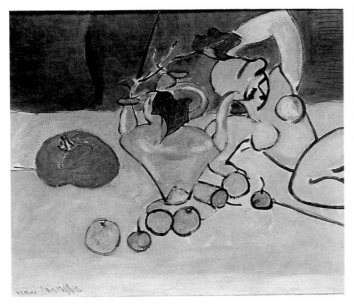

figures or simply represent one element within a still-life. 'What I am after, above all, is expression. . . . The entire arrangement of my picture is expressive: the place occupied by the figures, the empty spaces around them, the proportions, everything has its share.'[2] 'The place occupied by the figures' refers, not to space in general, but to the space of the painting; and the 'figures' themselves may be objects or fruit. Thus, Matisse's earliest sculptures, which are usually small and designed to be handled, were to play only a minor role in his paintings. *Standing Nude*, for instance, initially makes a ghost-like appearance behind the various dishes, plates and other objects in *Still-life with Melon*, and has much less physical presence than the enormous melon which gives the painting its title. It appears again in another still-life painted in 1906 (*Still-life with Plaster Figure*). This time it is seen in profile and dominates the composition of small objects in a most impressive manner. In this case, it is as though the statuette could not be dealt with in the same way as the other elements making up the still-life. Likewise, *Thorn Extractor* (1906) and *Woman Leaning on her Hands* (1905) seem tiny in the presence of the *Pelargonium* (1907). But the most astonishing example of this displacement of scale is the 1914 *Spray of Lilac*, a still-life with three elements: a glass jar holding a spray of lilac (a single stem laden with blossom), and framed by a pipe on the left and a small sculpture on the right (*Small Crouching Nude with Arms*, 1908). The sculpture is in fact very small (less than 6 in. high), but in the dazzlingly radiant presence of the lilac it looks minute. It is no taller than a single lilac flower and is so different that it has obviously been placed there to provide a contrast. Matisse painted the flowers and leaves for the sake of their colour rather than their form, and even deliberately left blank one corner of the canvas so as to integrate it into the spray of flowers. In contrast with the flowers, the sculpture is

37 *Still-life with Ivy*, 1916.

38 *Still-life with Plaster Figure*, 1906.

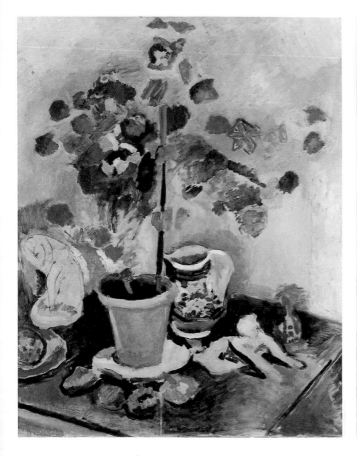

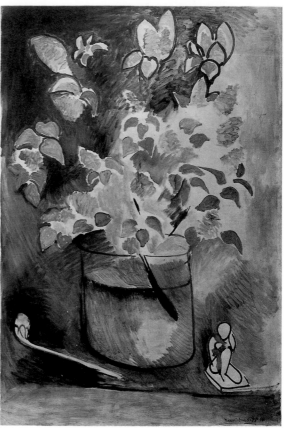

39 *Still-life with Geraniums and Fruit*, 1907.

40 *Spray of Lilac*, 1914.

perfectly and clearly defined in space, a slight but weighty presence which is closed in upon itself and which is geometrically constructed from small, compact volumes.

If we now go back to *The Red Studio*, we note that the sculptures it depicts (*Upright Nude with Arched Back*, 1904; *Decorative Figure*, 1908; and *Jeannette IV*, 1910–13) all appear to be of similar size, whereas in reality their dimensions are in fact very different. (They measure $8\frac{7}{8}$ in., $28\frac{3}{4}$ in. and $24\frac{1}{4}$ in. respectively.) In *The Pink Studio*, the *Decorative Figure* is taller and more solid, and its presence on the left of the painting is in itself sufficient to balance that of the *Kouros* and *The Back I* (which is in fact much bigger than the *Decorative Figure*). Its dark shape (it is a rare example of the use of bronze in Matisse's representations of his sculptures) echoes the palette hanging on the right. Its role, then, is to effect a symbolic link, to recall form and colour rather than to render the presence of the figure itself.

The same is not, however, true of *The Piano Lesson* (1916), in which the same *Decorative Figure* reappears, this time in the very ambiguous form of a flesh-coloured terracotta. Both this superb canvas and *The Music Lesson* (1917) express the tension between the temptations of abstraction – and Matisse rarely came so close to it – and his organic attachment to the living reality of the figure or body. The following year, he was to

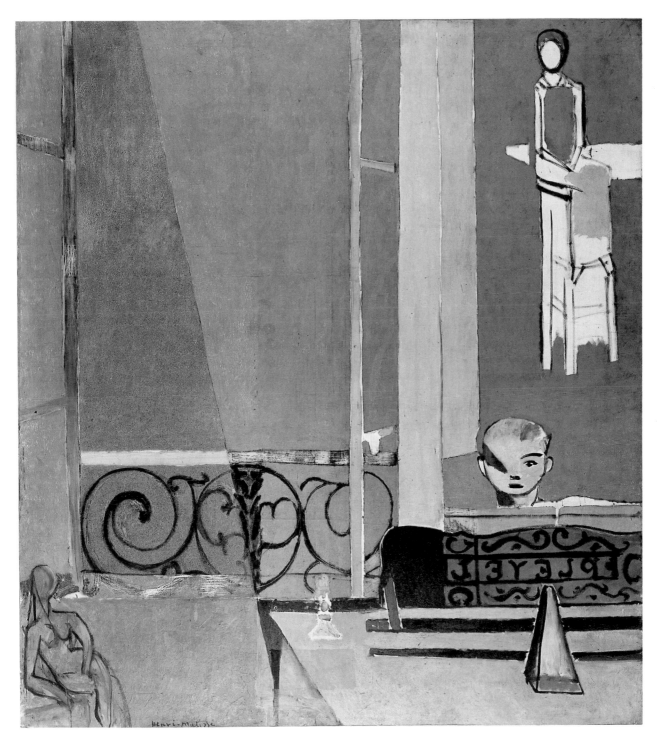

41　*The Piano Lesson*, 1916.

42 Constantin Brancusi, *Head of a Child*, 1913–15.

43 Constantin Brancusi, *Tête de femme, d'une muse*, 1912.

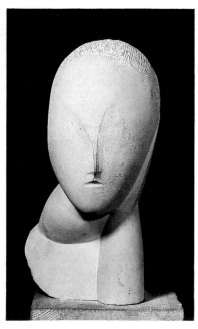

opt for his attachment to the figure and to use it to combat abstraction. The beauty of the two *Lessons* lies in the tension established between equally violent forces within the paintings themselves, and between the two versions. In both cases, the sculpture in the painting is given the decisive role of acting as a figure in all senses of the word.

In the first version, we see three figures: a seated nude on the left (a terracotta version of the *Decorative Figure*), the head of a child (Pierre Matisse) sitting at a piano on the right, and a third seated figure in an indeterminate space above the child. We immediately perceive the third figure as being different from both the nude and the child's head and assume that it is a painting hanging on the wall (perhaps *Woman on a High Stool*). The general structure of the composition is geometrical and angular, and it is dominated by ternary signs: the triangle of the metronome, echoed on a larger scale by the window and on a smaller scale by the triangle which cuts across the face of the child at the piano, and the three figures themselves. Neither the painted nude nor the painting have mouths or eyes. The face of the child is half drawn, half sculpted by the light itself. There is a considerable temptation to reduce it to a mere volume, with a curious similarity to certain sculptures made by Brancusi at this time (*Head of a Child*, 1913–15; *Newborn Child*, 1915). This 'sculptural' temptation dominates a number of Matisse's paintings of this period and can be seen in both the *Italian Girl* (1915), in which the oval mask of the face is carved and smoothed like Brancusi's *Tête de femme, d'une muse*, and in the monumental *Bathers by a River* (1916–17). But Matisse resisted the temptation: the attentive gaze of the child is fixed upon his score, but it is not static, and represents the urgent pulse of life. Paradoxical as it may seem, the *Decorative Figure*, placed at an angle and without any visible support in the left-hand corner of the painting, also helps to remove the immobile tension of abstraction. The sculpture acts as a sign and represents precariousness, instability in a world threatened by the static. It suggests the imperfection of suspended motion, as opposed to the artificial perfection of geometrical figures and the triangulation of space. In a sense, it symbolizes the help Matisse sought at certain crucial moments in the creation of sculpture: physical contact with the live figure.

The later *Music Lesson* brings us into the room, which is now overcrowded. There are two figures at the piano – the child and his sister Marguerite – with Matisse's eldest son on the left and their mother sitting in the garden behind them. The painting *Woman on a High Stool* is now obviously hanging on the wall. In the background by the pool, a final and monumental version of *Reclining Nude I*, now in the guise of a fountain, presides over the family gathering. The status of both sculpture and painting is now clarified in relation to the other figures. The stone nude is at home beneath the trees in the garden. Freed from the threats of abstraction, the graceful curves of the human figures return to the foreground.

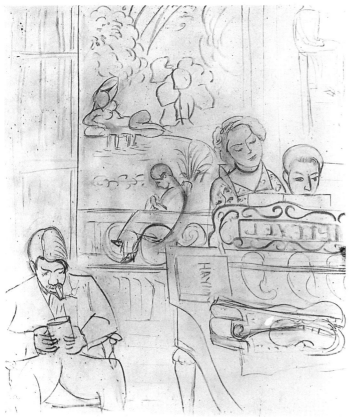

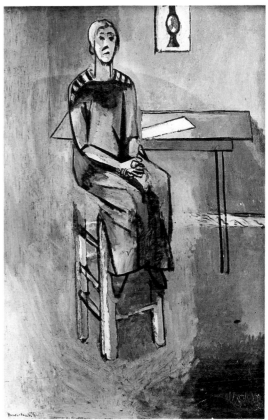

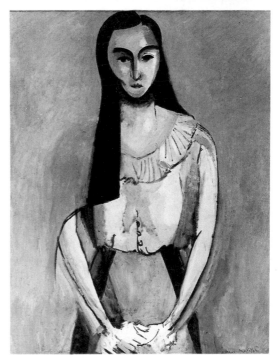

44 Study for *The Music Lesson*, 1917.

45 *Woman on a High Stool*, 1913–14.

46 *The Italian Girl*, 1915–16.

4 · After Nice
1924—32

During the First World War and as a result of his contacts with Cubism, Matisse had moved towards a style of painting which was more austere and more geometrical, but which also had more depth. In 1930, he made a distinction between the period when 'my paintings were made up of combinations of dots and arabesques ... my works were primarily decorative in character' and the period beginning in about 1914 when 'a deeper expression that was established in depth, by planes, began to emerge ... the intimate painting of today'.[1] This movement towards a more intimist register was precipitated when Matisse began to live partly in Nice. He first visited Nice in the winter of 1916—17, and from then onwards he regularly spent half the year there, from October to May. The move to the South, where the even, crystalline light was everything that he could hope for,[2] coincided with — or provoked — a marked return to the female nude, to an obsession that was to last for ten years.

At the very beginning of the Nice period, he produced three sculptures. *Seated Nude Clasping her Right Leg* (1918), is formally related to *Seated Nude (Olga)* (1910), perhaps because between 1910 and 1918, in both his paintings and his sculptures, Matisse worked essentially on portraits and monumental figures (signs rather than representation) such as *The Back II* (1913) and *The Back III* (1916—17) and *Bathers by a River* (1916—17). By 1918 he was ready to work on the nude in a more intimist mode once more, returning to a subject he had abandoned in 1910. In contrast, *Crouching Venus*, a sculpture after a cast of a Hellenistic sculpture in the Ecole des Beaux-Arts in Nice, probably answered a need to come to terms with a more Mediterranean and relaxed inspiration than that of previous years. In this context, the *Venus* can be seen simply as a celebration of the body, as a prelude to the odalisque theme in Matisse's painting.

Between 1918 and about 1925, Matisse produced no sculptures and devoted himself exclusively to painting. Once again, the absence of a *catalogue raisonné* is to be regretted, particularly as most exhibitions and retrospectives have not concentrated upon the Nice period. Although Matisse's return to the figure and to pictorial values which appear to have been more acceptable to his contemporaries brought him official successes (*Odalisque in Red Culottes* was purchased by the Musée du Luxembourg) and a certain recognition, it would be wrong to consider the paintings of the 1920s as merely academic. We still have to ask why

Matisse devoted himself to painting with such pleasure or even intoxication during this period. What is certain is that he was once again reactivating 'natural qualities ... which I had had to hold in check for a long time, the flavours of flavoursome painting'.[3] He was rediscovering the pleasure of painting fabrics, flowers and jewels, and above all the pleasure of painting the tender relationship between the naked body and the objects around it, the objects which caress it and form an environment which is a natural extension of its intimacy. The rooms of the Nice period clothe and house Matisse's nudes in the same way that, according to Lévi-Strauss, 'the knotted, plaited, woven, embroidered and patinated homes' of the Bororo clothe and house their primitive inhabitants. 'Their nudity appears to be protected by the velvety grass of the walls and by the fringe of palms. They slip out of their homes as though they were slipping out of loose dressing gowns of ostrich feathers. Their bodies are downy jewel-caskets, and their fine contours are heightened by their vivid make-up and face paint.'[4] Matisse's painting is now at its most Baudelairean and its most fluid: he is painting scents and reflections. But there is still one constant which prevents the painting from dissolving into dissipated surface sensations: the central axis of the stubborn exploration of the spatial shape of the figure. The serious, almost religious attitude towards the human figure also remains constant. As Matisse wrote in 1908, 'What interests me most is neither still life nor landscape, but the human figure. It is that which best permits me to express my almost religious awe towards life.'[5] He could have said the same thing twenty or thirty years later, or gone on saying it until the end of his life. He painted and drew an almost dizzying succession of figures: seated, reclining, standing, nude, grouped, clothed, looking out of a window, getting out of a bath, combing their hair, sleeping.

It was only after this period of intoxication with painting that he returned to sculpture. The return was marked by a masterpiece which condenses and sums up the accumulated experience of the Nice period. The *Large Seated Nude* (completed in 1925) relates to those paintings in which Matisse seems to feel a new need for concentration and construction, and particularly to *Decorative Figure on an Ornamental Ground* (1925–26) and *Seated Nude in an Armchair* (1926). He worked on the *Large Seated Nude* for a period of two years, using the model (Henriette Darricarrère) who had posed for him from about 1920 to 1927–28, in other words for the majority of the odalisques. It is worth referring here to 'Notes d'un peintre sur son dessin' (1939), the text in which Matisse expresses his relationship with his models most clearly. The haunting similarity between the drawings, lithographs and paintings in which the 'arms raised' pose reappears is definitely related to the model's lack of self-consciousness, to an accumulation of visual memory and experience combined with intense emotion and to their condensation into a deliberately chosen pose which is also, in more general terms, 'A generous tribute to the visible splendour of the female body which spreads in all directions within the tactile space it generates.' (Jean Leymarie.)[6] Matisse states that 'My models, human figures, are never

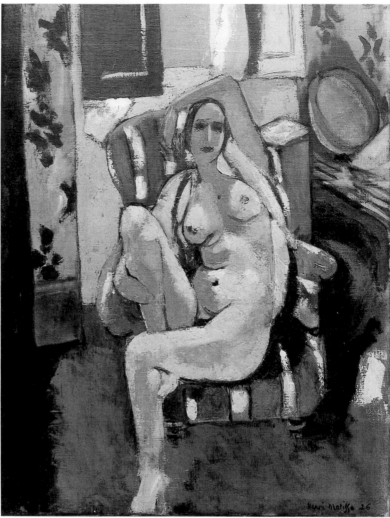

47 Study related to *Large Seated Nude*,
c. 1923—25.

48 *Seated Nude in an Armchair*, 1926.

49 Study related to *Large Seated Nude*,
c. 1923—25.

just "extras" in an interior. They are the principal theme in my work. I depend entirely on my model, whom I observe at liberty, and then I decide on the pose which best suits her nature. When I take a new model, I intuit the pose that will best suit her from her un-selfconscious attitudes of repose, and then I become a slave of that pose.'[7] The technique of observation 'at liberty' gave rise to a number of superb drawings which seem to walk around the model and then gradually crystallize. The drawings resulted first in a small sculpture known as *Small Nude in an Armchair* (1924), which might almost be a first sketch for the *Large Seated Nude*. With the exception of the detail of the leg, which is entwined with the other in the *Large Seated Nude* but merely raised and placed on the edge of the sofa in the small nude, the pose is the same. The clarity and legibility of the large nude is noteworthy: by reducing the couch or armchair to a round indeterminate form which functions as a plinth rather than a chair, and by posing the figure on it uneasily, Matisse is able to develop the arabesque of his nude in magnificent fashion, whereas in the smaller version, the solid presence of the chair prevents us from reading the movement of the legs clearly. It does, however, have a specifically spontaneous quality. It is also interesting to note that Matisse's preoccupation with painting the figure in terms of its environment, in relation to the furniture and objects which make up the décor in which it moves, is integrated into his sculpted work too: the object is almost clumsily included in the description of the nude, but the small dimensions of the sculpture reduce it to the intimist status of a familiar object.

51 Study of *Henriette*, 1927.

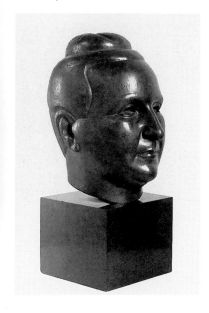

52 Jacques Lipchitz, *Portrait of Gertrude Stein*, 1920.

The monumental qualities of the *Large Seated Nude* relate it to the period 1910–16 and to Matisse's work on *The Backs*. If we study it in relation to the drawings, we note the importance of the formal displacements introduced by Matisse, the most spectacular being the suppression of the enveloping form of the chair: the torso is developed and majestically lengthened, the figure bends at the waist, the breasts and head (described as a simplified oval) become more slender so as not to break the arabesque, but the girth of the thighs becomes gigantic and is counterbalanced by the freer movement of the arms. Curiously, this sculpture, which was 'in progress' for two years, and which lived in the studio like an odalisque, functions as a reference or return to a different register. It may have helped Matisse to distance himself from the fluid and pearly paintings of the 1920s. It also allowed him to arrive once more at a new way of painting. It in fact seems to me that the most important painting of 1925–26, *Decorative Figure on an Ornamental Ground*, which marks the end of the decorative and sensual style of the first Nice period and the return to a more constructed and monumental expression, in a sense derives from Matisse's work on sculpture. Photographs taken in Nice in about 1924–25 show the original model of the sculpture standing against the very background – flowered wallpaper, decorative hangings and a Venetian mirror – which appears in the painting itself. The setting for the sculpture may have been the starting point for the canvas which, as the title itself makes clear, deals with the same problem: the relationship between figure and field or, more specifically, between a figure modelled in relief and a flat, artificially ornamental field. The painting represents a turning point: Matisse seems to be gathering strength for the new experiments in cutting out figures against a background which will eventually result in the large mural *Dance* in the Barnes Foundation.

The following years saw the production of three other groups of sculptures, all leading in very different directions. Again using Henriette as a model, Matisse first executed a series of portraits. It is almost as though, having drawn and painted innumerable images of her body and having sculpted a synthesis of them all in the *Large Seated Nude*, he wanted to attempt a true portrait that has an intensity which, to my knowledge, he never achieved in a painting. In that sense, the three states of the portrait can be related to the *Jeannette* series, but are based on greater familiarity with the subject. *Henriette I* is a relatively realistic study of Henriette's pensive, somewhat sad expression and of the peculiar form of her high, domed forehead. The second portrait, known as *Large Head*, stresses the static character and the symmetrical masses of the hair, cheeks and chin. The paintings and drawings of this period also stress the smooth, regular oval of the face. *Henriette II* is definitely the most dated of the three versions: it can be compared to certain sculptures by Jacques Lipchitz (*Portrait of Gertrude Stein*) and relates to the generalized contemporary reference to an almost Roman classicism, to the propriety of a smooth, regular finish which suggests the heavy coldness of marble. The third version, in contrast, contains pronounced volumes, for example the treatment of the

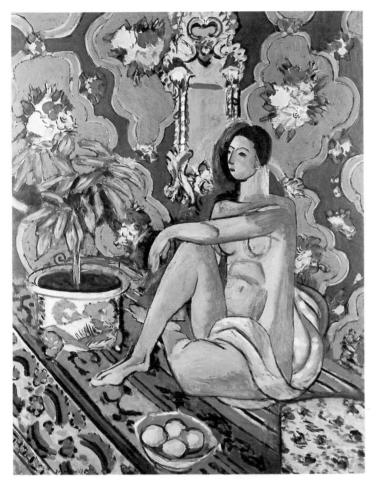

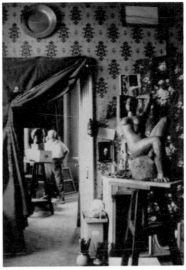

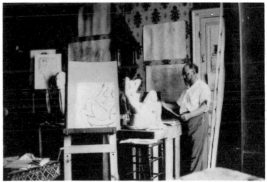

53 *Decorative Figure on an Ornamental Ground*, 1925–26.

54, 55 Matisse working on *Large Seated Nude* in his rooms in Nice, 1924–25.

56 *The Dance* (centre panel), 1931–32.

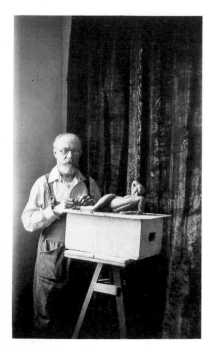

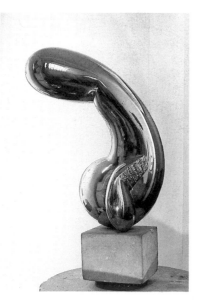

eyebrows, and the subtle handling of the fragmentation of mass and the modulation of light.

In a second series of sculptures, Matisse again returns to his favourite pose of *Reclining Nude I*, in *Reclining Nude II* (1927), and *Reclining Nude III* (1929). The first *Reclining Nude*, however, was characterized by a violent expressivity, by a tension which continually broke the arabesque. In the two later *Reclining Nudes*, Matisse is looking for a new mode of expression: rather than emphasizing joints and breaks, he chooses to describe and amplify the uninterrupted, flowing arabesque and even erases facial features which are too individualistic. He adopts two solutions. *Reclining Nude II* is constructed by simplifying and displacing masses, rather like *Large Seated Nude*. The twist of the body is still there, but it becomes decorative. In *Reclining Nude III*, the same techniques are exaggerated and produce effects that are almost bizarre. The arms and legs are shortened and the breasts flattened: the whole emphasis is placed upon the generous curve of the stomach, its two folds of flesh which are extended in the double line of the legs, stressing the horizontal pose of the body, bringing it closer to the ground and making it recline even more.

Certain other sculptures dating from 1929–30 also play their part in Matisse's search for organic simplicity: *Small Thin Torso* (1929), *Small Torso* (1929), *Tiari* (1930), *Venus in a Shell I* (1930) and *The Back IV* (1930). With the clear tranquillity of their volumes, these works are the sculptural equivalent of the line drawings of 1930–31. A pure light is contained within spaces that are clearly defined by vibrant and precise arabesques. These polished sculptures may also relate to Matisse's work on the Barnes murals and to what he called 'an architectural painting in which 'it seems that the human element has to be tempered, if not excluded'.[8] Thus *Small Torso* (even more so than *Small Thin Torso*) greatly resembles a polished pebble, a worn or ageless object. Both these sculptures suggest the universality of a form which is devoid of any individual particularity that might attract attention. *The Back IV* has a similar effect on a more monumental scale. It is as though the quantity of space enclosed within these very small sculptures were intended to give an idea of infinity.

Tiari (1930) is a combination of a woman's head and the *tiari* flower worn by Tahitian women, a memory of Matisse's recent visit to the islands. The deliberate nature of the plant metaphor makes this work unique in Matisse's *oeuvre*. It has been compared to certain works by Arp and to Brancusi's *Leda* or *Princess X*, but it must also be seen in the context of Matisse's life and in terms of the poetic effects of the visit to Tahiti and the various stimuli Matisse derived from it: 'The local tones of things did not change, but in the light of the Pacific, their total effect gave me a sensation similar to that which I experienced when I looked into a large golden bowl.'[9] The sensation of harmony is indeed, as John Elderfield points out,[10] the main subject of *Tiari*, even though Matisse also brings to it all the lessons he learned from his formal work on the five versions of *Jeannette*, the four versions of *The Back* and the three versions of *Henriette*.

At the end of this productive period in sculpture, he made the two versions of *Venus in a Shell* (1930, 1932). In the first state and in the sequel to the group of sculptures we have been discussing, the body is treated as a single and unified smooth form, with the curved torso and raised arms forming a single stem. The stem is very heavily outlined, and the legs and thighs are placed at right angles to it. Perhaps, as Albert Elsen has suggested, the origin of the pose is to be found in certain Hellenistic sculptures.[11] A photograph of Matisse at work shows that there was an earlier version of the *Venus*. A more realistic drawing (a study of a model) has also to be taken into account. But above all, this pose should be related to Matisse's work on the illustrations for Mallarmé's poems (1930), to his creation of purified plastic signs which provide an equivalent to the poet's images without imitating them.

It is immediately obvious that the second state, produced two years later, is very different, even though it uses the same elements. The figure appears to have been fragmented, to have become more complicated and to have been enriched with new forms (especially the neck and breasts). The face is expressively detached and is placed in front of the mass of the arms. The light no longer flows evenly over a smooth surface, but creates a rougher space of breaks and passages inside the sculpted block itself. We will return to these breaks in our discussion of the four *Blue Nudes* (paper cut-outs, 1952) which should in my opinion, be related to the second version of the *Venus*.

59 Study for illustration to the poems of Mallarmé, 1930.

60 Matisse working on *Venus in a Shell* (preliminary version).

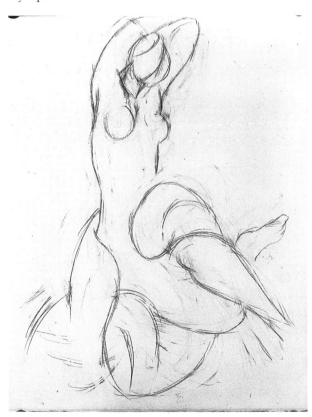

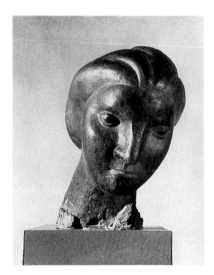

61 Pablo Picasso, *Head of a Woman*, 1931–32.

To conclude, it is worth noting that the period 1924–32, during which Matisse produced so many sculptures, coincides almost exactly with Picasso's desire to establish a studio for sculpture in the stables of the château at Boisgeloup, which he had recently acquired. It was there that the superb large heads of Marie-Thérèse Walter, which are so well known, were produced between 1930 and 1931. The point is not that a definite relationship between the sculptures of Matisse and Picasso can be established and certainly not that the one can be shown to have influenced the other. In suggesting certain formal similarities, it is important to bear in mind that Picasso and Matisse always took an interest in one another's work; and in order not to underestimate that interest, it should be fully explored. It is difficult to go further because, whereas in the case of Picasso, we have a complete catalogue and much archive material, with Matisse we have only a fragmentary corpus of painting and drawings.

We can then, in my view, usefully compare the neo-classicism of a portrait head of Marie-Thérèse with the head of *Henriette II*. They share the same calm, smooth vision, and very similar techniques are used in both for the hair and the eyes (but there is no similarity at all between *Henriette II* and the jubilation displayed by Picasso in the later heads, in which the volumes swell so magnificently). The important point is that it is impossible for Picasso's *Reclining Bather* not to be related ironically to the odalisques and, more specifically, to the *Reclining Nudes*. This *Reclining Bather* refers to Matisse's odalisques with playful aggression, toying with the arabesque but fragmenting it – a parody of an odalisque. It was preceded by a series of drawings executed in August 1930. In June 1930, an exhibition of sculptures by Matisse had opened at the Galerie Pierre. It cannot be doubted that Picasso saw the exhibition.

62 Pablo Picasso, *Reclining Woman*, 1932.

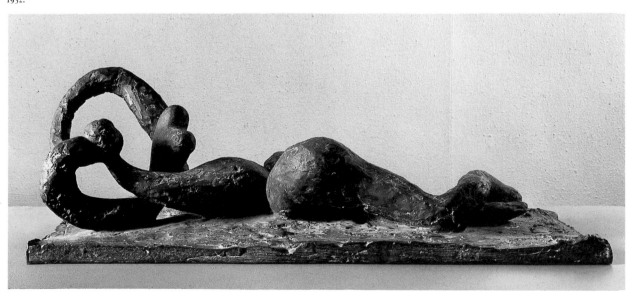

5 · The Carver of Light
1932—54

Between the end of the 1930s and his death in 1954, Matisse produced only three sculptures. Two of these are nudes of modest dimensions – *Seated Nude, Arm Raised (Pochade)* (1949), and *Standing Nude (Katia)* 1950 – which should be compared with the series of drawings published in *Cahiers d'art* in 1952 (and in *Verve* in 1958). The drawings depict nudes and faces and all display the same extreme freedom, no matter whether they are made with the brush or in charcoal. The third sculpture is the *Christ* executed for the Vence chapel (1949), a classical theme handled in linear rather than plastic terms. Matisse created a minimal sign which harmonizes with the Stations of the Cross, which he himself described as a collection of 'Black threadlike drawings which decorate the walls but at the same time leave them very light. The result is an ensemble of black on white, in which the white dominates'.[1] The theme is suggested rather than fully developed. This was Matisse's way of respecting both the spiritual space of the spectator in a building steeped in tradition and the integrity of his own conception of the space inside the chapel as a sort of book: the stained-glass windows provide pages of coloured light, the wall, pages of clear writing.

63 Study for the ceramic panel of the Stations of the Cross at the Chapel of the Rosary, Vence, *c.* 1950.

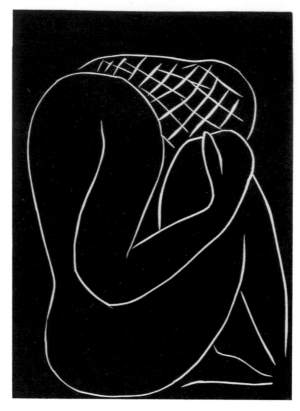

64 Illustration for *Pasiphaë* by Montherlant, 1943.

In the last ten years of his life, Matisse's relationship with sculpture finds a new and sublime expression in his paper cut-outs. He puts it very simply: 'Cutting into colour reminds me of a sculptor's carving into stone.'[2] Every word in this sentence is important and condenses the depth of the painter's experience of life, his search for the simplicity of the cut-out, a figure against a ground or in space, his impossible attempt to preserve the freshness of emotion, which only the immediacy of the act of cutting can recover, from his accumulated knowledge, practice and discipline. Georges Duthuit has extended the comparison with 'la taille directe' by showing that with the cut-outs, perhaps for the first time, 'The technique of statuary is applied to the substance of painting. The artist cuts into a block of chromatics rather than of marble or sandstone. He thus sets himself a very demanding task, as colour does not at first sight lend itself to sculptural treatment. He has to give volume to a substance which is much less amenable to traditional representations of volume than the supports of the brush or pencil. He has to invent a language to express its weights and measures.'[3]

It should perhaps be pointed out that, before he began to explore colour as a substance to be carved, Matisse had already used linocuts for his illustrations for Montherlant's *Pasiphaë*. The role of the vibrant and incisive movement of the gouge through the supple linoleum involves almost the same risks as using scissors to cut paper: there is

no room for hesitation, second thoughts or for even the slightest lapse in concentration: 'The slightest distraction in the tracing of a line causes a slight involuntary pressure of fingers on the gouge and has an adverse effect on the line.'[4] Even so, in his linocuts Matisse was simply tracing a white line against a black ground and not cutting into blocks of colour, a process which offers much wider and richer range of ways to express volume.

Although Matisse willingly took such risks in his engravings and line drawings, he could not or would not do so in his sculptures. He always preferred modelling, presumably because he was less confident of his abilities, less experienced and less practised. As in his paintings, he proceeded by adding and reworking, constructing the sculpture by adding to it, layer by layer. Perhaps he also wanted to be in physical, tactile contact with the figure as it grew out of the initial block, to be able to effect, with the same almost total freedom he enjoyed in his paintings, the necessary displacements and twists in several stages, but always using the same malleable material. That was only possible with the perfect plasticity of modelling clay − and even so Matisse did sometimes have technical setbacks, as with the first version of *Reclining Nude I*, which broke because he reworked it too often. To my knowledge, Matisse only really carved once (*The Dance*, 1907, sculpted log, Musée Matisse, Nice). Even then, he worked in bas relief, a technique which involves all the transitional stages and values of modelling and none of the brutality of the 'presence or absence' of sculpture in the round.

Basically, Matisse dared to carve or cut only certain elements of his sculptures, sometimes with fortuitous authority (as in the left eye of *Jeannette V* or the face of *Venus in a Shell II*, which is transformed into an empty disc). This second version of *Venus in a Shell* calls for further comment because of its relationship with the four *Blue Nudes* which, twenty years later, were to take up the same formal elements in the new language of the paper cut-out. If only because of the initial motif, which may have been borrowed from Hellenistic Greek statuary and which certainly has numerous 'classical' connotations, in both the ancient and the European sense of the word, *Venus in a Shell* provides a repertoire of signs, a synthesis of influences and of Matisse's own experience as a sculptor. But the primitive, possibly African, plastic language which provided Matisse with inspiration throughout his life is also integrated into the sculpture. (We know that in 1908 Matisse began to acquire a small collection of primitive objects, 'without any particular beauty and without any market value, which he collected to inspire him in his own research.'[5]) As well as being an elaborate fusion of several languages, the sculpture does give a feeling of immediacy, of a direct presence and something of the familiar grandeur of certain idols. By 1932, Matisse could allow himself to stress breaks (legs are broken, thighs are separated from torsos, necks are fragmented) without any fear of producing only 'groupings of fragments', so confident was he in the strength of the relationship he had established between the fragments.

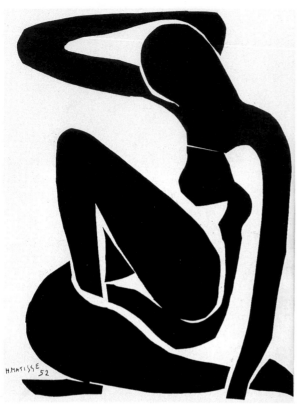

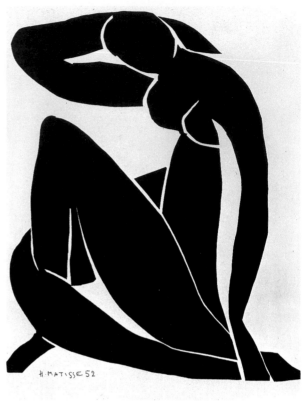

65 *Blue Nude I*, 1952.

66 *Blue Nude II*, 1952.

The four *Blue Nudes* of 1952 are much more than a successful synthesis. They are free and severe forms which leap into space. They are all the more astonishing in that Matisse, never a man to go back on anything he said, appears to be contradicting the comments he made on sculpture to the students in his 'academy' in 1908: 'The joints, like wrists, ankles, knees or elbows, must show that they can support the limbs ... the joint is better when exaggerated than underexpressed. Above all, one must be careful not to cut the limbs at the joints, but to have the joints an inherent part of the limb. . . . Put in no holes that hurt the ensemble, as between thumb and finger lying at the side. Express by masses in relation to one another, and large sweeps of line in interrelation.'[6]

In the *Blue Nudes*, on the other hand, it is the empty spaces between the cut-out limbs which stress the joints. The empty spaces represent solids, the swelling of volumes (the overlap of a leg which is bent *in front of* the thigh). Far from constituting breaks which 'hurt the ensemble', the empty spaces inscribe the figure within its own space, in a uniform light. Strictly speaking, the *Blue Nudes* are composed of fragments, but they are not disjointed and perhaps represent the culminating point of Matisse's reflections on the figure in space, the final outcome of his practice as a sculptor. The figure is no longer drawn in an abstract,

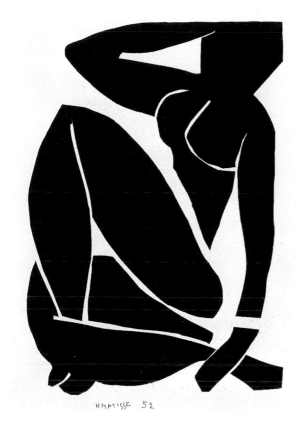

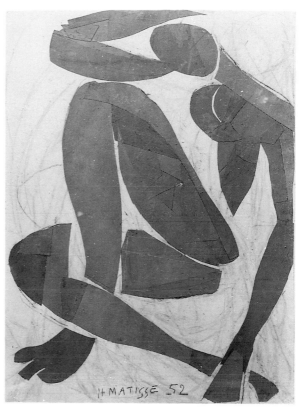

67 *Blue Nude III*, 1952. 68 *Blue Nude IV*, 1952.

neutral and transparent space. It is no longer closed in upon itself or clearly separated from the space around it as in *Reclining Nude I*. It does not include a limited quantity of precisely drawn space which is handled differently from the surrounding space (like the empty spaces which outline and contain *The Serpentine*). In the *Blue Nudes*, the figure is permeated with space. No longer isolated, it breathes in and through space. It becomes a transitional space where light can be exchanged and can circulate, just like the windows which so often appear in Matisse's paintings. In the same year, 1952, Matisse created the decoration known as *The Swimming Pool* for his own pleasure. In a frieze over 50 ft long, the bodies of female bathers mingle with marine creatures and cleave through a transparent element (presumably water, but it is impossible to tell whether it is liquid, air or crystal) from which they cannot be separated. Inside and outside no longer have any meaning, either for the spectator or for these fluid bodies, which we see now from the side, now beneath the surface, now above it. Blue against white, white against blue ... the respective definitions of figure and space are at once certain and uncertain. Form itself absorbs space and returns to it in a movement which reverberates through our very bodies and which extends to infinity the sculptural content (in Matisse's sense of the word) of the blue nudes.

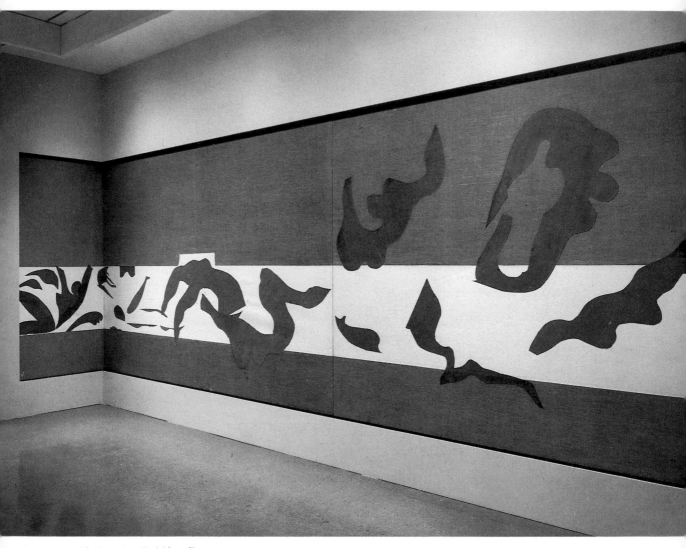

69 *The Swimming Pool* (detail), 1952.

THE PLATES

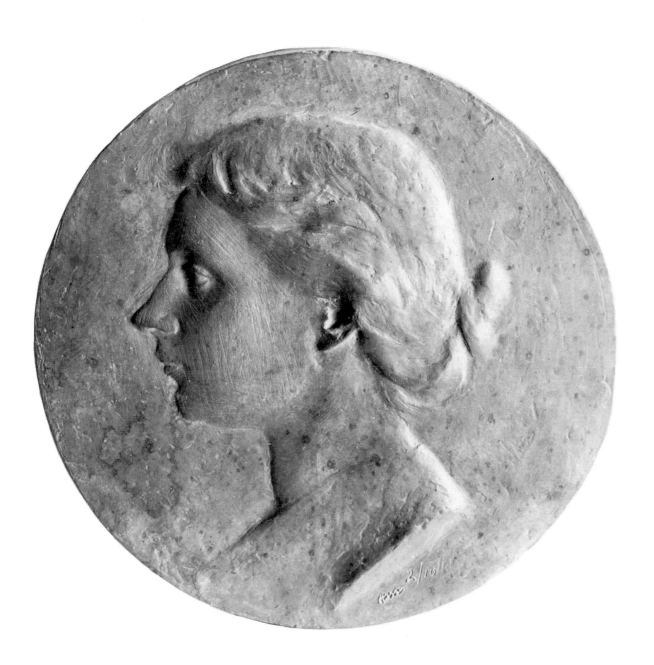

1 *Profile of a Woman*, 1894

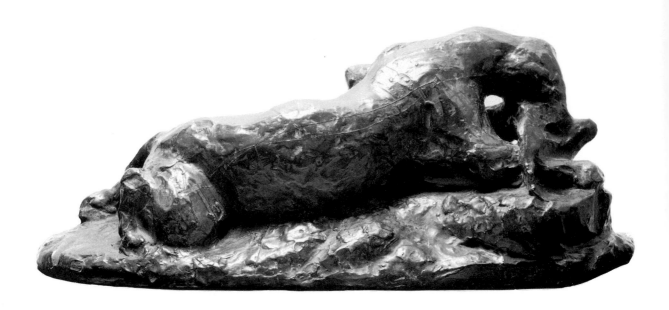

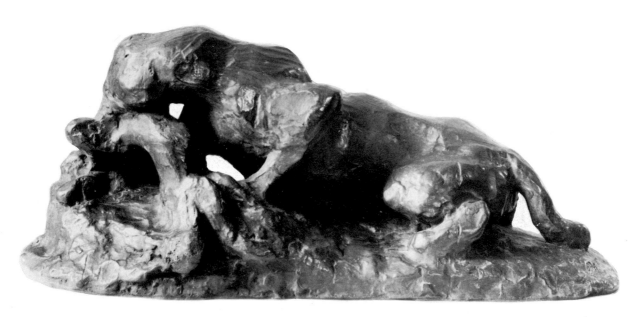

2* Copy after Barye's *Jaguar Devouring a Hare*, 1899–1901

3 *Bust of a Woman*, 1900

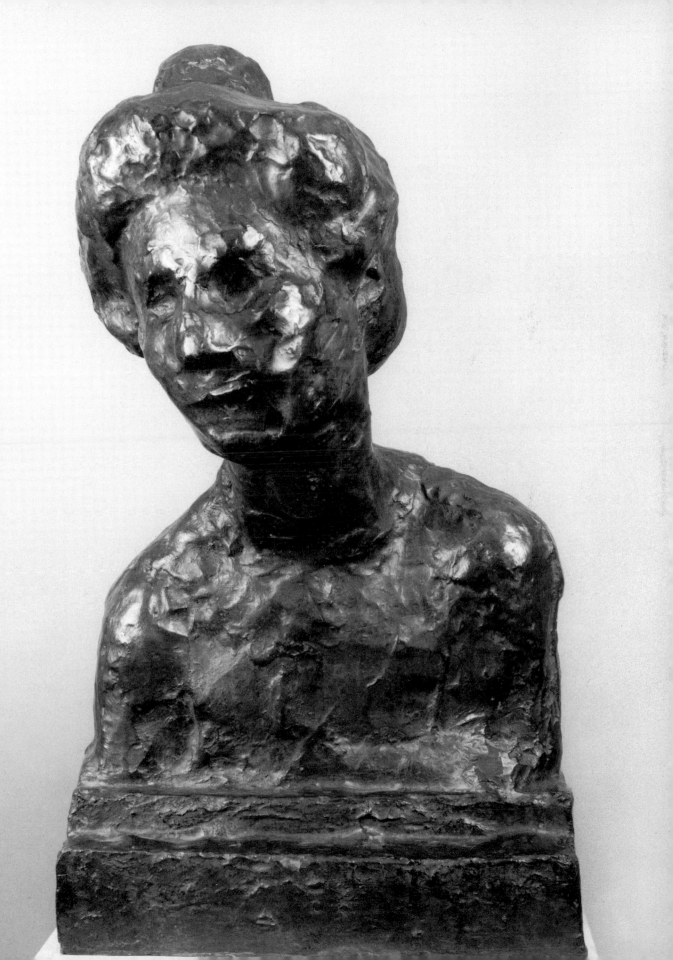

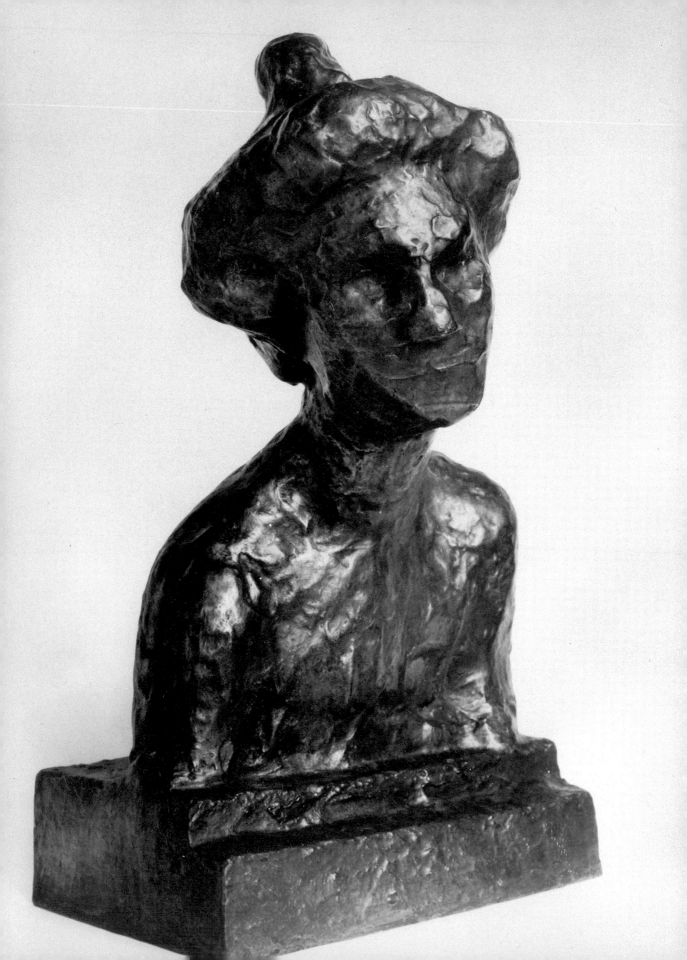

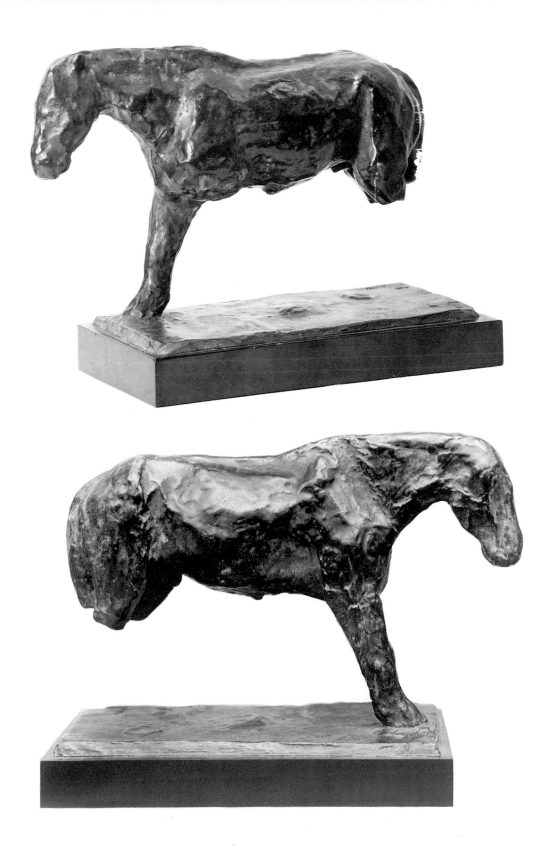

4* *The Horse*, 1901

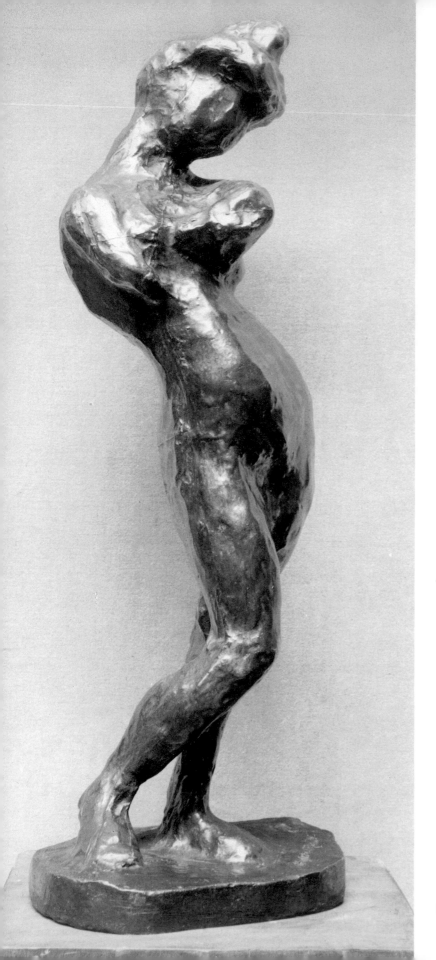

5* *Madeleine I*, 1901

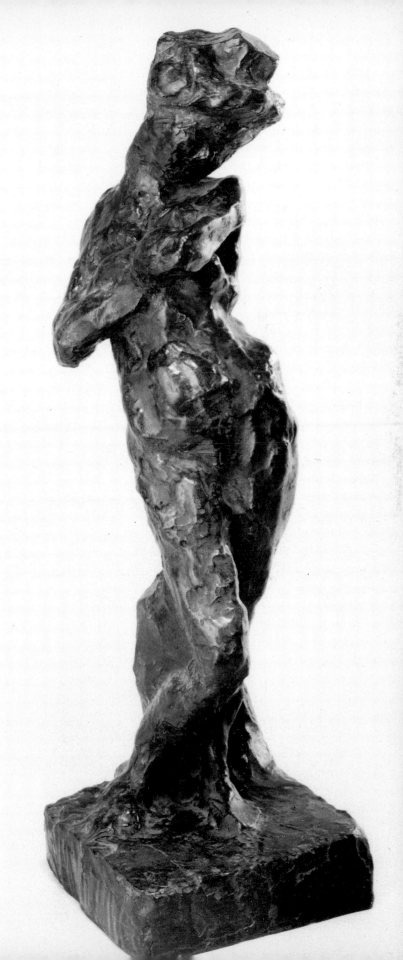

6* *Madeleine II*, 1903

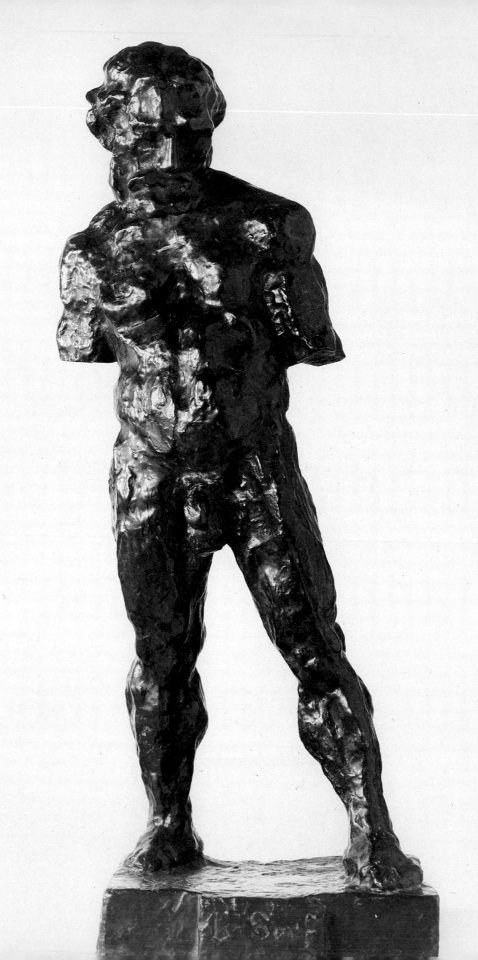

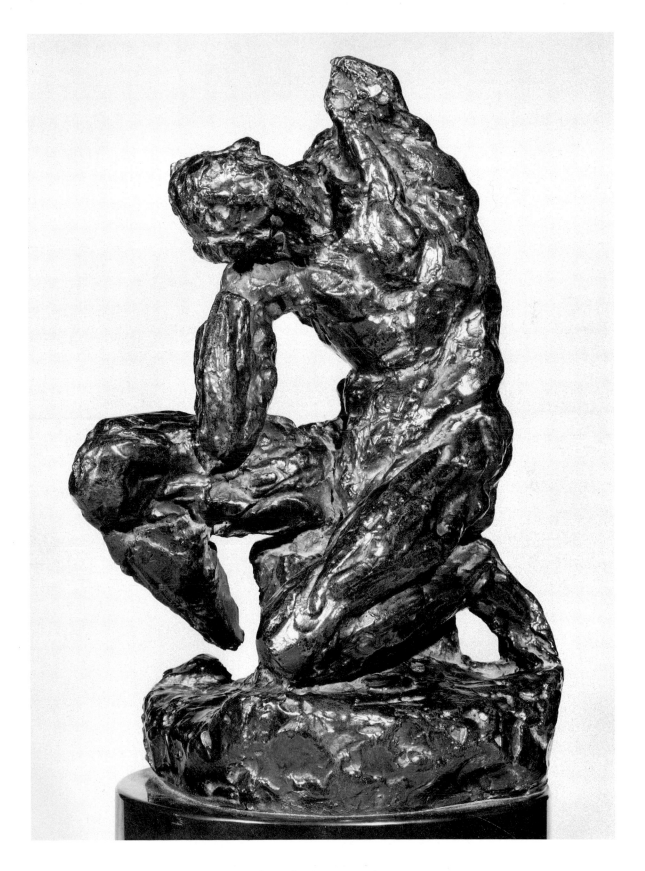

8 Copy after Puget's *Ecorché*, 1903

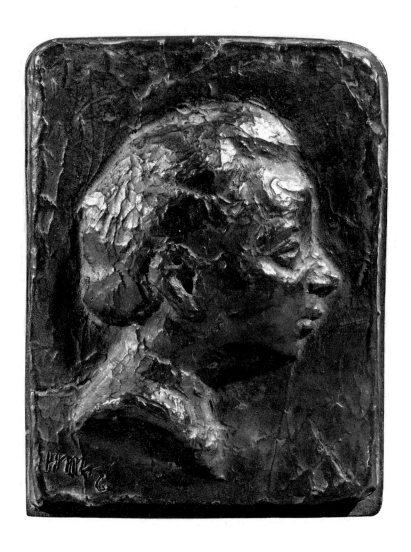

9 *Profile of a Child (Marguerite)*, 1903

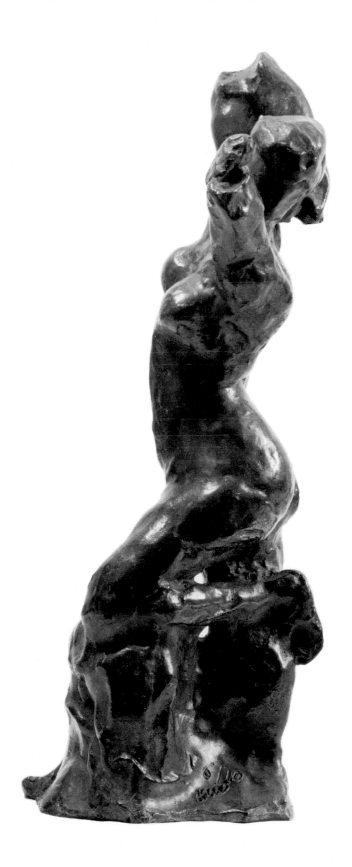

10* *Upright Nude with Arched Back*, 1904

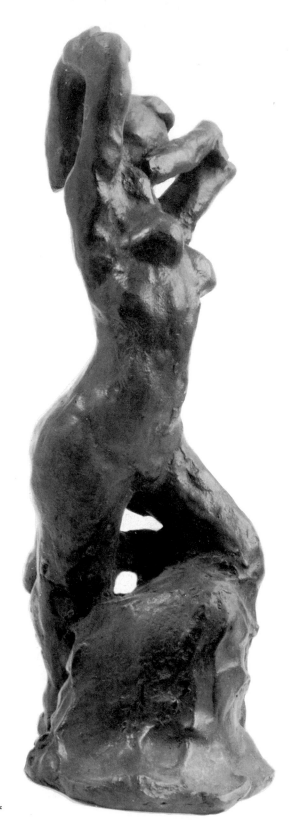

10a*

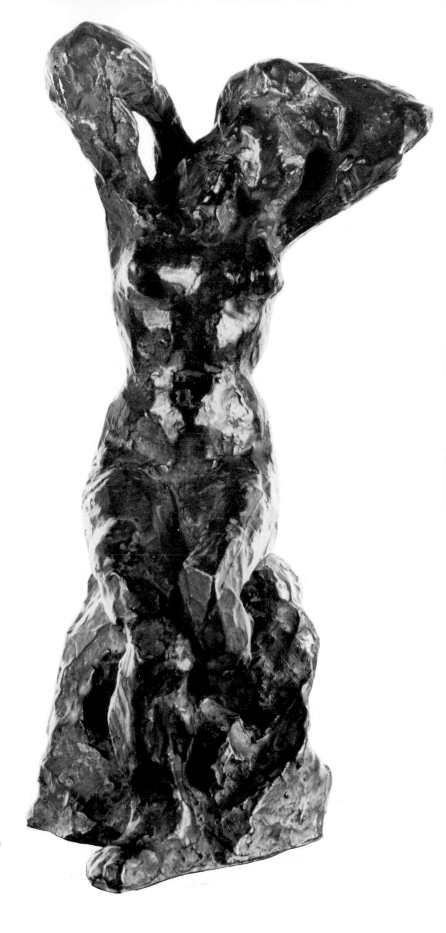

11 *Seated Nude with Arms on Head*, 1904

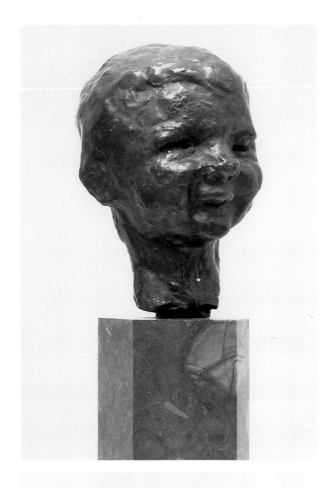

12* *Head of a Child (Pierre Matisse)*, 1905

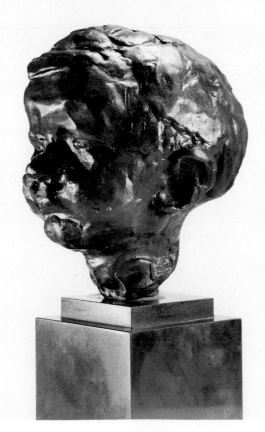

13 *Head of a Child (Pierre Manguin)*, 1905

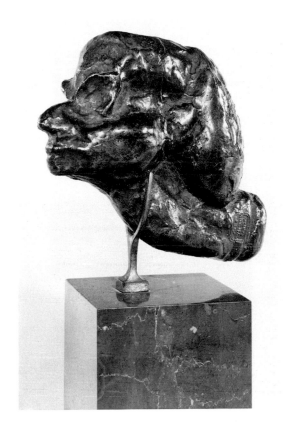

14* *Rosette (La Pipe)*, 1905

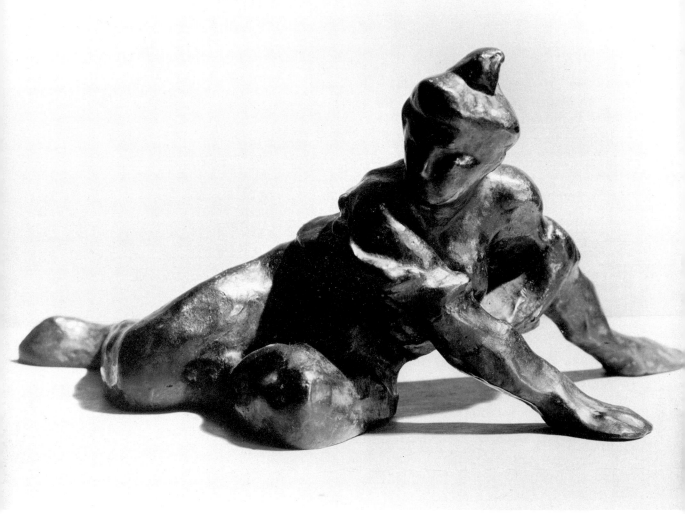

15* *Woman Leaning on her Hands,* 1905

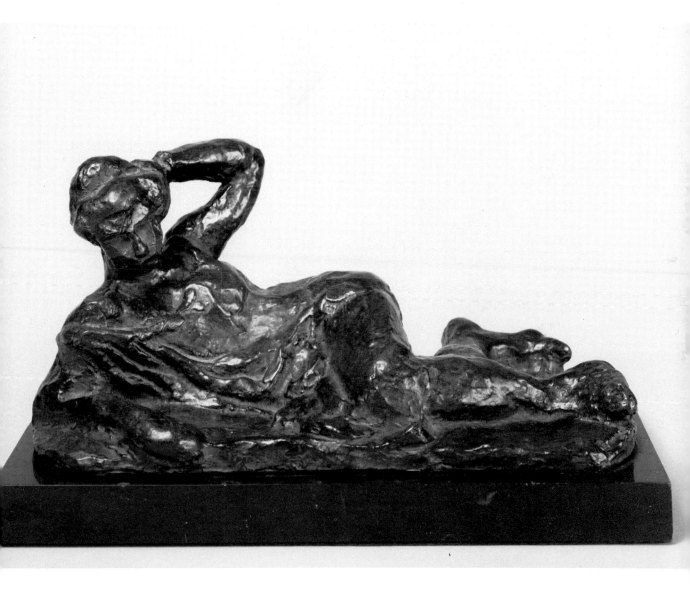

16 *Reclining Figure with Chemise*, 1906

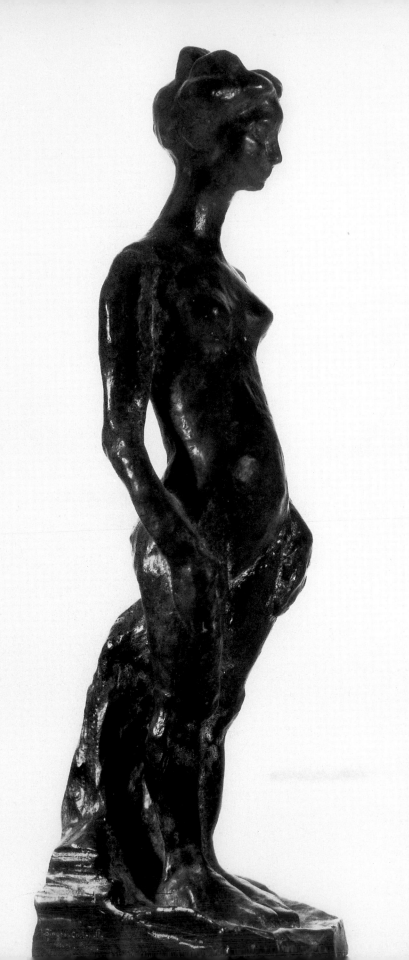

17* *Standing Nude*, 1906

18* *Standing Nude*
Arms on Head, 190

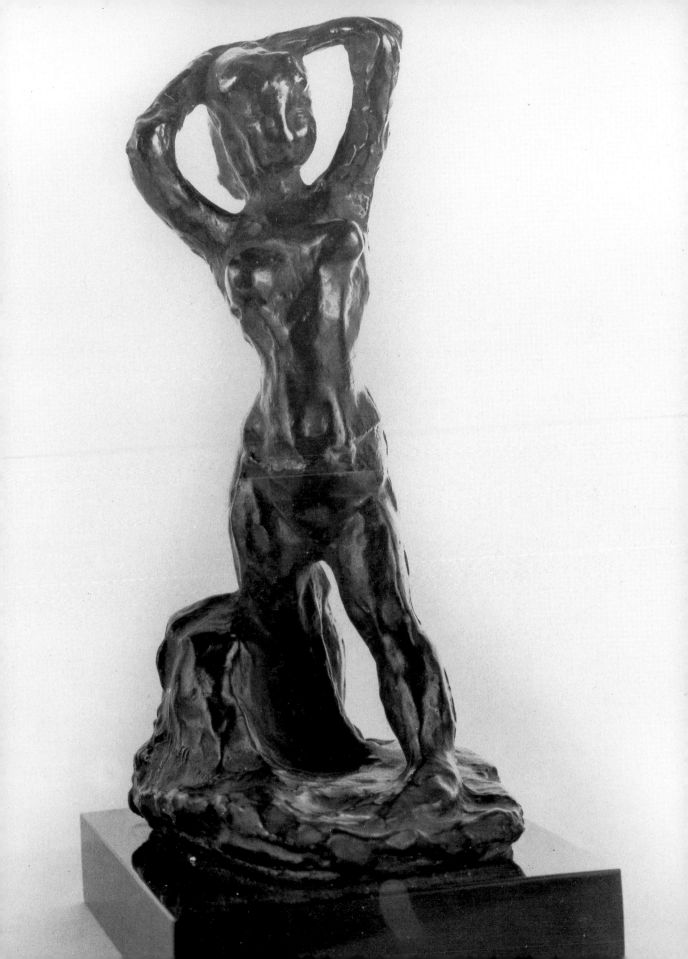

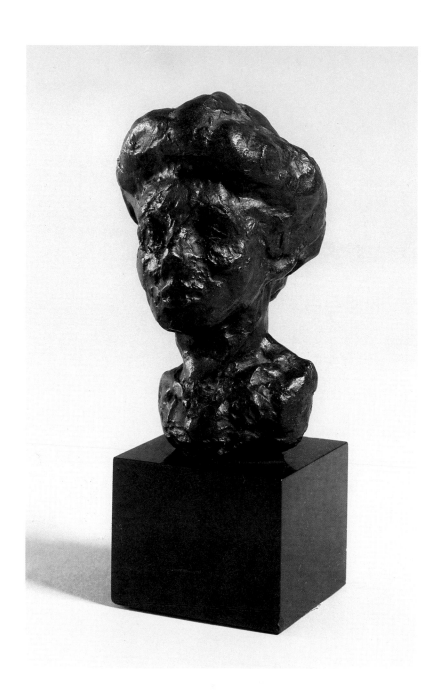

19 *Small Head with Flat Nose*, 1906

20* *Torso with Head (La Vie)*, 1906

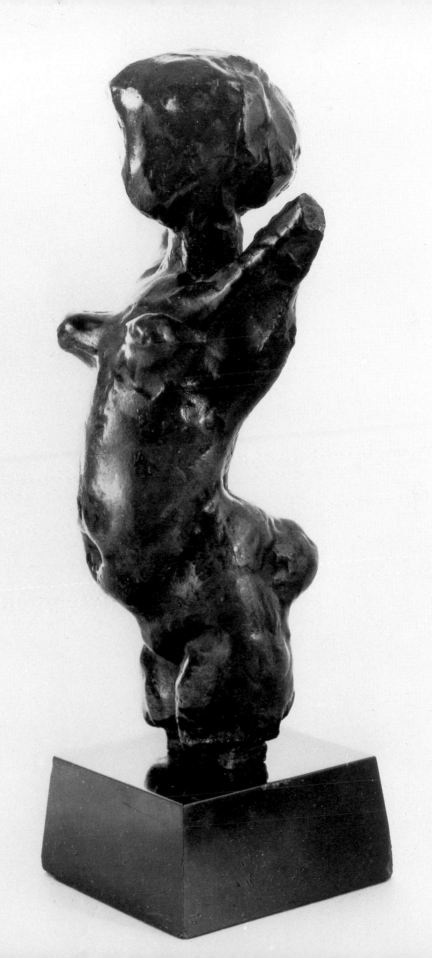

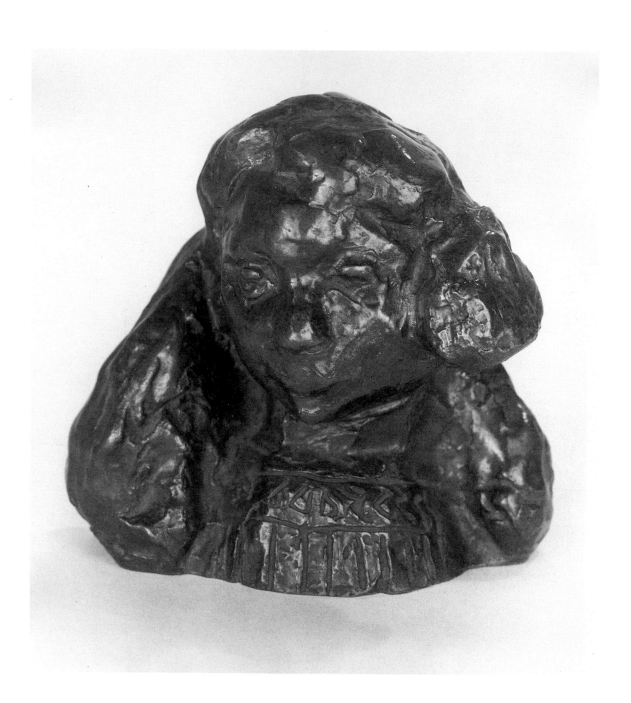

21 *Head of a Young Girl*, 1906

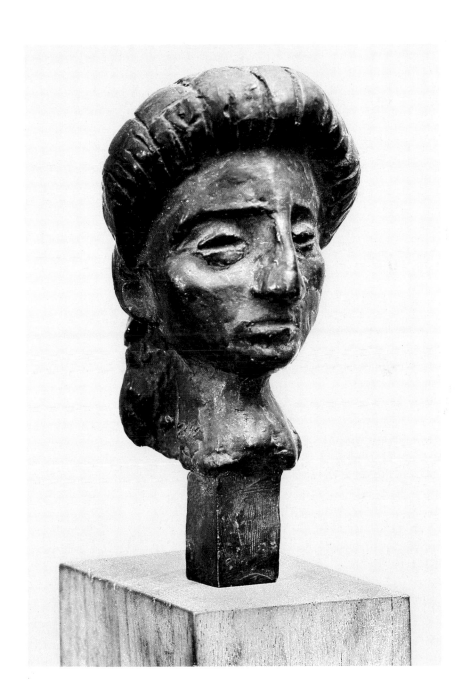

22 *Small Head with Upswept Hair*, 1906

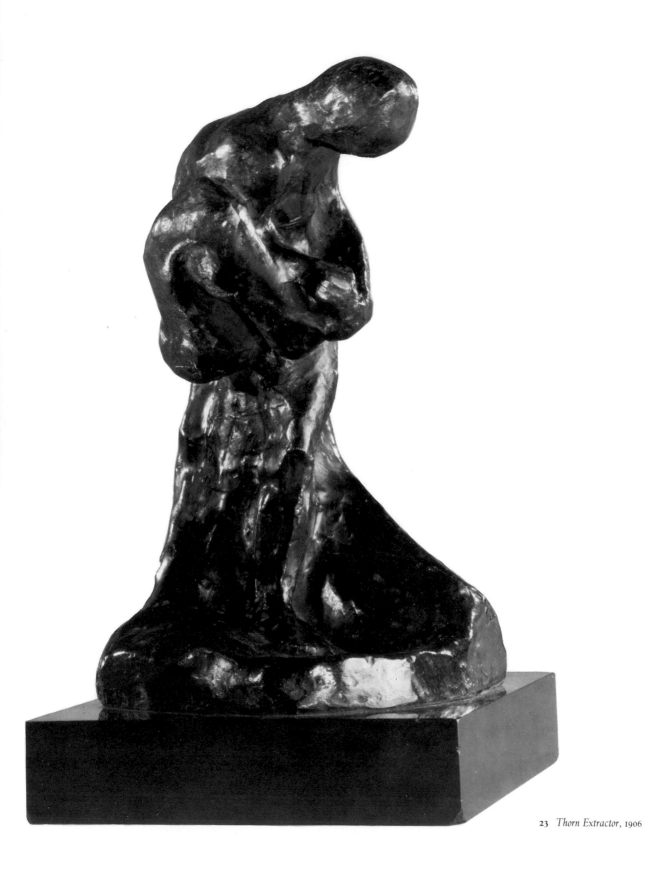

23 *Thorn Extractor*, 1906

23a*

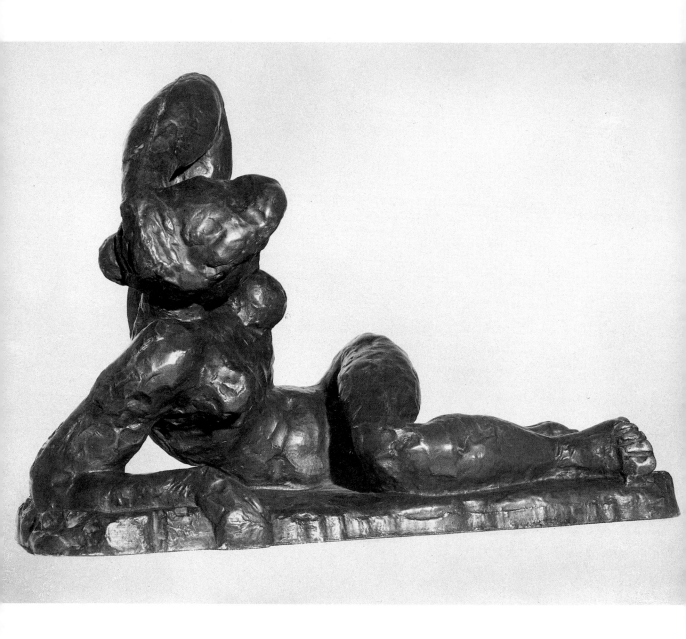

24 *Reclining Nude I (Aurore)*, 1907

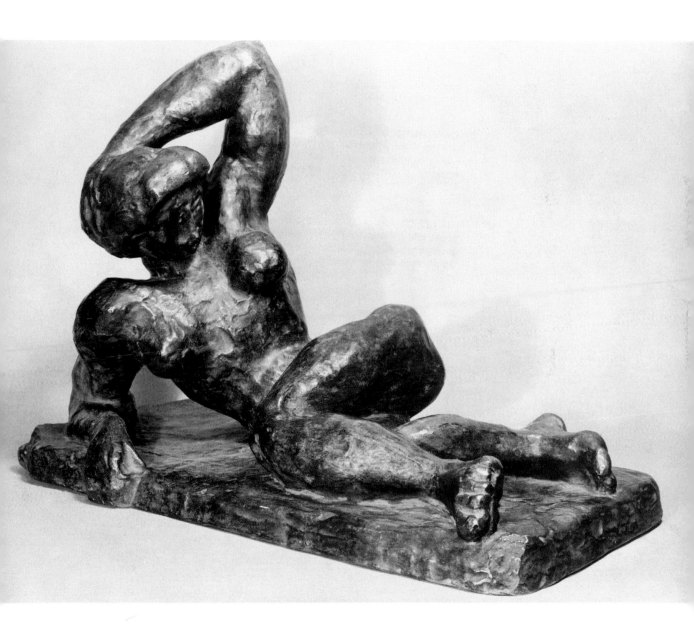

24a*

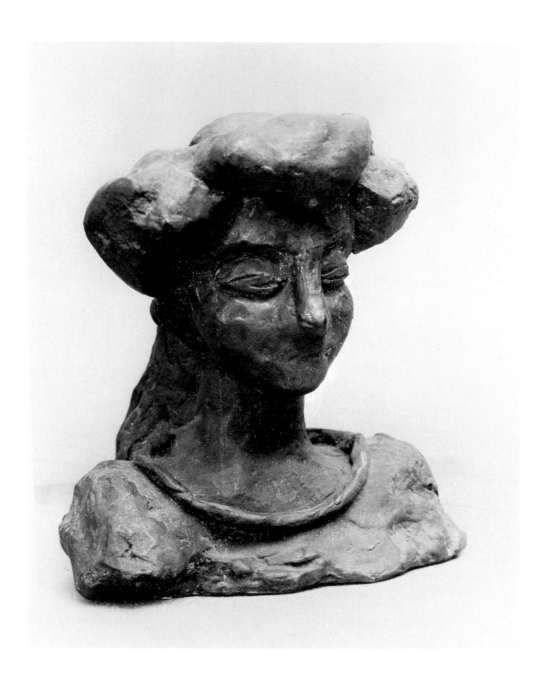

25* *Head with Necklace*, 1907

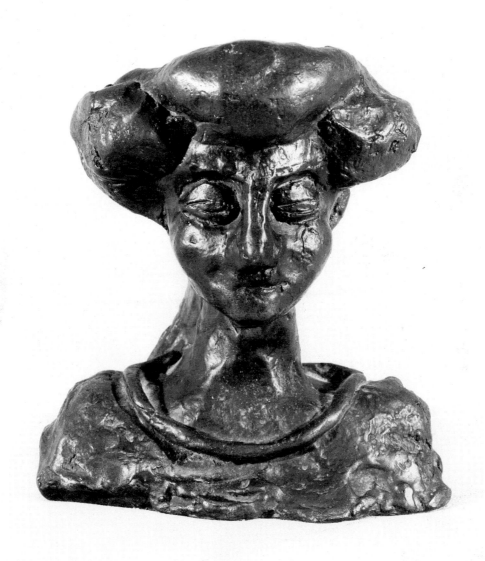

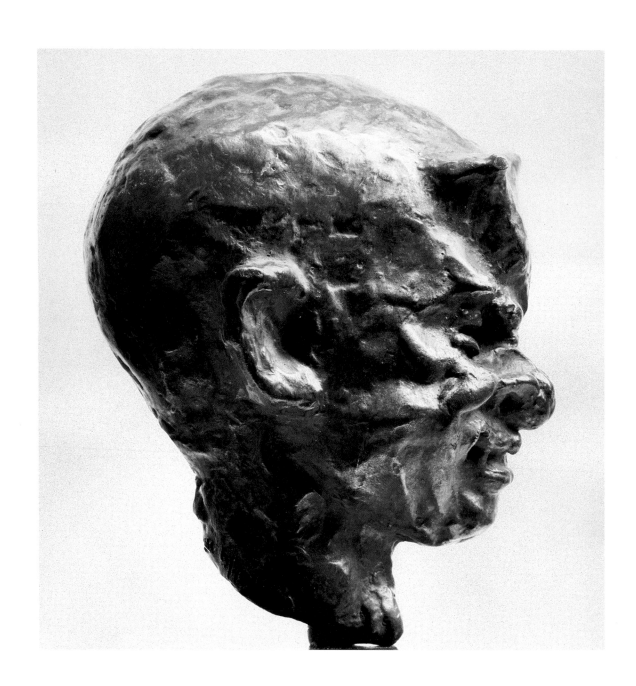

26 *Head of a Faun*, 1907

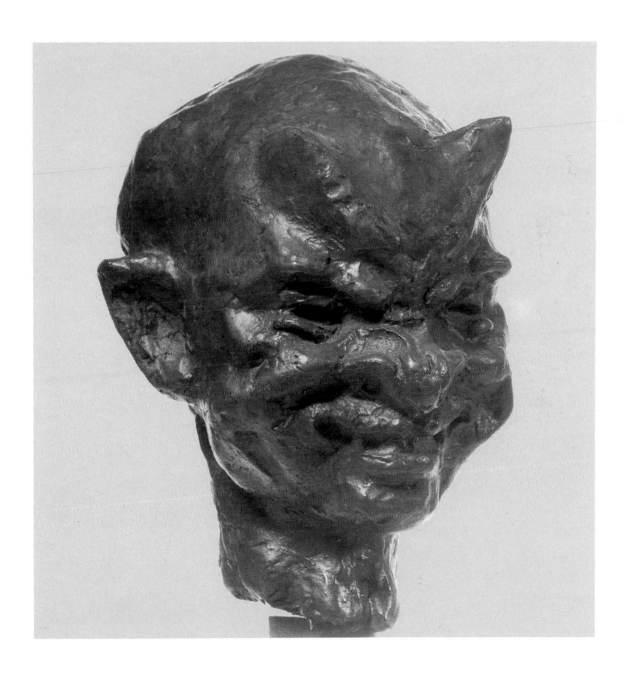

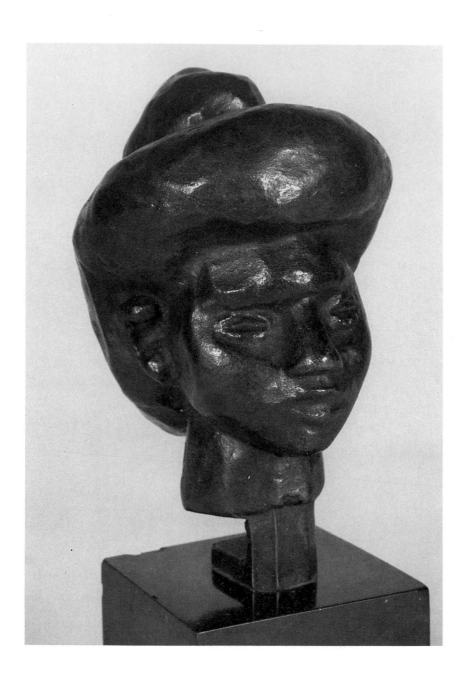

27 *Small Head with Comb*, 1907

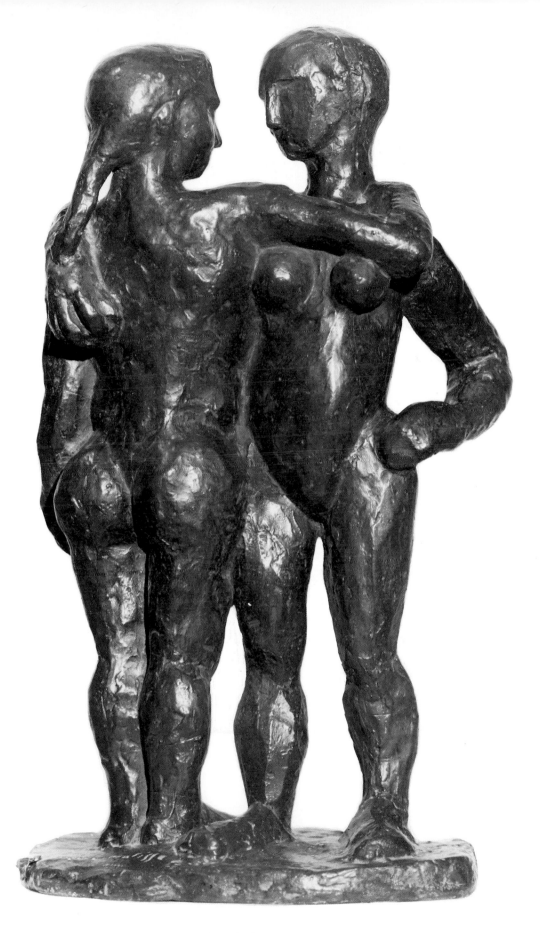

28 *Two Negresses*, 1908

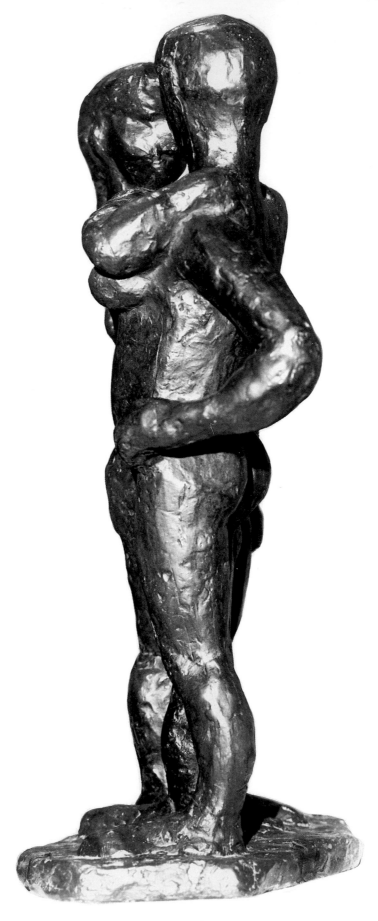

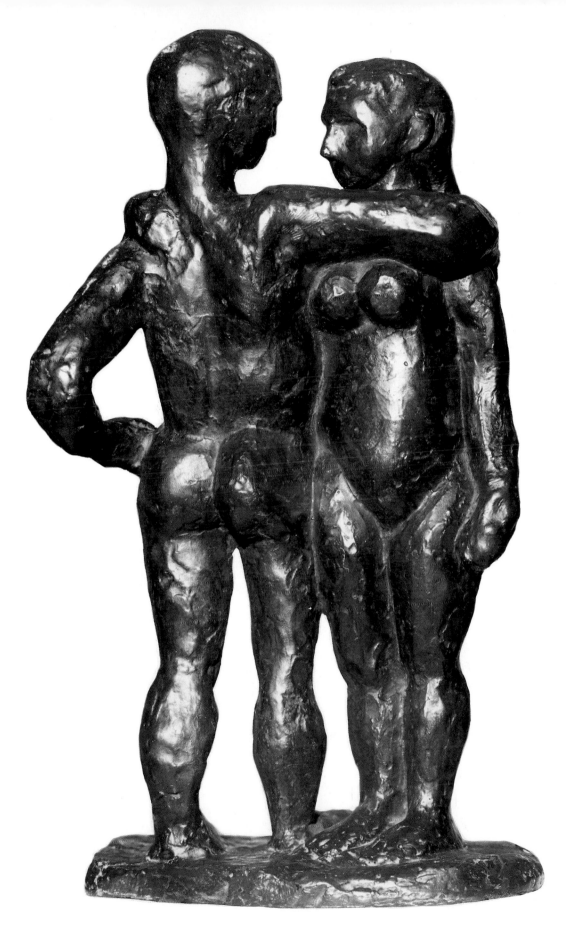

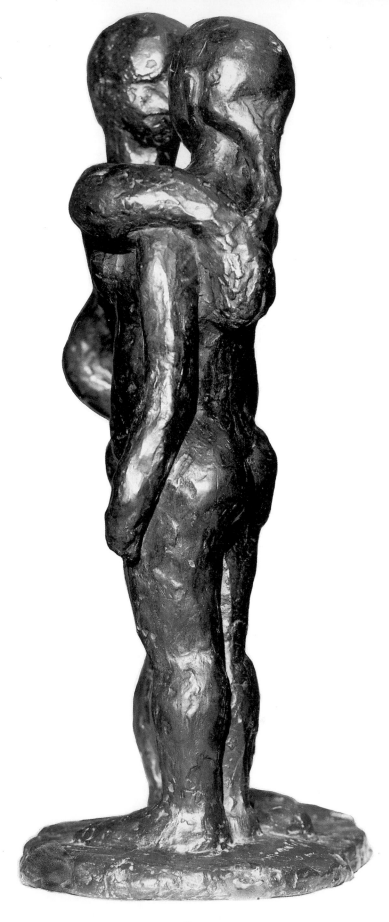

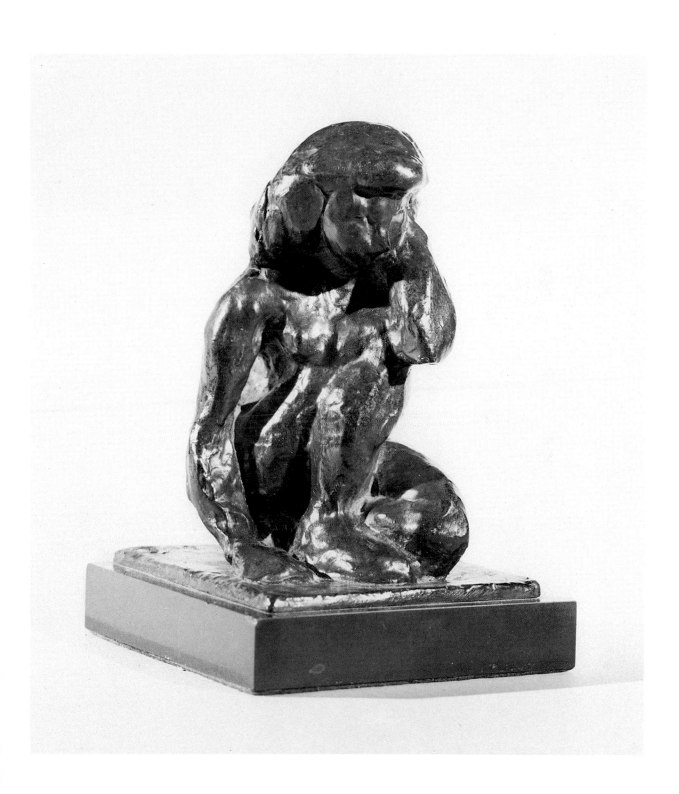

29 *Small Crouching Nude with Arms*, 1908

30 *Small Crouching Nude without an Arm*, 1908

31 *Small Crouching Torso*, 1908

32, 32a *Seated Figure, Right Hand on Ground*, 1908 ▷

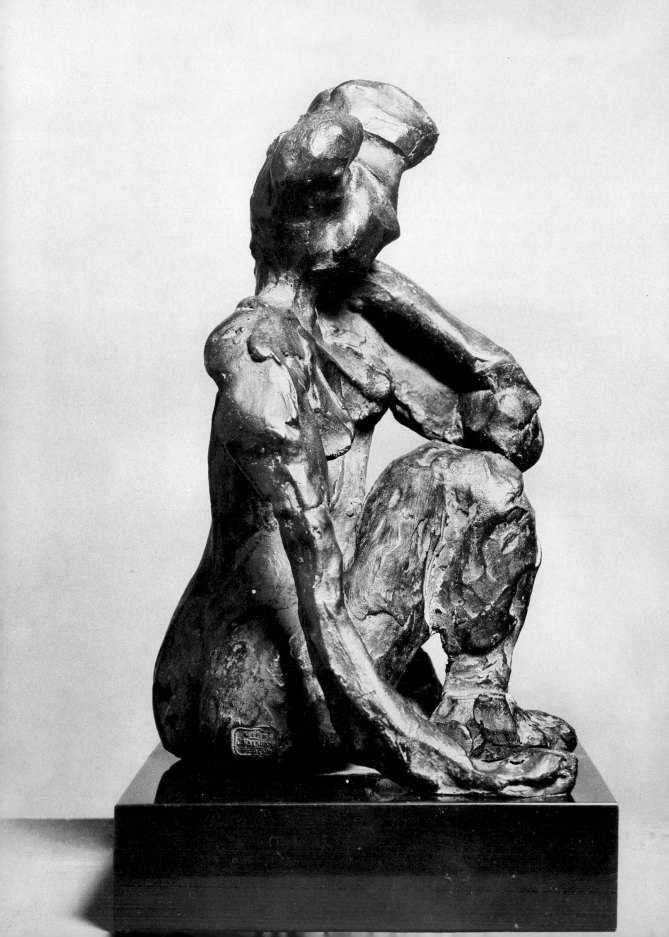

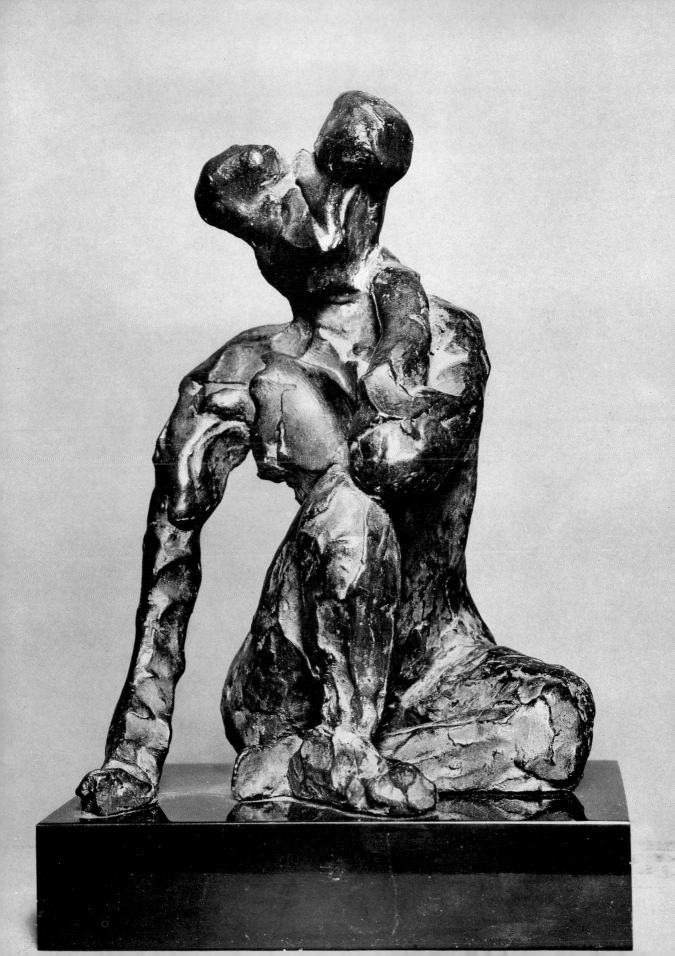

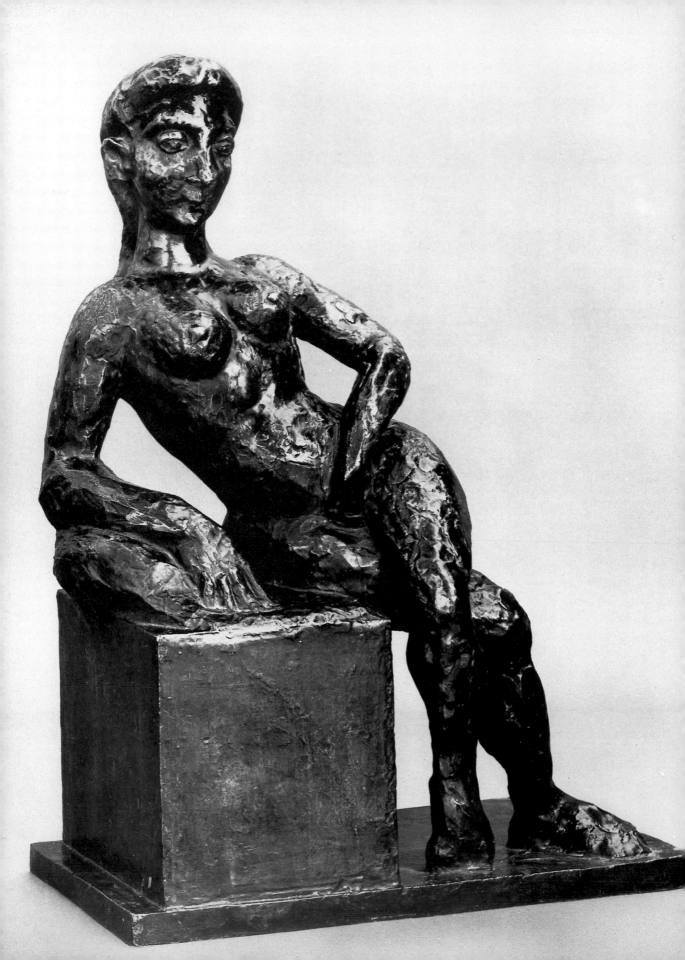

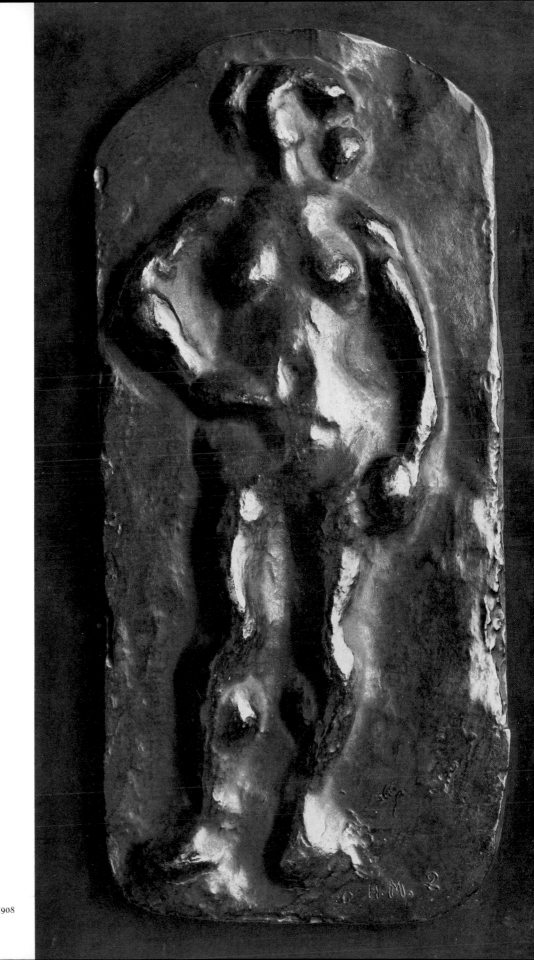

33* *Decorative Figure*, 1908

34 *Standing Nude*, 1908

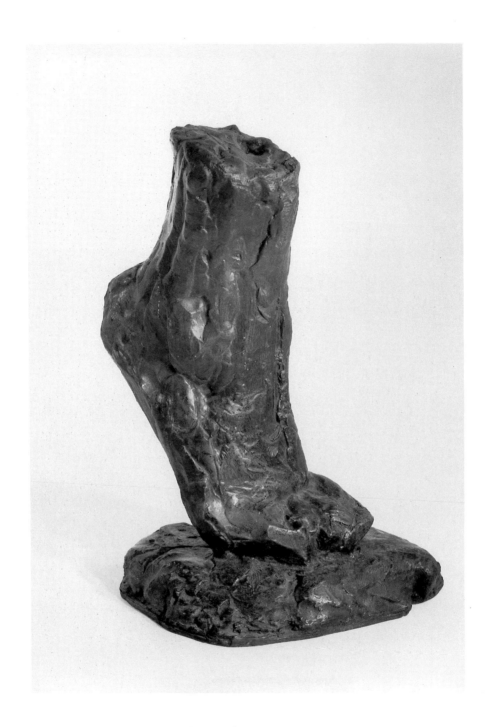

35* *Study of a Foot, c. 1909*

36 *Torso without Arms or Head*, 1909

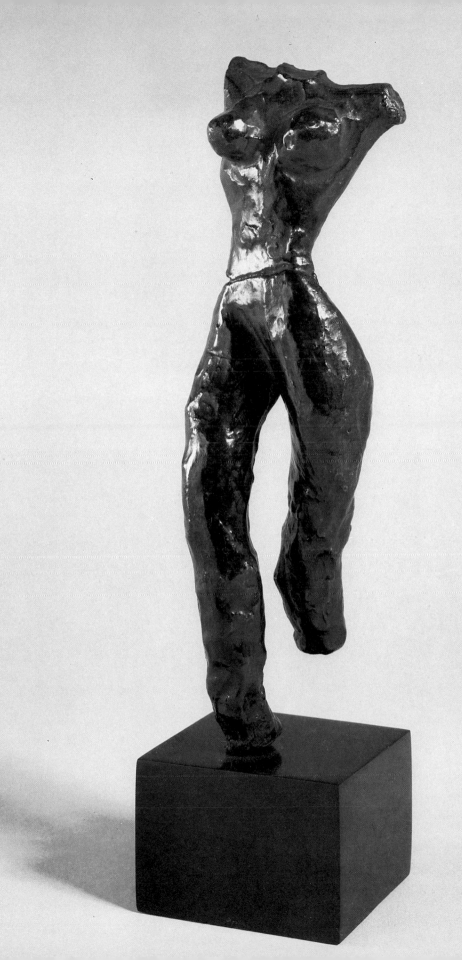

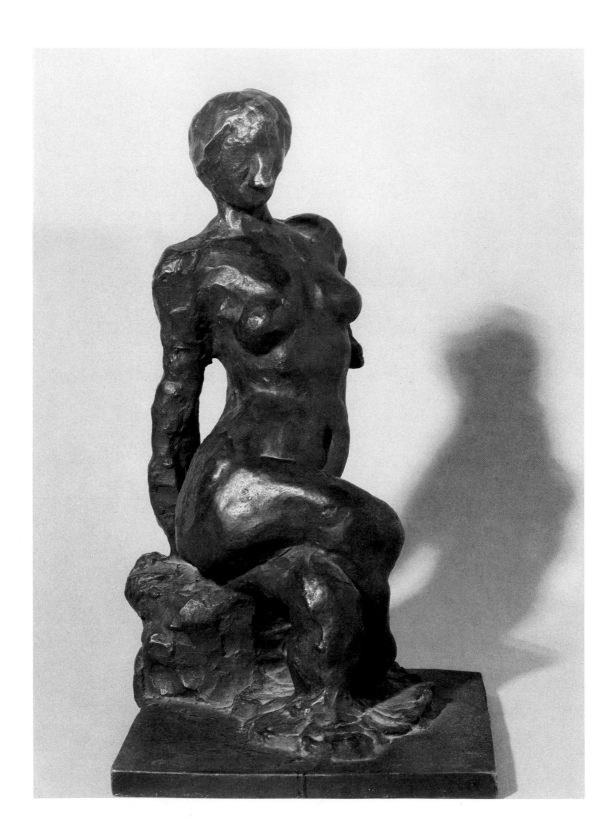

37 *Seated Nude, Arm behind her Back*, 1909

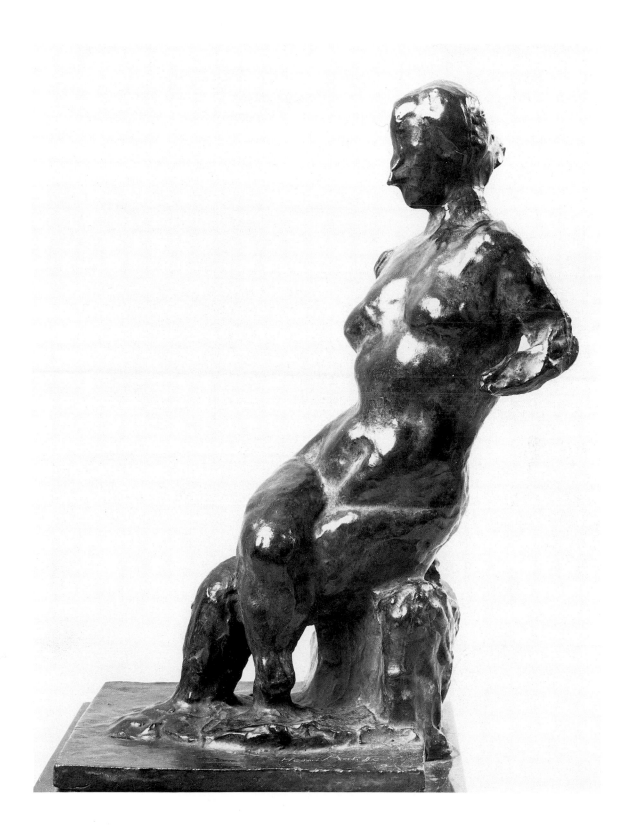

37a*

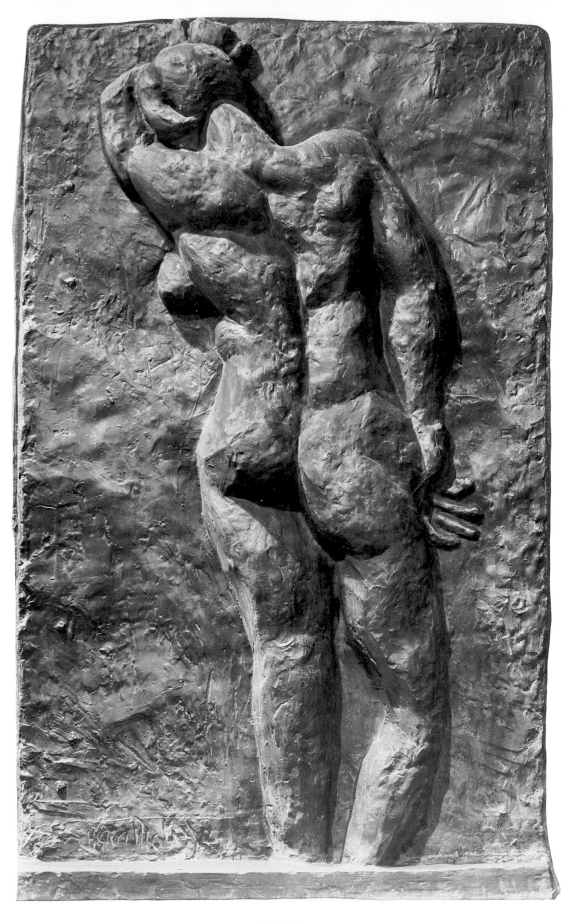

38 *The Back I*, 1909

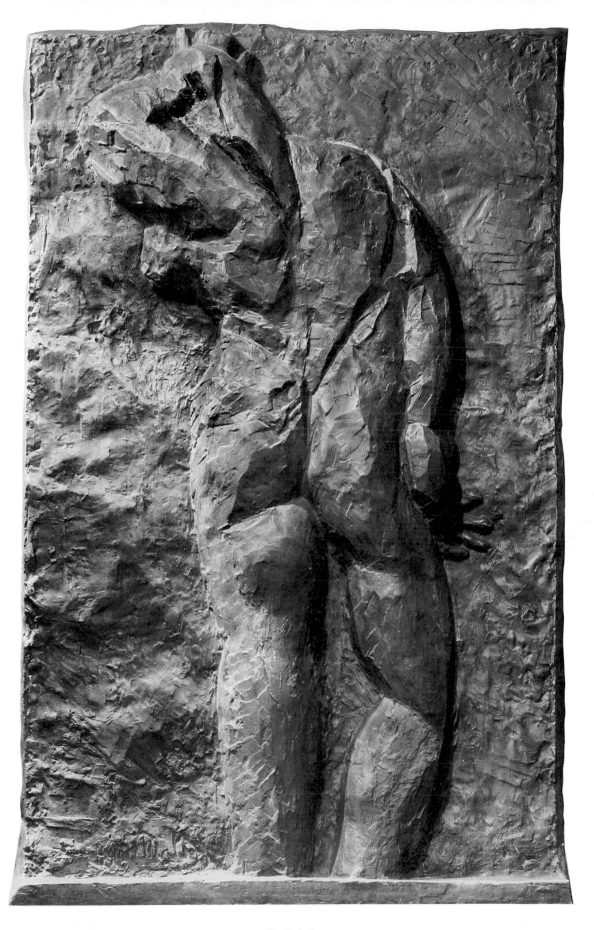

39 *The Back II*, 1913

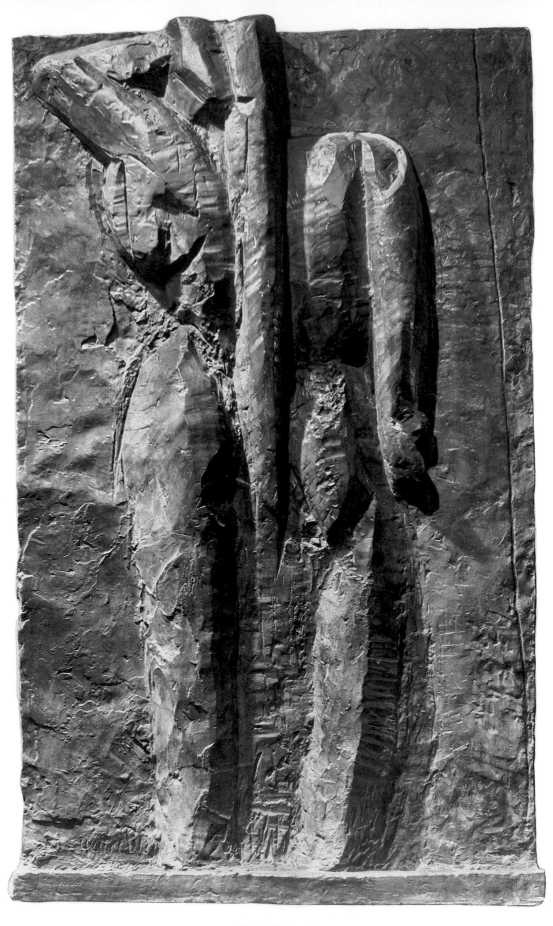

40 *The Back III*, 1916–17

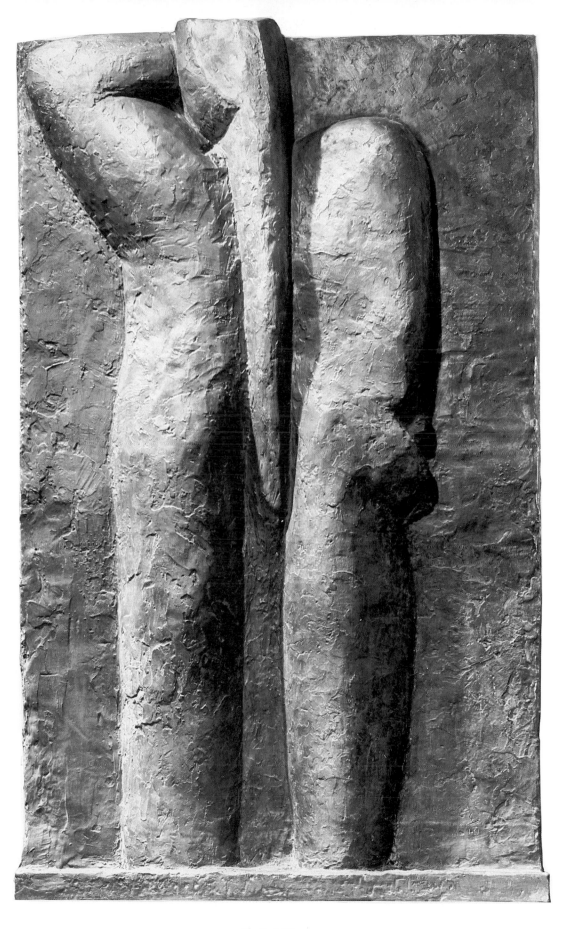

41 *The Back IV*, 1930

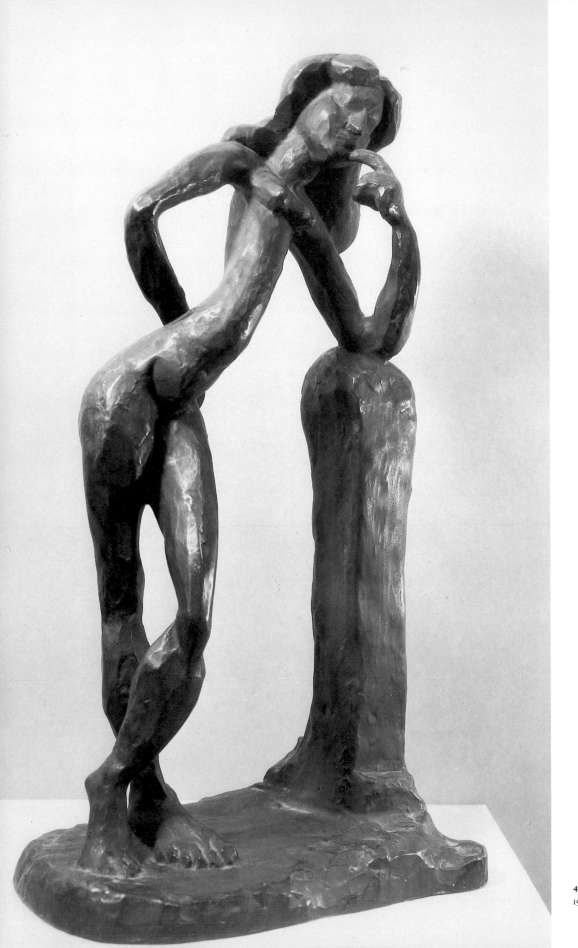

42*, 42a* *The Serpentin*
1909

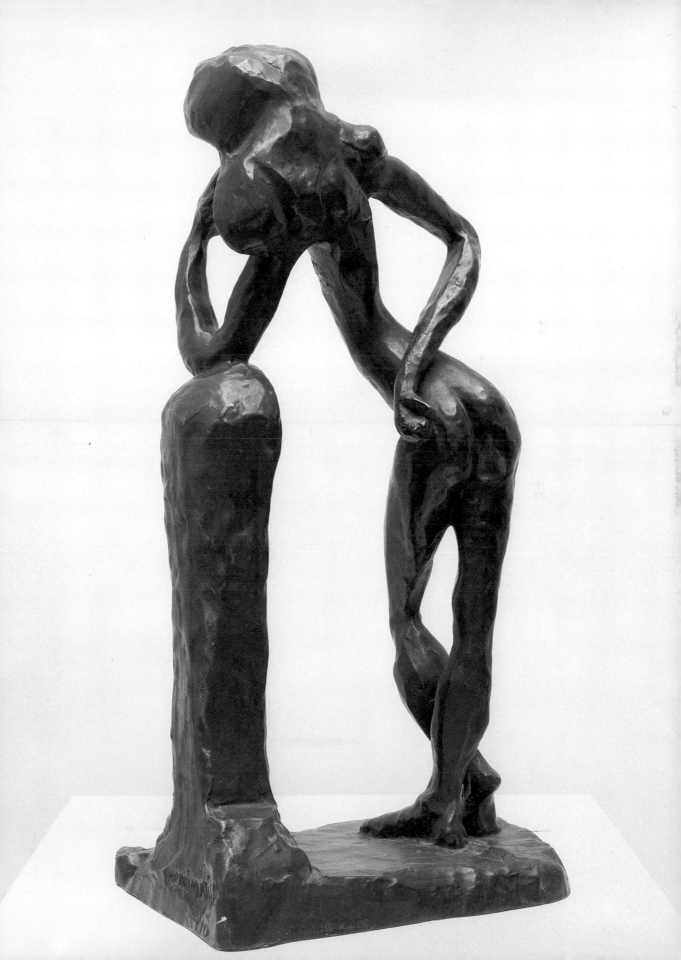

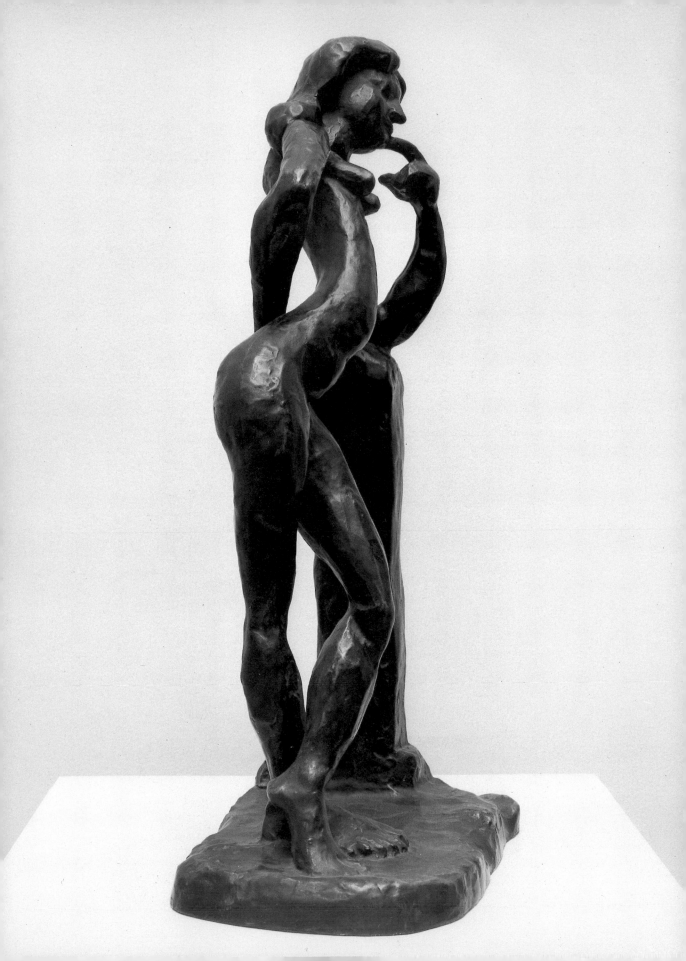

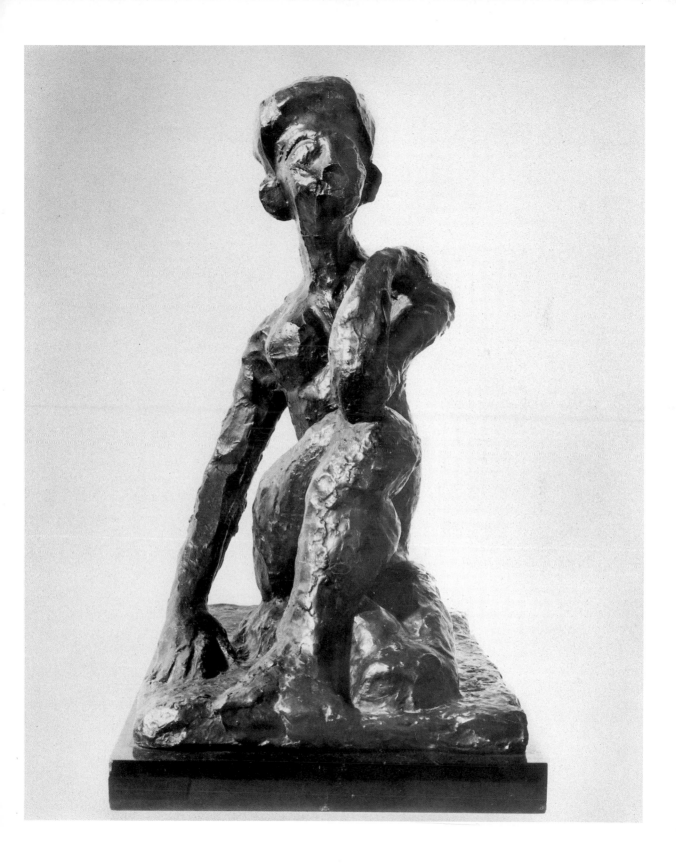

43* *Seated Nude (Olga)*, 1910

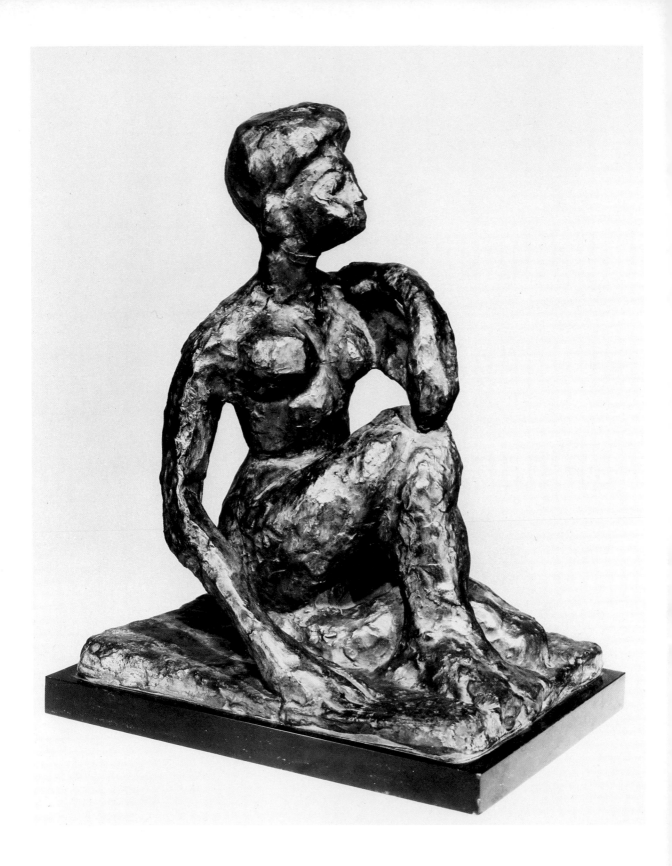

43a *

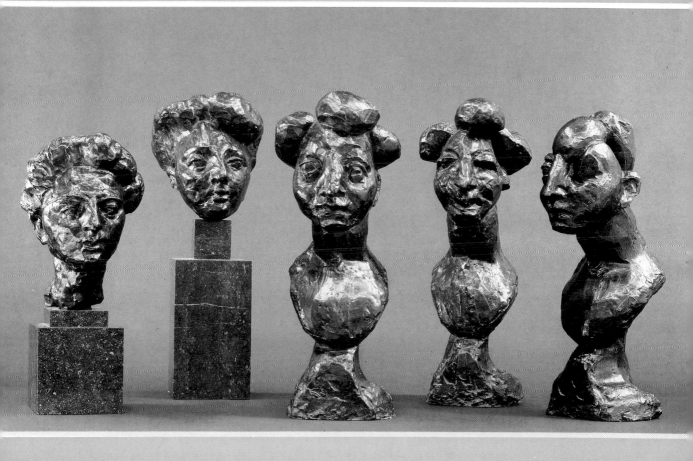

44–48 *Heads of Jeannette (Jeanne Vaderin)*, 1910–13

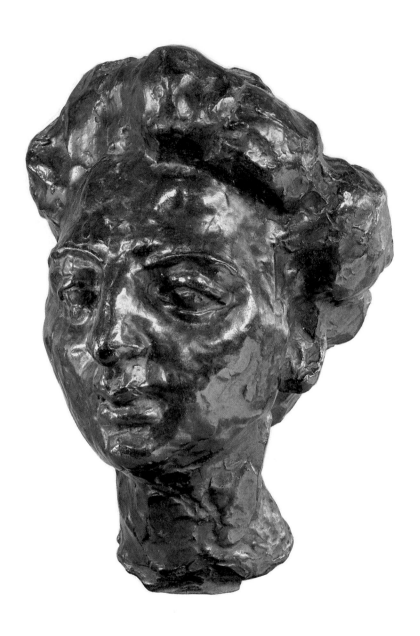

44 *Jeannette I*, 1910

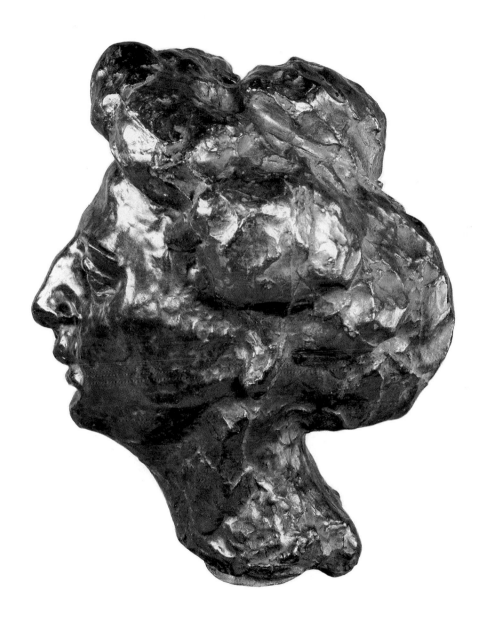

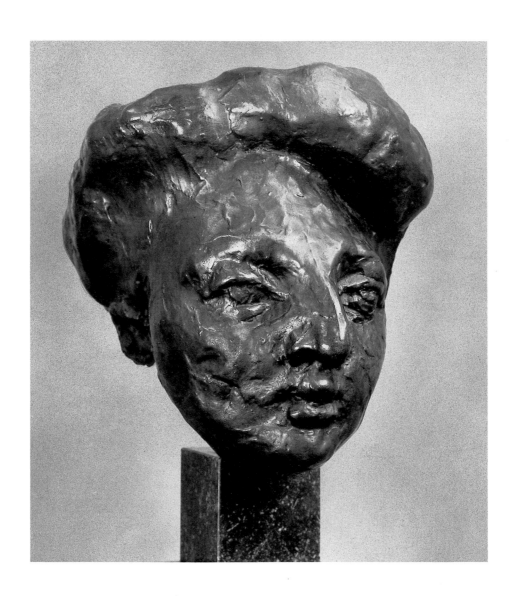

45* *Jeannette II,* 1910

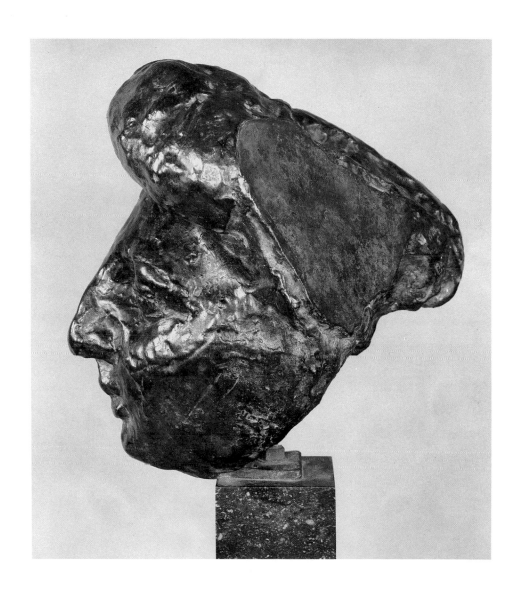

45a

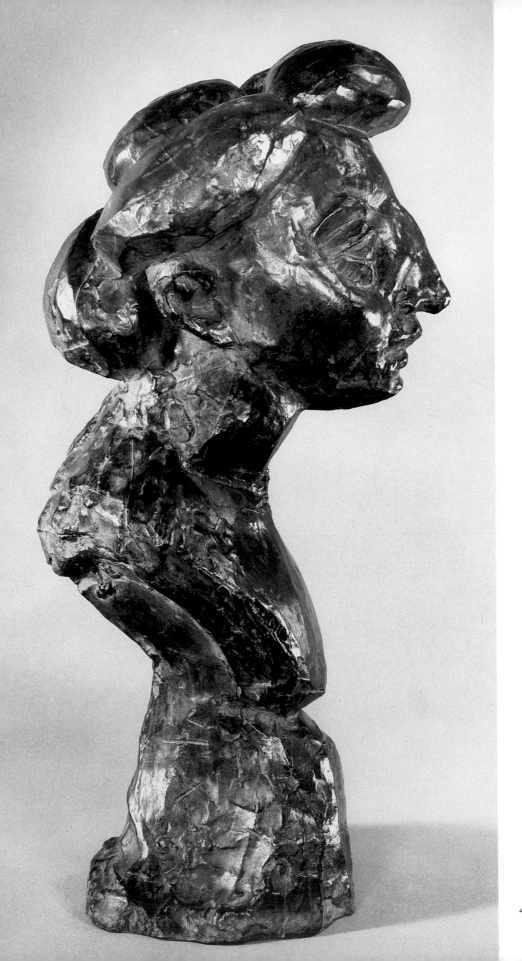

46 *Jeannette III*, 1911

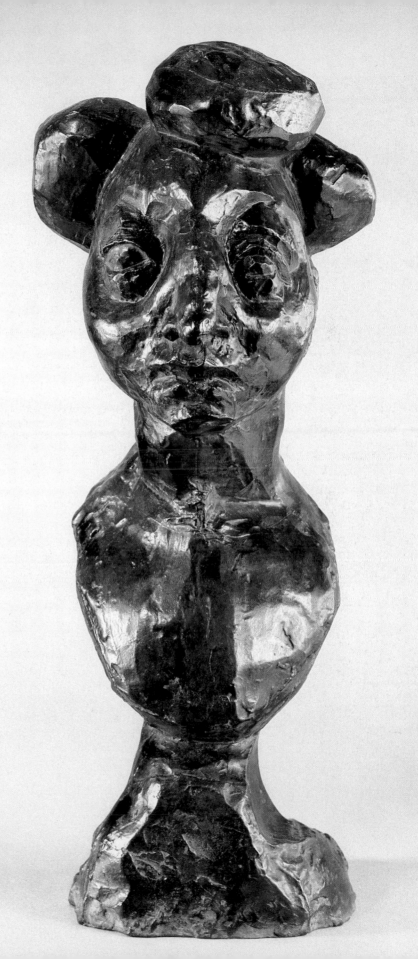

46a

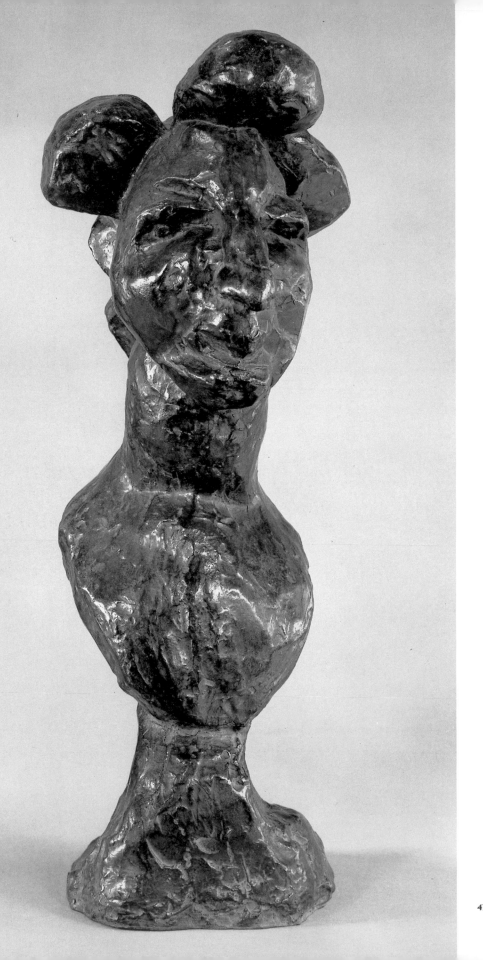

47 *Jeannette IV*, 1911

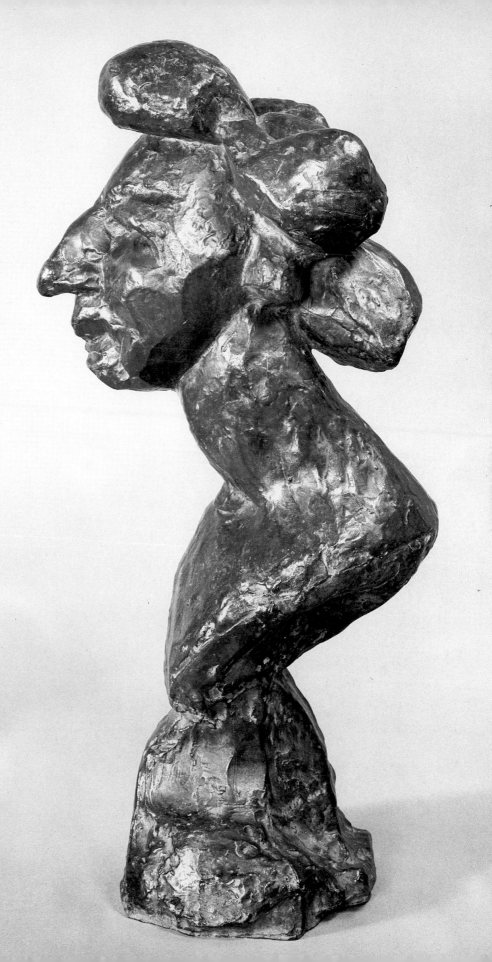

47a

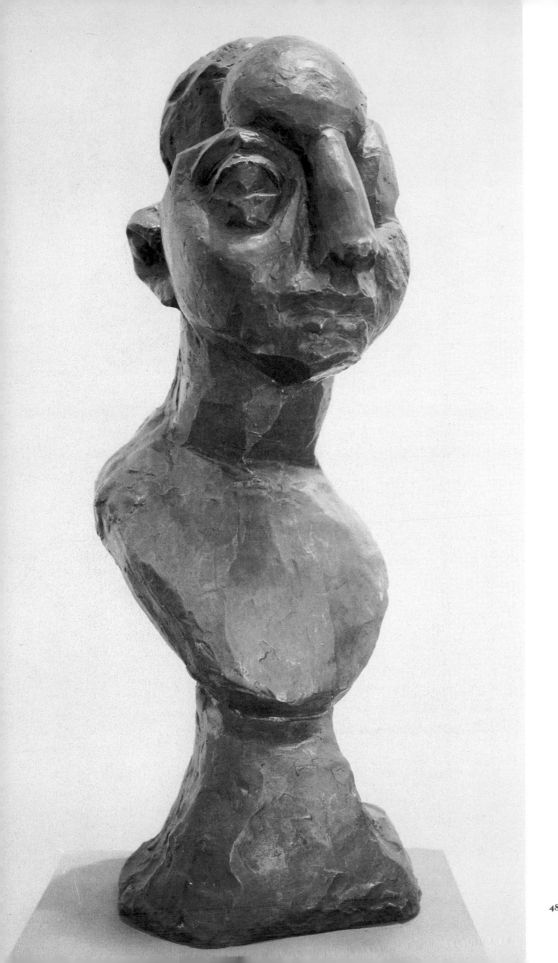

48* *Jeannette V*, 1913

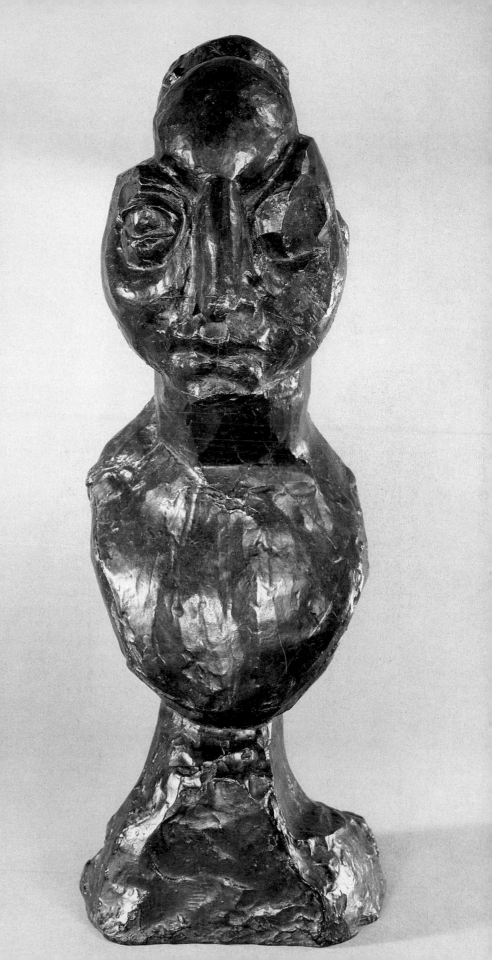

48a

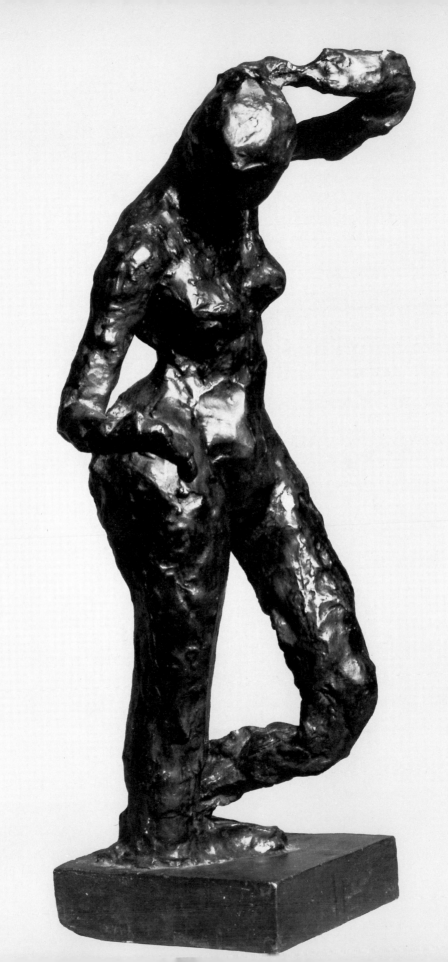

50 *The Dance*, 1907

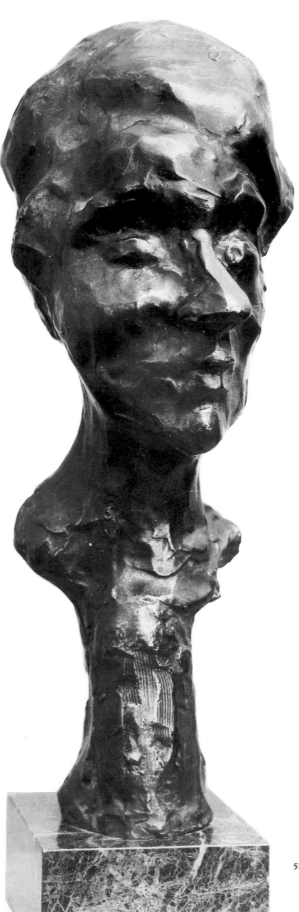

51 *Head of Marguerite*, 1915

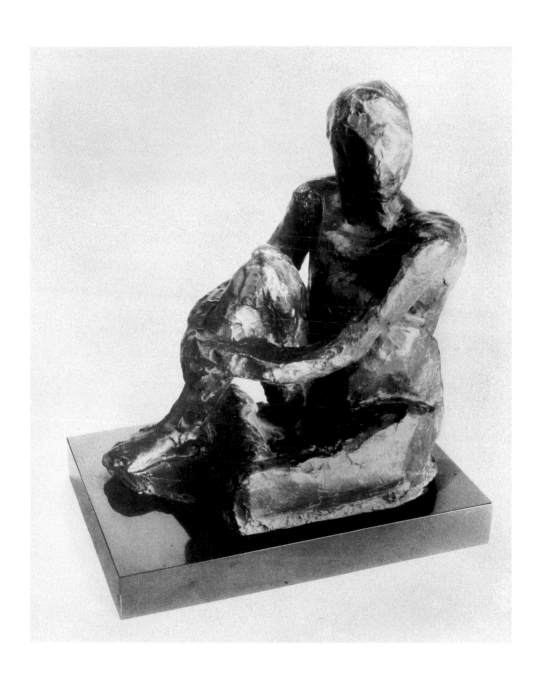

52* *Seated Nude Clasping her Right Leg,* 1918

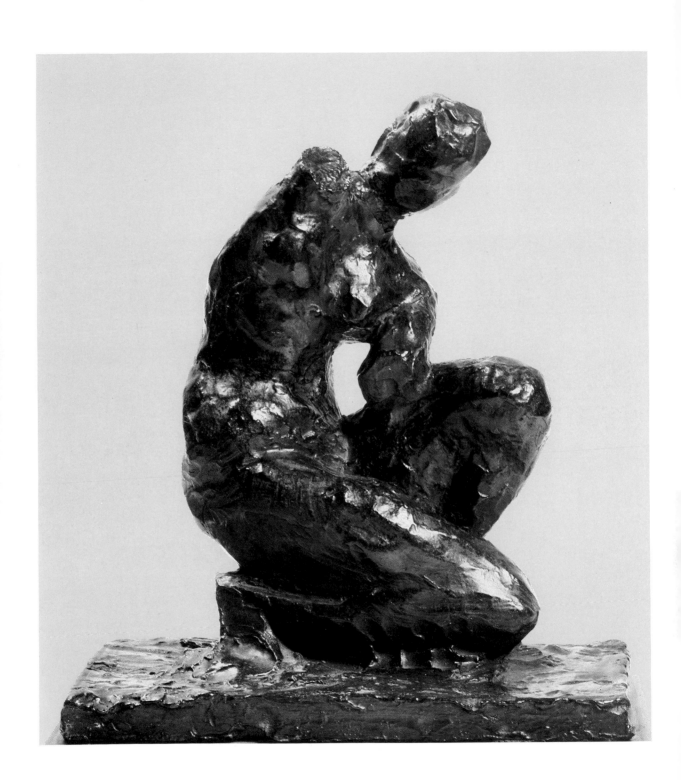

53 *Crouching Venus,* 1918

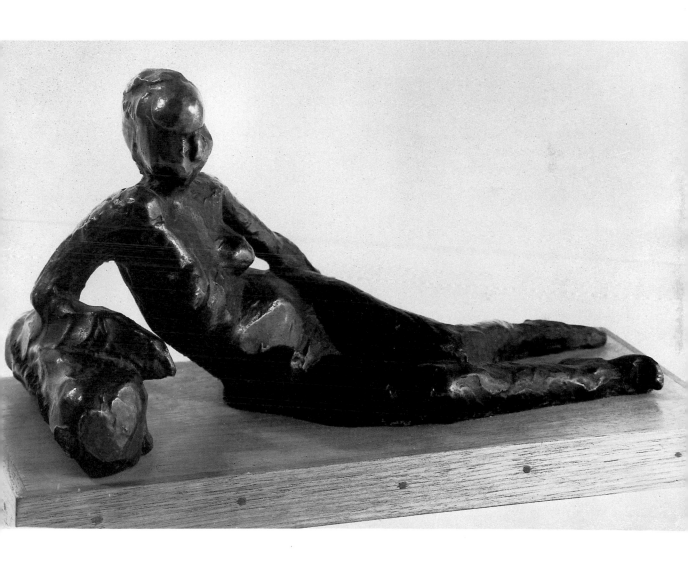

54 *Figure with Cushion,* 1918

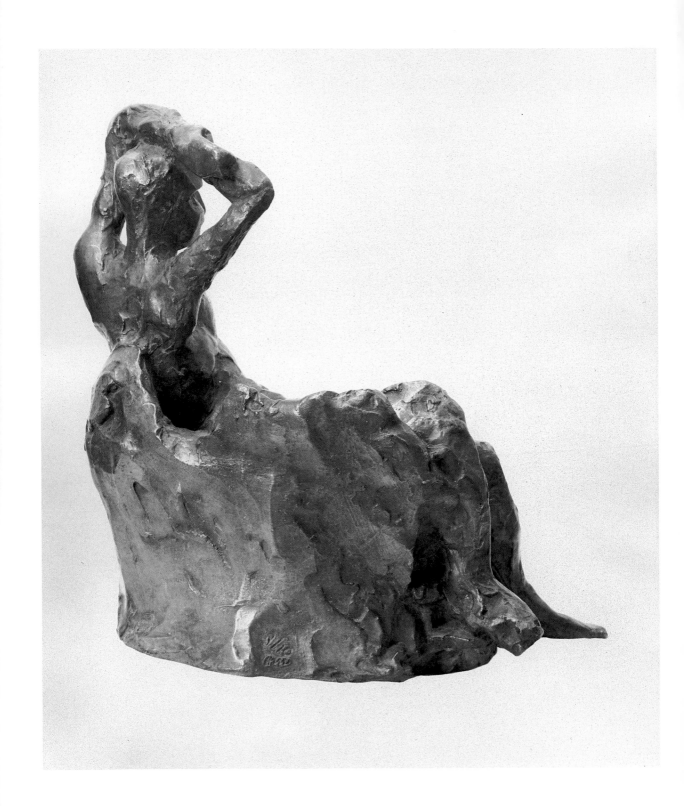

55* *Small Nude in an Armchair*, 1924

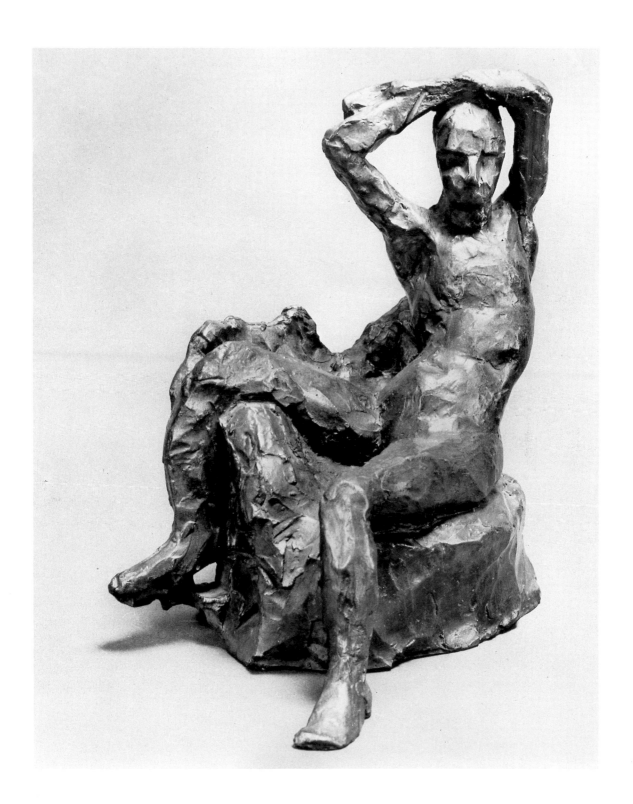

55a*

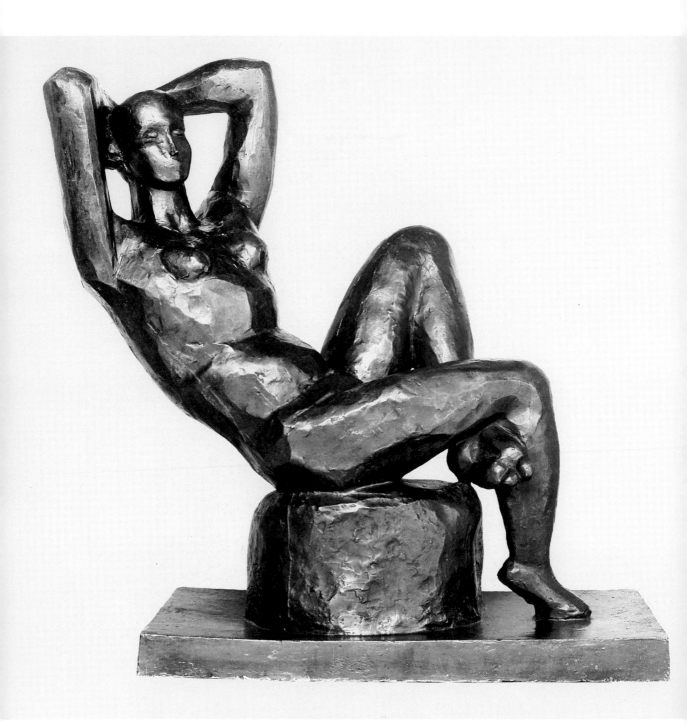

56* *Large Seated Nude*, 1923–25

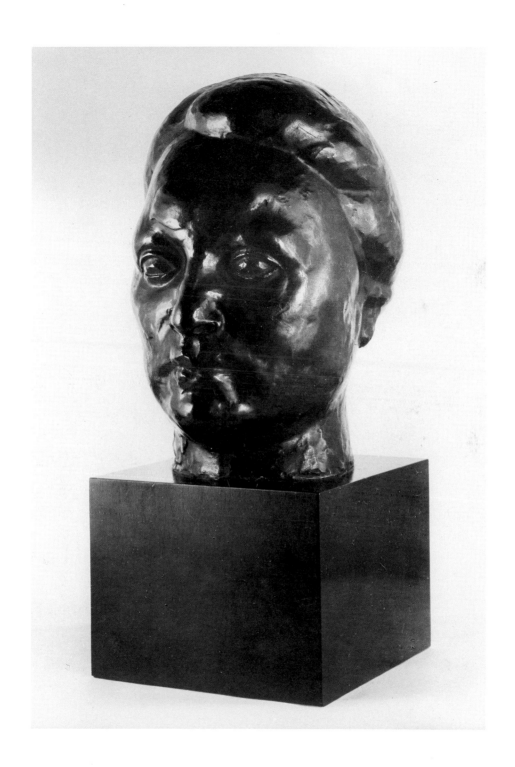

57* *Henriette I, 1925*

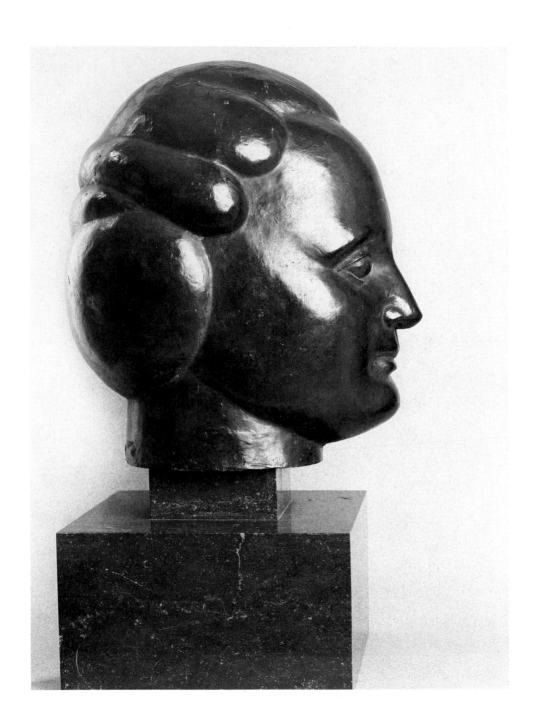

58 *Henriette II*, 1927

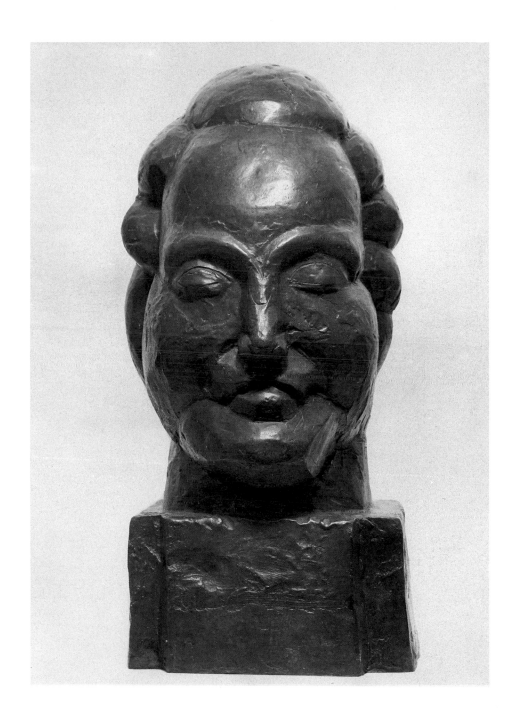

59* *Henriette III,* 1929

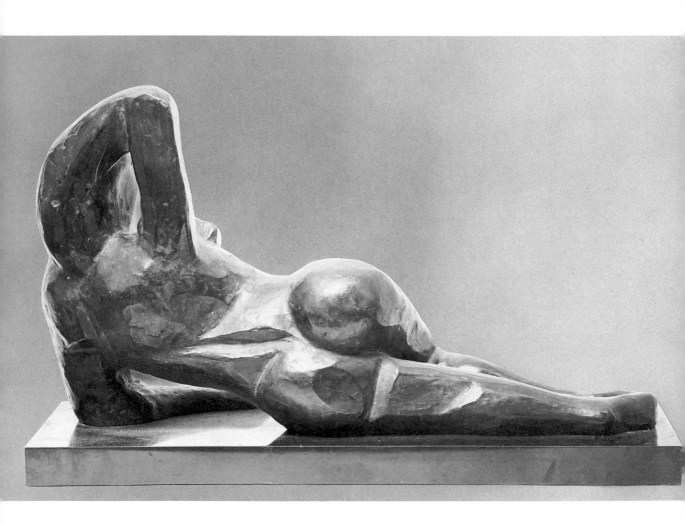

60* *Reclining Nude II*, 1927

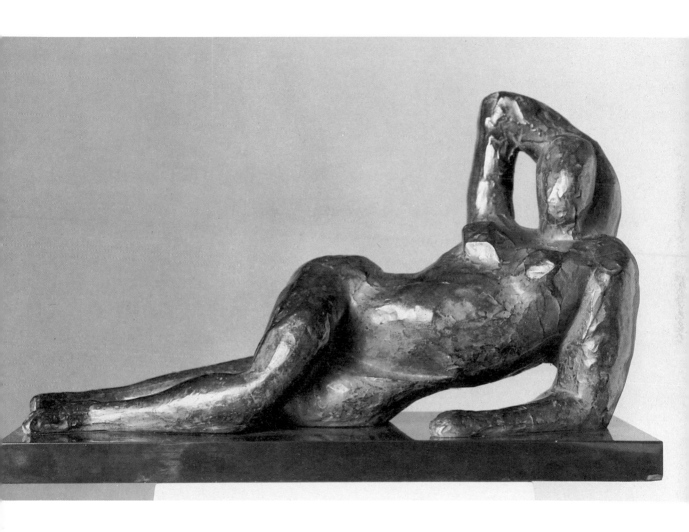

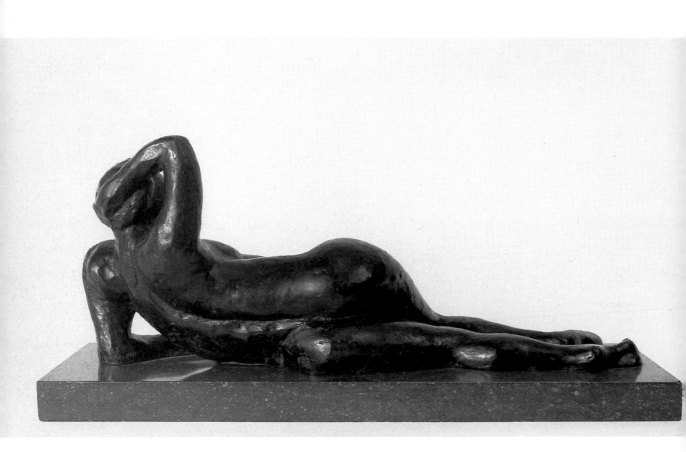

61 *Reclining Nude III,* 1929

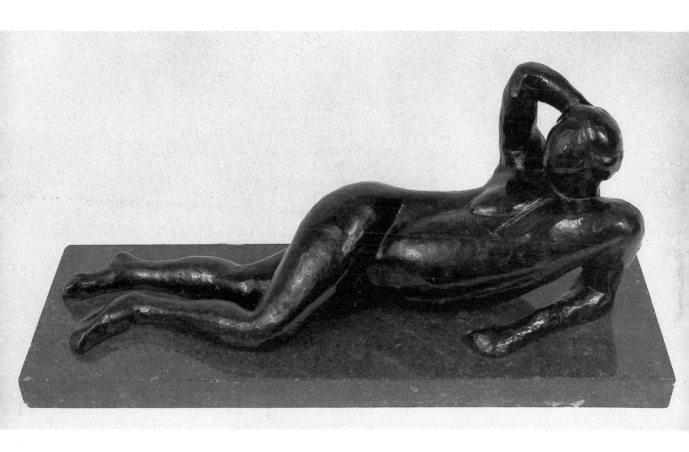

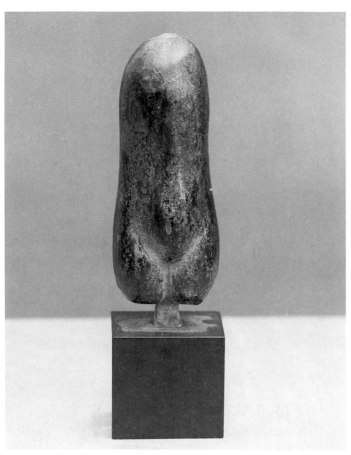

62 *Small Torso*, 1929

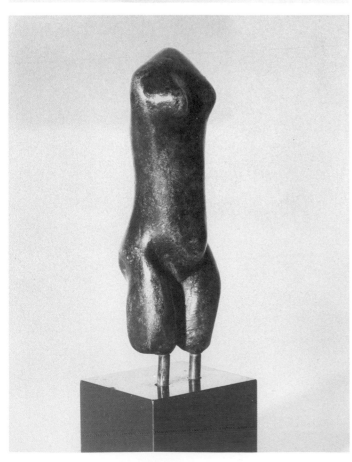

63 *Small Thin Torso*, 1929

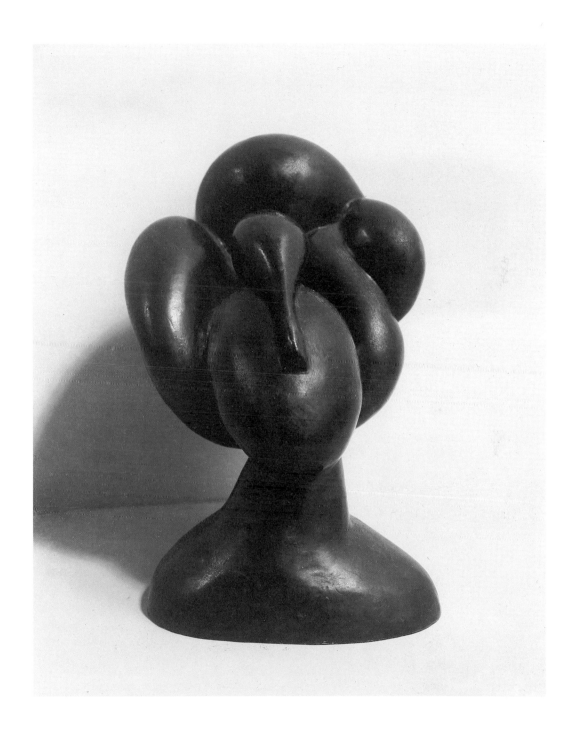

64 *Tiari*, 1930

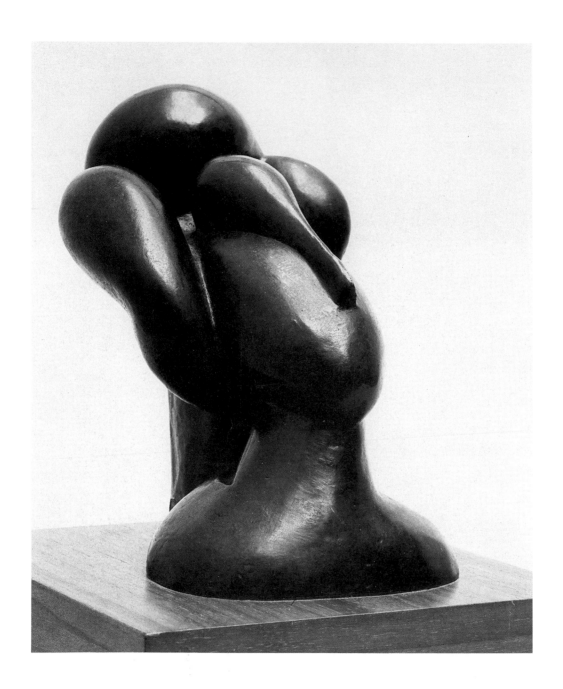

64a

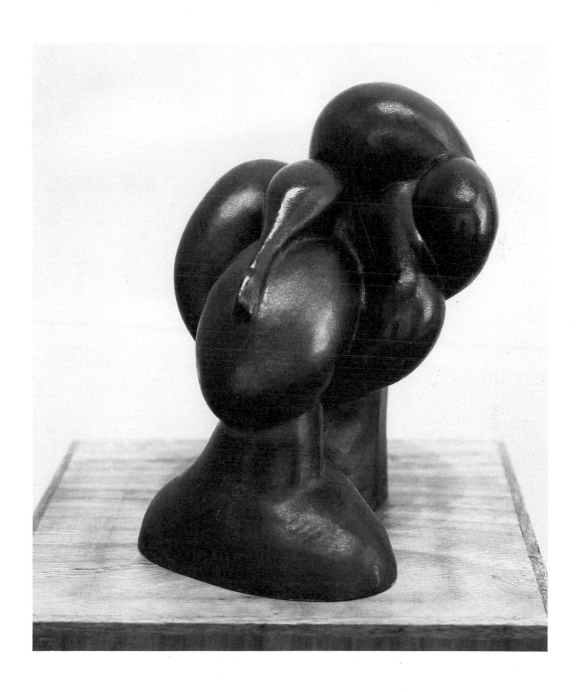

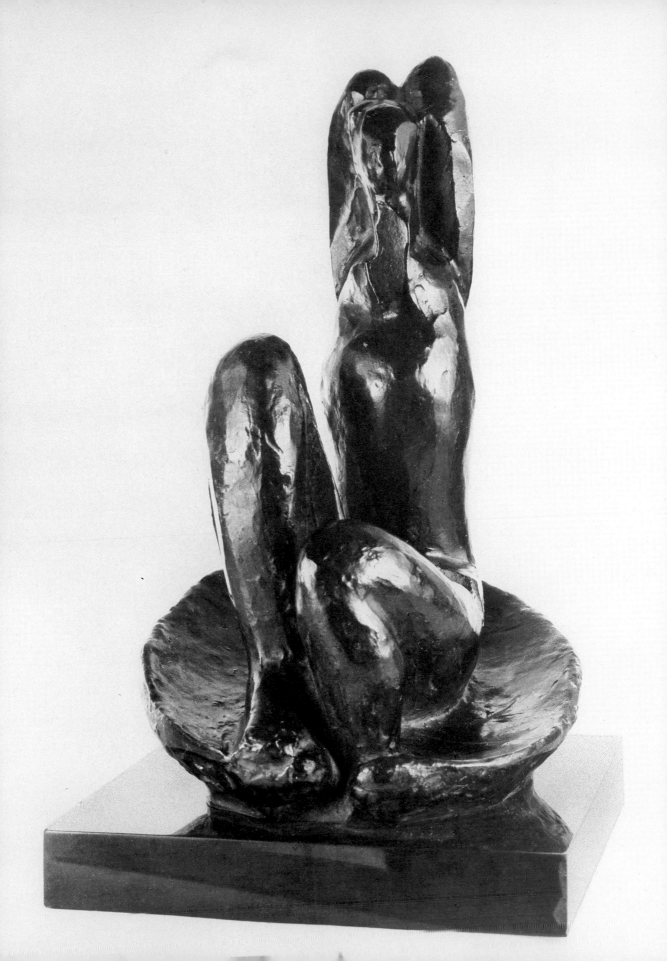

65* *Venus in a Shell I*, 1930

66 *Christ*, 1949

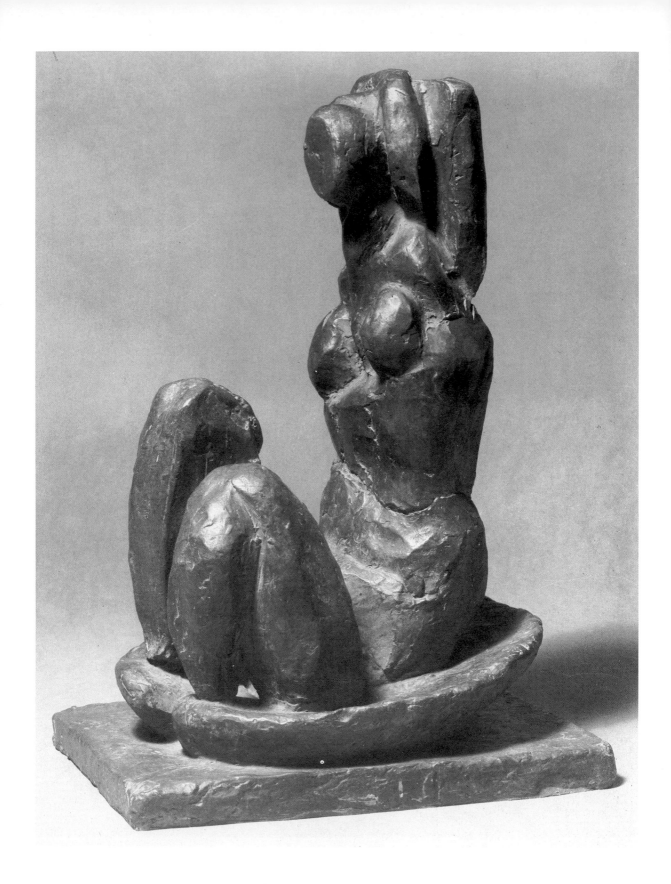

67* *Venus in a Shell 11*, 1932

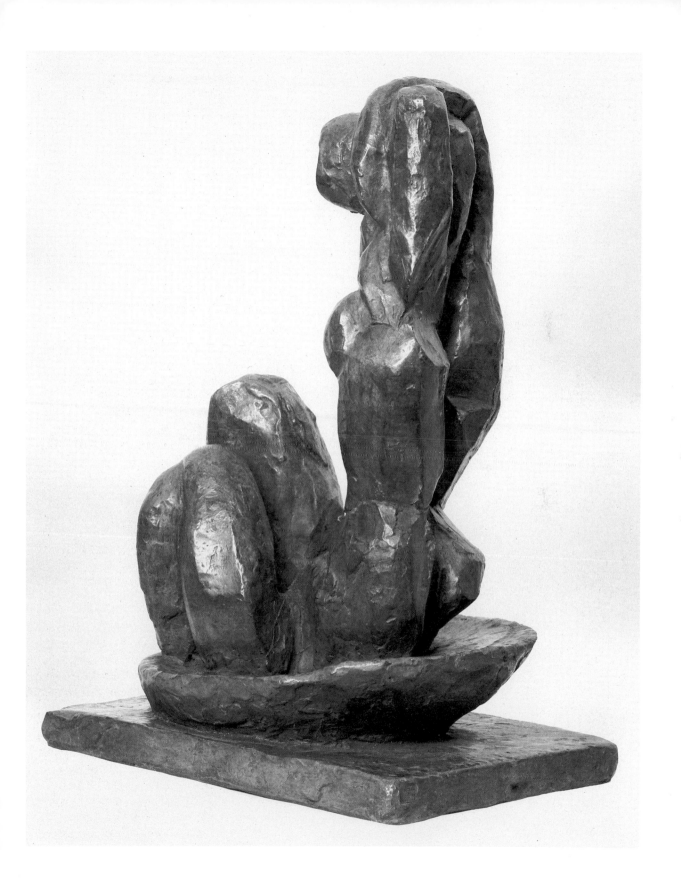

67a 68*, 68a* *Seated Nude, Arm Raised (Pochade)*, 1949 ▷

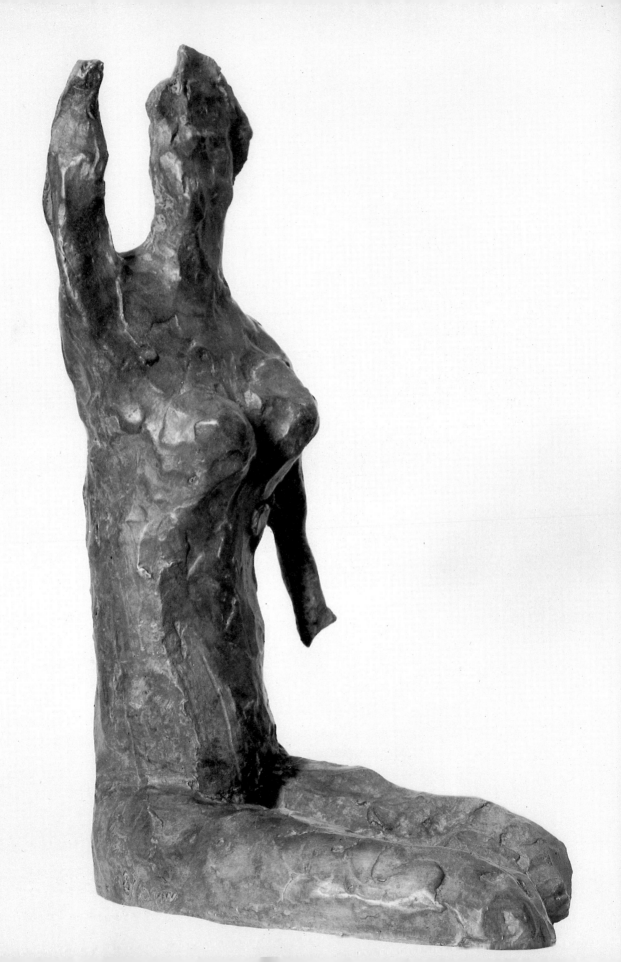

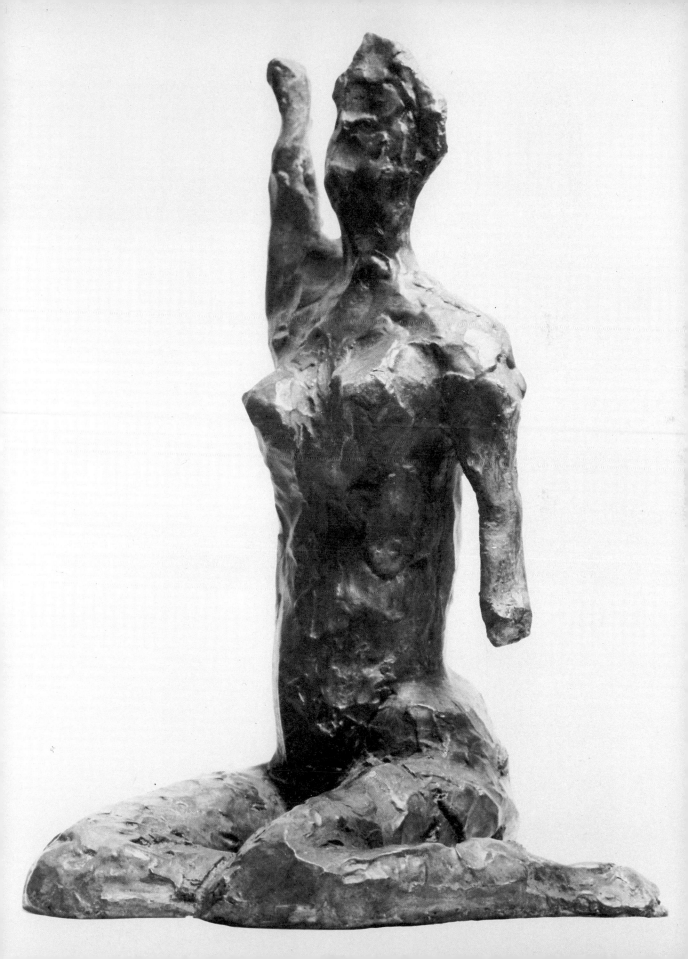

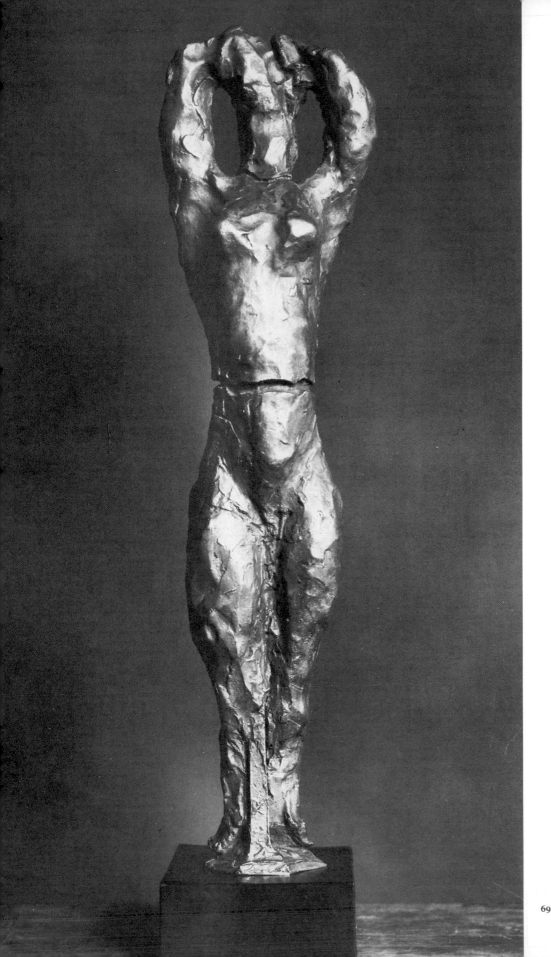

69 *Standing Nude (Katia)*, 1950

THE CATALOGUE

Measurements are given in centimetres and inches, height × width × depth. Matisse bronzes are in editions of ten with the exception of no. 1 and no. 66. Inscriptions are given where known and the name of the founder, date the edition was cast, and number of the cast indicated. The main founders used were A. Bingen-Costenoble/Fondeurs, Paris ('Costenoble') and Cire/C. Valsuani/Perdue ('Valsuani').

1 *Profile of a Woman.* 1894
Bronze medallion
25.4 (10) diameter
Signed H.M. Valsuani 1959
Musée Matisse, Nice-Cimiez.
 Donation Jean Matisse
(There exists another
 medallion of the same subject
 with slight variations.)

2 Copy after Barye's
Jaguar Devouring a Hare. 1899–1901
Bronze
23 × 56 × 23 $(9\frac{1}{8} × 22 × 9\frac{1}{8})$
Signed H.M. 9/10. Valsuani 1966
Private collection

3 *Bust of a Woman.* 1900
Bronze
62 $(24\frac{3}{8})$
Signed H.M. 5/10. Valsuani 1966
Private collection

4 *The Horse.* 1901
Bronze
17 $(6\frac{3}{4})$
Valsuani 1966
Galerie Jan Krugier, Geneva

5 *Madeleine I.* 1901
Bronze
59.5 $(23\frac{3}{8})$
Signed Henri Matisse 2/10
Cone Collection,
 Weatherspoon Art Gallery,
 University of North Carolina
 at Greensboro

(Reproduction of the cast
owned by The Baltimore
Museum of Art.)

6 *Madeleine II.* 1903
Bronze
59.5 $(23\frac{3}{8})$
Signed H.M. Valsuani 1952
Private collection

7 *The Serf.* 1900–03
Bronze
92.3 × 33 × 30.5 $(36\frac{3}{8} × 13 × 12)$
Signed H.M. 0/10. Valsuani
Musée Matisse, Le Cateau-
 Cambrésis

8 Copy after Puget's *Écorché.* 1903
Bronze
23 (9)
Signed H.M. 8/10. Valsuani 1958
Private collection

9 *Profile of a Child (Marguerite).* 1903
Bronze, bas relief
12.8 × 9.2 $(5 × 3\frac{5}{8})$
Signed H.M. 6/10
Private collection

10 *Upright Nude with Arched Back.* 1904
Bronze
22.4 × 9.1 $(8\frac{7}{8} × 3\frac{5}{8})$
Signed H.M. –/10. Valsuani
San Diego Museum of Art: Gift
 of Mr and Mrs Norton S.
 Walbridge

11 *Seated Nude with Arms on Head.* 1904
Bronze
35 $(13\frac{3}{4})$
Signed H.M. 1/10. Valsuani,
 before 1957
Collection of Mr and Mrs
 Sidney E. Cohn

12 *Head of a Child (Pierre Matisse).*
 1905
Bronze
16.2 $(6\frac{3}{8})$
Signed H. Matisse. Cast before
 1957
Private collection

13 *Head of a Child (Pierre Manguin).*
 1905
Bronze 13 $(5\frac{1}{8})$

Signed H. Matisse. Valsuani 1952
Musée Matisse, Nice-Cimiez.
 Donation Jean Matisse

14 *Rosette (La Pipe).* 1905
Bronze
10.8 $(4\frac{1}{4})$
Signed H.M. 5/10. Valsuani 1967
Musée Matisse, Nice-Cimiez.
 Donation Jean Matisse

15 *Woman Leaning on her Hands.* 1905
Bronze
13.5 × 24.8 × 13.5 $(5\frac{1}{4} × 9\frac{3}{4} × 5\frac{1}{4})$
Signed H.M. 8/10.
Pedro Perez Lazo, Caracas

16 *Reclining Figure with Chemise.* 1906
Bronze
14 × 30 × 15 $(5\frac{1}{2} × 11\frac{7}{8} × 5\frac{7}{8})$
Signed H.M. 10/10. Valsuani 1953
Hirshhorn Museum and
 Sculpture Garden,
 Smithsonian Institution,
 Washington DC

17 *Standing Nude.* 1906
Bronze
48 × 12.1 × 15.2 $(18\frac{7}{8} × 4\frac{3}{4} × 6)$
Signed H.M. –/10. Costenoble
 before 1957
Mr and Mrs Harry W.
 Anderson

18 *Standing Nude, Arms on Head.* 1906
Bronze
29 $(11\frac{3}{8})$
Signed Henri Matisse. Valsuani
State Museum, The Hermitage,
 Leningrad

19 *Small Head with Flat Nose.* 1906
Bronze
14 $(5\frac{1}{2})$
Signed H.M. 6/10. Valsuani
Hirshhorn Museum and
 Sculpture Garden,
 Smithsonian Institution,
 Washington DC

20 *Torso with Head (La Vie).* 1906
Bronze
23 $(9\frac{1}{8})$
Signed Henri Matisse 9/10.
The Metropolitan Museum of
 Art, New York.

The Alfred Stieglitz Collection, 1949

21 *Head of a Young Girl.* 1906
Bronze
15.9 × 16.5 × 14.3 ($6\frac{1}{4}$ × $6\frac{1}{2}$ × $5\frac{5}{8}$)
Signed Henri Matisse 5/10.
Valsuani
The Baltimore Museum of Art.
 The Cone Collection formed
 by Dr Claribel Cone and Miss
 Etta Cone of Baltimore,
 Maryland (BMA 1950.426)

22 *Small Head with Upswept Hair.* 1906
Bronze
11.4 ($4\frac{1}{2}$)
Signed H.M. 5/10
Dr Ruth Bakwin

23 *Thorn Extractor.* 1906
Bronze
21.5 × 14.9 × 15.2 ($8\frac{1}{2}$ × $5\frac{7}{8}$ × 6)
Signed H.M. 6/10
Art Gallery of Ontario,
 Toronto. Gift of Sam and
 Ayala Zacks, 1970

24 *Reclining Nude I (Aurore).* 1907
Bronze
34.2 × 50.2 × 28.6 ($13\frac{1}{2}$ × $19\frac{3}{4}$ × $11\frac{1}{4}$)
Signed Henri Matisse 1/10.
 Costenoble
Musée National d'Art Moderne,
 Paris. Centre Georges
 Pompidou
(24a*: reproduction of the cast
 owned by The Museum of
 Modern Art, New York.
 Acquired through the Lillie P.
 Bliss Bequest.)

25 *Head with Necklace.* 1907
Bronze
15 × 13 × 10 ($5\frac{7}{8}$ × $5\frac{1}{8}$ × $3\frac{7}{8}$)
Signed H.M. 9/10. Valsuani
 before 1957
Waddington Galleries Ltd,
 London

26 *Head of a Faun.* 1907
Bronze
14 ($5\frac{1}{2}$)
Signed H.M. 2/10. Valsuani 1959
Musée Matisse, Nice-Cimiez.
 Donation Jean Matisse

27 *Small Head with Comb.* 1907
Bronze
9.5 ($3\frac{3}{4}$)
Signed H.M. 7/10. Valsuani
Cone Collection,
 Weatherspoon Art Gallery,
 University of North Carolina
 at Greensboro

28 *Two Negresses.* 1908
Bronze
47 ($18\frac{1}{2}$)
Signed Henri Matisse. 9/10.
 Valsuani
The British Rail Pension Fund
 on loan to the Tate Gallery,
 London

29 *Small Crouching Nude with Arms.*
 1908
Bronze
15.3 (6)
Signed Henri Matisse 3/10.
 Costenoble
Thyssen-Bornemisza
 Collection, Lugano

30 *Small Crouching Nude without an*
 Arm. 1908
Bronze
12 ($4\frac{3}{4}$)
Signed H.M. 7/10. Costenoble
 before 1957
Cone Collection,
 Weatherspoon Art Gallery,
 University of North Carolina
 at Greensboro

31 *Small Crouching Torso.* 1908
Bronze
8 ($3\frac{1}{8}$)
Signed H.M.
Private collection

32 *Seated Figure, Right Hand on Ground.*
 Paris, autumn 1908
Bronze
19 × 13.7 × 11.2 ($7\frac{1}{2}$ × $5\frac{3}{8}$ × $4\frac{3}{8}$)
Signed 7/10 H.M.
The Museum of Modern Art,
 New York, Abby Aldrich
 Rockefeller Fund, 1952

33 *Decorative Figure.* Summer 1908
Bronze

73 ($28\frac{3}{4}$)
Signed H.M.
Private collection

34 *Standing Nude.* 1908
Bronze, bas relief
22.3 × 10.1 × 4.4 ($8\frac{3}{4}$ × 4 × $1\frac{3}{4}$)
Signed H.M. 2. Valsuani 1953
Art Gallery of Ontario,
 Toronto. Gift of Sam and
 Ayala Zacks, 1970

35 *Study of a Foot.* c. 1909
Bronze
27.2 ($10\frac{3}{4}$)
Signed H.M. 0/10. Valsuani 1952
State Museum, The Hermitage,
 Leningrad

36 *Torso Without Arms or Head.* 1909
Bronze
25 ($9\frac{7}{8}$)
Signed H.M. 5. Valsuani
Hirshhorn Museum and
 Sculpture Garden,
 Smithsonian Institution,
 Washington DC

37 *Seated Nude, Arm Behind her Back.*
 1909
Bronze
29.5 × 17.5 × 22 ($11\frac{5}{8}$ × $6\frac{7}{8}$ × $8\frac{5}{8}$)
Signed Henri Matisse 1/10.
 Costenoble
Musée National d'Art Moderne,
 Paris. Centre Georges
 Pompidou

38 *The Back I.* Issy-les-Moulineaux,
 autumn 1909
Bronze, bas relief
190 × 116 × 13 ($74\frac{3}{4}$ × $45\frac{5}{8}$ × $5\frac{1}{8}$)
Signed and dated on lower
 right, 4/10. Georges Rudier
The Trustees of the Tate
 Gallery, London

39 *The Back II.* Issy-les-Moulineaux,
 autumn 1913
Bronze
188 × 121 × 15.2 (74 × $47\frac{5}{8}$ × 6)
Signed Henri Matisse/H.M. 4/10.
 Georges Rudier
The Trustees of the Tate
 Gallery, London

40 *The Back III.* Issy-les-Moulineaux, autumn 1916–17
Bronze, bas relief
190 × 112 × 15.2 $(74\frac{3}{4} \times 44 \times 6)$
Signed Henri Matisse H.M. 4/10.
Georges Rudier
The Trustees of the Tate
Gallery, London

41 *The Back IV.* Nice, 1930
Bronze, bas relief
188 × 112.4 × 15.2 $(74 \times 44\frac{1}{4} \times 6)$
Signed H.M. 4/10. Valsuani
The Trustees of the Tate
Gallery, London

42 *The Serpentine.* Issy-les-Moulineaux, autumn 1909
Bronze
54.6 × 29.2 × 19 $(21\frac{1}{2} \times 11\frac{1}{2} \times 7\frac{1}{2})$
Signed Henri Matisse 1/10.
Valsuani
The Philadelphia Museum of
Art. Gift of R. Sturgis and
Marion B.F. Ingersoll
(Reproductions of the cast
owned by The Museum of
Modern Art, New York. Gift
of Abby Aldrich Rockefeller.)

43 *Seated Nude (Olga).* 1910
Bronze
43 $(16\frac{7}{8})$
Signed H.M. 5. Valsuani
Mr and Mrs Lee V. Eastman
(43*: reproduction of the cast
owned by the Hirshhorn
Museum and Sculpture
Garden, Smithsonian
Institution, Washington DC.)

44 *Jeannette I.* Issy-les-Moulineaux,
1910
Bronze
33 × 28.8 × 25.5 $(13 \times 11\frac{3}{8} \times 10)$
Signed H.M. 4/10. Valsuani
The Los Angeles County
Museum of Art, presented by
the Art Museum Council in
memory of Penelope Rigby
(68.3.1)

45 *Jeannette II.* Issy-les-Moulineaux,
1910
Bronze

26.2 × 21 × 24.5 $(10\frac{3}{8} \times 8\frac{1}{4} \times 9\frac{5}{8})$
Signed H.M. 5/10. Valsuani
The Los Angeles County
Museum of Art, presented by
the Art Museum Council in
memory of Penelope Rigby
(68.3.2)
(45*: reproduction of the cast
owned by The Museum of
Modern Art, New York. Gift
of Sidney Janis.)

46 *Jeannette III.* Issy-les-Moulineaux, 1911
Bronze
60.3 × 26 × 28 $(23\frac{3}{4} \times 10\frac{1}{4} \times 11)$
Signed H.M. 4/10. Valsuani
The Los Angeles County
Museum of Art, presented by
the Art Museum Council in
memory of Penelope Rigby
(M.68.48.1)

47 *Jeannette IV.* Issy-les-Moulineaux, autumn 1911
Bronze
61.5 × 27.4 × 28.7 $(24\frac{1}{4} \times 10\frac{3}{4} \times 11\frac{1}{4})$
Signed H.M. 4/10. Valsuani
The Los Angeles County
Museum of Art, presented by
the Art Museum Council in
memory of Penelope Rigby
(M.68.48.2)

48 *Jeannette V.* Issy-les-Moulineaux,
autumn 1913
Bronze
58 × 21.3 × 27.1 $(22\frac{7}{8} \times 8\frac{3}{8} \times 10\frac{5}{8})$
Signed H.M. 1/10. Valsuani
The Los Angeles County
Museum of Art, presented by
the Art Museum Council in
memory of Penelope Rigby
(M.68.48.2)
(48*: reproduction of the cast
owned by The Museum of
Modern Art, New York.
Acquired through the Lillie P.
Bliss Bequest.)

49 *The Dance.* 1911
Bronze
41 $(16\frac{1}{8})$
Signed H.M. 10/10. Valsuani
Private collection

50 *The Dance.* 1907
Wood
43.2 × 15.2 (17×6)
Unique work (not in
exhibition)
Musée Matisse, Nice-Cimiez

51 *Head of Marguerite.* 1915
Bronze
32 $(12\frac{5}{8})$
Signed H.M. 3/10. Valsuani
Private collection

52 *Seated Nude Clasping her Right Leg.*
1918
Bronze
23 $(9\frac{1}{8})$
Signed H.M. 2/10. Valsuani 1952
Private collection

53 *Crouching Venus.* 1918
Bronze
26 $(10\frac{1}{4})$
Signed H.M. 8/10. Valsuani
before 1957
Mr and Mrs Walter Bareiss

54 *Figure with Cushion.* 1918
Bronze
13 × 26 × 10.5 $(5\frac{1}{8} \times 10\frac{1}{4} \times 4\frac{1}{8})$
Signed Henri Matisse 2/10.
Valsuani 1959
The Baltimore Museum of Art.
The Cone Collection, formed
by Dr Claribel Cone and Miss
Etta Cone of Baltimore,
Maryland (BMA 1950.433)

55 *Small Nude in an Armchair.* 1924
Bronze
23.2 × 21.6 × 16.8 $(9\frac{1}{8} \times 8\frac{1}{2} \times 6\frac{5}{8})$
Signed H.M. 6/10. Valsuani
Dr and Mrs Martin L. Gecht

56 *Large Seated Nude.* 1923–25
Bronze
84 $(33\frac{1}{8})$
Signed H.M. 2/10. Valsuani
The Minneapolis Institute of
Arts. Gift of Dayton Hudson
Corporation
(Reproduction of the cast
owned by The Baltimore
Museum of Art.)

57 *Henriette I.* 1925
Bronze

29.5 ($11\frac{5}{8}$)
Signed H.M. 3/10. Valsuani 1966
Musée Matisse, Nice-Cimiez.
Donation Jean Matisse

58 *Henriette II.* 1927
Bronze
32.5 × 22 × 29 ($12\frac{3}{4}$ × $8\frac{5}{8}$ × $11\frac{3}{8}$)
Signed 8/10 H.M. Valsuani
before 1957
Musée National d'Art Moderne,
Paris. Centre Georges
Pompidou

59 *Henriette III.* 1929
Bronze
40 ($15\frac{3}{4}$)
Signed H.M. 8/10. Valsuani
National Museum of Wales,
Cardiff

60 *Reclining Nude II.* 1927
Bronze
29 × 51.4 × 16.5 ($11\frac{3}{8}$ × $20\frac{1}{4}$ × $6\frac{1}{2}$)
Signed H.M. 10/10. Valsuani
The Trustees of the Tate
Gallery, London

61 *Reclining Nude III.* 1929
Bronze
18.5 × 46.3 × 13.2 ($7\frac{1}{4}$ × $18\frac{1}{4}$ × $5\frac{1}{4}$)
Signed H.M. 3/10. Valsuani

Mr and Mrs David Mirvish,
Toronto

62 *Small Torso.* 1929
Bronze
9 ($3\frac{1}{2}$)
Signed H.M. 9
Mr and Mrs Benjamin Weiss

63 *Small Thin Torso.* 1929
Bronze
8 ($3\frac{1}{8}$)
Signed H.M. 3/3
Musée Matisse, Nice-Cimiez.
Donation Jean Matisse

64 *Tiari.* 1930
Bronze
20.3 × 14 × 13 (8 × $5\frac{1}{2}$ × $5\frac{1}{8}$)
Signed H.M. 2/10. Valsuani 1951
The Museum of Modern Art,
New York. A. Conger
Goodyear Fund, 1955

65 *Venus in a Shell I.* 1930
Bronze
31 × 18.3 × 20.6 ($12\frac{1}{4}$ × $7\frac{1}{4}$ × $8\frac{1}{8}$)
Signed H.M. 5/10. Valsuani
Private collection

66 *Christ.* 1949
Chapel of the Rosary for the
Dominican Nuns of Vence
Bronze
35 ($13\frac{3}{4}$)
1/5 Musée Matisse, Nice-Cimiez

67 *Venus in a Shell II.* 1932
Bronze
33.7 ($13\frac{1}{4}$)
Signed H.M. 3/10. Valsuani
1958–59
Hirshhorn Museum and
Sculpture Garden,
Smithsonian Institution,
Washington DC

68 *Seated Nude, Arm Raised (Pochade).*
1949
Bronze
25.7 ($10\frac{1}{8}$)
Signed H.M. 6/10. Valsuani
before 1957
Private collection

69 *Standing Nude (Katia).* 1950
Bronze
45 ($17\frac{3}{4}$)
Signed H.M. 4/10. Valsuani
Private collection, New York

LIST OF
ILLUSTRATIONS
IN THE TEXT

*Measurements are given in centimetres and inches,
height × width × depth.*

1 ALBERT MARQUE: *Portrait of Jean Baignères,*
1905. Terracotta, 29 ($11\frac{3}{8}$). From *L'Illustration*, 4
November 1905.

2 Study for *Luxe, calme et volupté* 1904–05. Oil
on canvas, 32.2 × 40.5 ($12\frac{5}{8}$ × 16). Private
collection.

3 *Luxe, calme et volupté*, 1904–05. Oil on canvas,
98.4 × 118.4 ($38\frac{3}{4}$ × $46\frac{5}{8}$). Musée National d'Art
Moderne, Paris (Photo: Giraudon).

4 *Bonheur de vivre*, 1905–06. Oil on canvas,
174 × 238 ($68\frac{1}{2}$ × $93\frac{3}{4}$). © The Barnes Founda-
tion, Merion, Pa.

5 Study for *Reclining Figure with Chemise*, 1906.

Charcoal. Photo: Marc Vaux (Archive
Musée National d'Art Moderne, Paris).

6 *Blue Nude (Souvenir of Biskra)*, 1907. Oil on
canvas, 92 × 140 ($36\frac{1}{4}$ × $55\frac{1}{8}$). The Baltimore
Museum of Art: The Cone Collection,
formed by Dr Claribel Cone and Miss Etta
Cone of Baltimore, Maryland.

8 *Standing Nude*, 1907. Oil on canvas, 91.4 × 63.5
(36 × 25). The Tate Gallery, London.

11 *Upright Nude with Arched Back*, 1904. Bronze,
22.4 × 9.1 ($8\frac{7}{8}$ × $3\frac{5}{8}$). San Diego Museum of
Art. Gift of Mr and Mrs Norton S.
Walbridge.

14 *Bathers with a Turtle*, 1908. Oil on canvas,
179.1 × 220.3 ($70\frac{1}{2}$ × $86\frac{3}{4}$). Gift of Mr and Mrs
Joseph Pulitzer, Jr. The St Louis Art
Museum.

16 *Le Luxe II*, 1907–08. Oil on canvas, 209.5 × 139 ($82\frac{1}{2}$ × $54\frac{3}{4}$). Statens Museum for Kunst, Copenhagen. J. Rump Collection.

18 Photograph by Edward Steichen of Matisse working on *The Serpentine*, autumn 1909. First published in *Camera Work*, New York, nos 42–43, 1913.

19 *Head, White and Rose*, 1914. Oil on canvas, 75 × 46.5 ($29\frac{1}{2}$ × $18\frac{3}{8}$). Musée National d'Art Moderne, Paris, Centre Georges Pompidou.

20 GEORGES BRAQUE: *Le Guéridon*, 1911. Oil on canvas, 116 × 81 ($45\frac{5}{8}$ × $31\frac{7}{8}$). Musée National d'Art Moderne, Paris, Centre Georges Pompidou.

21 GEORGES BRAQUE: *Composition*, 1912. Collage, 48 × 62 ($18\frac{7}{8}$ × $24\frac{3}{8}$). Collection Ernst Beyeler, Basel.

22 PABLO PICASSO: *Mandolin and Clarinet*, 1914. Painted wood and pencil, 58 × 36 × 23 ($22\frac{7}{8}$ × $14\frac{1}{8}$ × 9). Musée Picasso, Paris.

23 *Girl with Tulips*, 1910. Charcoal, 73 × 58.8 ($28\frac{3}{4}$ × $23\frac{1}{8}$). State Museum, The Hermitage, Leningrad.

24 PABLO PICASSO: *Woman in Green*, 1909. Oil on canvas, 100 × 81 ($39\frac{3}{8}$ × 32). Stedelijk van Abbemuseum, Eindhoven (Photo: Giraudon).

25 PABLO PICASSO: *Head of a Woman (Fernande)*, 1909. Bronze, 40.5 × 24 × 26 (16 × $9\frac{1}{2}$ × $10\frac{1}{4}$). Kunsthaus, Zürich.

26 PABLO PICASSO: *The Glass of Absinthe*, 1914. Painted bronze, 21.6 × 15.5 ($8\frac{1}{2}$ × $6\frac{1}{8}$). The Museum of Modern Art, New York. Gift of Mrs Bertram Smith.

27 PABLO PICASSO: *Guitar and Bottle*, 1913. Card and paper, 102 × 80 ($40\frac{1}{8}$ × $31\frac{1}{2}$). The Museum of Modern Art, New York. Gift of the artist.

29 *Bathers by a River*, 1916. Oil on canvas, 262 × 391 (103 × 154). The Art Institute of Chicago. Charles H. and Mary F. S. Worcester Collection.

30 *The Back*, 1909–10. Ink on paper. Whereabouts unknown.

31 PAUL CÉZANNE: *Nature morte avec 'L'Amour en plâtre'*, c.1895. Oil on paper mounted on panel, 65 × 81 ($25\frac{5}{8}$ × $31\frac{7}{8}$). Courtauld Institute Galleries, London (Courtauld Collection).

32 *Interior with Aubergines*, 1911. Tempera, 212 × 246 ($83\frac{1}{2}$ × 77). Musée de Peinture et de Sculpture, Grenoble.

33 *The Pink Studio*, 1911. Oil on canvas, 177.2 × 209 ($69\frac{3}{4}$ × $82\frac{1}{4}$). The Pushkin Museum, Moscow.

34 *The Red Studio*, 1911. Oil on canvas, 181 × 219.1 ($71\frac{1}{4}$ × $86\frac{1}{4}$). The Museum of Modern Art, New York. Mrs Simon Guggenheim Fund.

35 *Bronze with Carnations*, 1908. Oil on canvas, 60.5 × 73.5 ($23\frac{3}{4}$ × 29). The National Gallery, Oslo.

36 *Goldfish and Sculpture*, 1911. Oil on canvas, 116.2 × 100 ($45\frac{3}{4}$ × $39\frac{3}{8}$). The Museum of Modern Art, New York. Gift of Mr and Mrs John Hay Whitney.

37 *Still-life with Ivy*, 1916. Oil on canvas, 60 × 73 ($23\frac{5}{8}$ × $28\frac{3}{4}$). Musée des Beaux-Arts et d'Archéologie, Besançon (Photo: Giraudon).

38 *Still-life with Plaster Figure*, 1906. Oil on canvas, 54 × 45 ($21\frac{1}{4}$ × $17\frac{3}{4}$). Yale University Art Gallery, New Haven, Connecticut.

39 *Still-life with Geraniums and Fruit*, 1907. Oil on canvas, 100 × 81 ($39\frac{3}{8}$ × $31\frac{7}{8}$). The Art Institute of Chicago. Collection of J. Winterbotham.

40 *Spray of Lilac*, 1914. Oil on canvas, 146 × 97 ($57\frac{1}{2}$ × $38\frac{1}{4}$). Private collection.

41 *The Piano Lesson*, 1916. Oil on canvas, 245.1 × 212.7 ($96\frac{1}{2}$ × $83\frac{3}{4}$). The Museum of Modern Art, New York. Mrs Simon Guggenheim Fund.

42 CONSTANTIN BRANCUSI: *Head of a Child*, 1913–15. Wood, 25.9 ($10\frac{1}{4}$). Musée National d'Art Moderne, Paris, Centre Georges Pompidou.

43 CONSTANTIN BRANCUSI: *Tête de femme, d'une muse*, 1912. Plaster, 45 × 25 × 21.5 ($17\frac{3}{4}$ × $9\frac{7}{8}$ × $8\frac{1}{2}$). Musée National d'Art Moderne, Paris, Centre Georges Pompidou.

44 Study for *The Music Lesson*, 1917. Pencil. Whereabouts unknown.

45 *Woman on a High Stool*, 1913–14. Oil on canvas, 147 × 95.5 ($57\frac{7}{8}$ × $37\frac{5}{8}$). The Museum of Modern Art, New York.

46 *The Italian Girl*, 1915–16. Oil on canvas, 116 × 89 ($45\frac{15}{16}$ × $35\frac{1}{4}$). The Solomon R. Guggenheim Museum, New York (Photo: Carmelo Guadagno).

47 Study related to *Large Seated Nude*, c.1923–25. Conté crayon. Photo: Marc Vaux (Archive Musée National d'Art Moderne, Paris).

48 *Seated Nude in an Armchair*, 1926. Oil on canvas, 73 × 54 ($28\frac{3}{4}$ × $21\frac{1}{4}$). Collection William S. Paley, New York.

49 Study related to *Large Seated Nude*, c.1923–25. Conté crayon. Photo: Marc Vaux (Archive Musée National d'Art Moderne, Paris).

50 Study related to *Large Seated Nude*, c.1923–25. Ink. Photo: Marc Vaux (Archive Musée National d'Art Moderne, Paris).

51 *Study of Henriette*, 1927. Pencil. Whereabouts unknown. Photo: Marc Vaux (Archive Musée National d'Art Moderne, Paris).

53 JACQUES LIPCHITZ: *Portrait of Gertrude Stein*, 1920. Bronze, 34.3 ($13\frac{1}{2}$) Musée National d'Art Moderne, Paris, Centre Georges Pompidou (Photo: Jacqueline Hyde).

53 *Decorative Figure on an Ornamental Ground*, 1925–26. Oil on canvas, 130.2 × 97.5 ($51\frac{1}{4}$ × $38\frac{3}{8}$). Musée National d'Art Moderne, Paris, Centre Georges Pompidou (Photo: Giraudon).

56 *The Dance* (detail), 1931–32. Oil on canvas, 356.5 × 1283 ($140\frac{1}{2}$ × 505). Musée d'Art Moderne de la Ville de Paris (Photo: Bulloz).

58 CONSTANTIN BRANCUSI: *Princess X*, 1916. Bronze, 56.5 × 41.9 × 24.1 ($22\frac{1}{4}$ × $16\frac{1}{2}$ × $9\frac{1}{2}$). Musée National d'Art Moderne, Paris, Centre Georges Pompidou.

59 Study for illustration to the poems of Mallarmé, 1930. Pencil. Photo: Marc Vaux (Archive Musée National d'Art Moderne, Paris).

61 PABLO PICASSO: *Head of a Woman*, 1931–32. Bronze, 50 × 31 × 27 ($19\frac{5}{8}$ × $12\frac{1}{4}$ × $10\frac{5}{8}$). Musée Picasso, Paris.

62 PABLO PICASSO: *Reclining Woman*, 1932. Bronze, 19 × 70.5 × 31.4 ($7\frac{1}{2}$ × $27\frac{3}{4}$ × $12\frac{3}{8}$). Musée Picasso, Paris.

63 Study for the ceramic panel of the Stations of the Cross, at the Chapel of the Rosary, Vence, c.1950. Ink on paper. Musée Matisse, Nice-Cimiez.

65 *Blue Nude I*, 1952. Paper cut-out, 115 × 78.1 ($45\frac{3}{8}$ × $30\frac{3}{4}$). Collection Ernst Beyeler, Basel.

66 *Blue Nude II*, 1952. Paper cut-out, 116.2 × 88.9 ($45\frac{3}{4}$ × 35). Musée National d'Art Moderne, Paris, Centre Georges Pompidou.

67 *Blue Nude III*, 1952. Paper cut-out, 101 × 74 ($39\frac{3}{4}$ × $29\frac{1}{8}$). Musée National d'Art Moderne, Paris, Centre Georges Pompidou.

68 *Blue Nude IV*, 1952. Paper cut-out, 102 × 74 ($40\frac{1}{2}$ × $29\frac{1}{8}$). Musée Matisse, Nice-Cimiez.

69 *The Swimming Pool* (detail), 1952. Gouache on cut and pasted paper mounted on burlap, 230.2 × 796.3 ($90\frac{5}{8}$ × $313\frac{1}{2}$). The Museum of Modern Art, New York. Mrs Bernard F. Gimbel Fund.

CHRONOLOGY

1869 31 December: Henri Emile Benoît Matisse born at Le Cateau-Cambrésis (département du Nord).

1882–87 Studies at the Lycée Saint-Quentin.

1887–88 Studies law in Paris; returns to Saint-Quentin to become a clerk in a law office.

1889 Attends morning classes (drawing from casts) at the Ecole Quentin Latour (Saint-Quentin).

1890 Begins painting, while convalescing from appendicitis.

1891–92 Abandons law and becomes a student under Bouguereau at the Académie Julian in Paris to prepare for the competition for entry to the Ecole des Beaux-Arts.
February: takes the entrance examination and fails.

1892 Draws from the Antique at the Cour Yvon at the Ecole des Beaux-Arts; begins (unofficially) in Gustave Moreau's class. Evening classes at the Ecole des Arts Décoratifs (where he meets Albert Marquet).

1893 Works with Gustave Moreau and begins copying at the Louvre, at Moreau's suggestion.

1894 Makes numerous copies at the Louvre. Birth of daughter Marguerite.

1894–95 Winter: prepares again for the entrance examination to the Ecole des Beaux-Arts, and passes.

1895 March: officially enters Gustave Moreau's class at the Ecole des Beaux-Arts. Meets Manguin, Piot, Bussy, Rouault. Begins to paint outdoors in Paris. Moves to 19 quai Saint-Michel. Summer in Brittany.

1896 Salon de la Société des Beaux-Arts accepts 4 of his paintings. Elected an Associate Member of the Société Nationale. Second stay in Brittany; visits Belle-Ile.

1897 Discovers Impressionism through the Caillebotte Bequest shown at the Musée du Luxembourg. Exhibits the painting *La Desserte* at the Salon de la Nationale. Works in Brittany where he meets the painter John Russell (sees 2 drawings by Van Gogh, one of which he buys).

1898 Marries Amélie Parayre of Toulouse. Spends honeymoon in London where on Pissarro's advice he studies Turner. Spends six months in Corsica, then the next six months in Toulouse and Fenouillet.

1899 Returns to Paris after one year abroad. Birth of son Jean. Works under Cormon who has succeeded Moreau at the Beaux-Arts; asked to leave the school. For a few months attends classes at the Académie E. Carrière (where he meets André Derain). Evening sculpture classes at the Ecole Communale de la Ville de Paris (rue Etienne Marcel). Exhibits for the last time at the Salon de la Nationale. Purchases Cézanne's painting *Three Bathers*, a plaster bust of Henri Rochefort by Rodin, head of a boy by Gauguin and a second drawing by Van Gogh.

1900 Winter: works at the studio of La Grande Chaumière under Bourdelle.
Financial hardship. Paints exhibition decorations at the Grand Palais for the Exposition Universelle. Studies sculpture in the evenings. Birth of son Pierre.

1901 Late winter rest in Villars-sur-Ollon, Switzerland. Exhibits at the Salon des

	Indépendants. Sees Van Gogh's retrospective at Galerie Bernheim-Jeune. Meets Maurice Vlaminck.
1902	Exhibits at Galerie Berthe Weill with his friends from the Atelier Gustave Moreau. One-year stay in Bohain with wife and children.
1903	Foundation of the Salon d'Automne where Matisse exhibits along with his friends, including Camoin, Manguin, Rouault, Puy and Derain. Gauguin's retrospective takes place. Sees exhibition of Islamic art at the Pavillon de Marsan. First attempts at engraving.
1904	First one-man show with Ambroise Vollard, Paris. Summer: Saint-Tropez with Paul Signac and H. E. Cross. Sends 13 works to the Salon d'Automne.
1905	*Luxe, calme et volupté* exhibited at the Salon des Indépendants and bought by Signac. First summer stay in Collioure (with André Derain). Meets Auguste Maillol who introduces him to Daniel de Monfried, 'guardian' of the Gauguin collection. October: famous 'Fauve' Salon d'Automne; the Steins begin to buy his work. Takes a studio in the Couvent des Oiseaux, rue de Sèvres, Paris.
1906	March: one-man show at the Galerie Druet, Paris, including drawings and woodcuts. Late spring: visit to Biskra, Algeria. Summer: Collioure. Exhibits at the Salon d'Automne. Claribel and Etta Cone start buying his works. Develops interest in African art. *Bonheur de vivre* exhibited at the Salon des Indépendants and bought by Leo Stein. Meets Picasso at the Steins. Returns to Collioure for the winter.
1907	*Blue Nude* exhibited at the Salon des Indépendants. Mid June – mid July: Collioure. Mid July – mid August: Padua, Florence, Arezzo and Siena. Autumn: back in Collioure. Exchanges paintings with Picasso who is working on *Les Demoiselles d'Avignon*. Admirers organize a school (Académie Matisse) in rue de Sèvres, Paris, where he teaches.
1908	Moves to boulevard des Invalides where his studio and school are also established. Visits Bavaria (to Munich with Hans Purrmann). First exhibition in the US at Alfred Stieglitz's 'Little Galleries of the Photo-Secession' ('291'), New York; shows drawings, watercolours and prints. Exhibits at the Salon d'Automne. December: 'Notes d'un peintre' published in *La Grande Revue*, vol. 52, 24–25. The Russian collector S. I. Shchukin starts buying his work.
1909	Shchukin commissions *Dance* and *Music*. February: visits Cassis (in the south of France). Spring: back in Paris for the Salon des Indépendants. June–September: Cavallière (near Saint-Tropez). September: moves to Issy-Les-Moulineaux (south west of Paris), where he builds a studio. Loses interest in his school. First contract with the Galerie Bernheim-Jeune. December: second visit to Germany; meets Paul Cassirer. Begins *The Serpentine* and *Back I*.
1910	First exhibition at Bernheim-Jeune. Second exhibition at Gallery '291' in New York.

Late summer: travels to Munich to see an exhibition of Islamic art. Brief stay in Paris for the Salon d'Automne where he exhibits *Dance* and *Music*.

November–January 1911: travels to Spain; paints in Seville.

1911 End January: back in Paris.

Stays in Issy until May. Exhibits at the Salon des Indépendants.

June–September: Collioure.

Autumn: visits Moscow for installation of the Shchukin decorations; studies Russian icons.

December–April 1912: first trip to Tangier.

1912 Spring: back in Issy for summer. First exhibition exclusively organized for his drawings and sculptures at Gallery '291' in New York.

Exhibits at the Salon des Indépendants. Danish collectors and I. A. Morosov in Moscow begin to buy his work.

Autumn–late February 1913: second trip to Tangier.

1913 April: returns to Paris for his one-man show at Galerie Bernheim-Jeune.

Summer: Issy, with a short visit to Collioure and Cassis.

By November: back in his old studio at 19 quai Saint-Michel. Participates in the Armory Show in New York.

1914 Stays at quai Saint-Michel until the summer.

August: spends one month in Issy. Rejected from military service, having volunteered to be drafted after the war declaration in August 1914.

First half of September: joins his family, travelling to the south of France (Toulouse and Bordeaux).

Mid-September–early October: Collioure, where he has extended discussions with Juan Gris. Back in Paris, quai Saint-Michel, for the Salon d'Automne. Remains there until spring 1915.

1915 Stays in Paris until the spring, with a short visit to Arcachon, near Bordeaux.

Summer and autumn: Issy. The model Laurette begins posing for him.

Late November: short trip to Marseilles with Marquet, followed by brief stay at L'Estaque, north of Marseilles.

December: returns to his studio on quai Saint-Michel.

1916 Stays in Paris until the spring.

Summer: Issy, with short trips to L'Estaque and Marseilles.

Winter: Paris, with a short trip to L'Estaque.

1917 January–May: first winter in Nice staying at the Hôtel Beau Rivage.

Summer: back in Issy.

Autumn: Paris, quai Saint-Michel.

Winter: Nice. Visits Renoir at Cagnes. Sale of the Collection J. Doucet at the Hôtel Drouot (includes 5 works by Matisse).

1918 Spring: moves to an apartment on the promenade des Anglais, then to Villa des Alliès, both in Nice.

Summer: Paris and Cherbourg.

Autumn: back in Nice, at the Hôtel de la Méditerranée. Visits Renoir at Cagnes and Bonnard at Antibes. Exhibits with Picasso at Galerie Paul Guillaume.

1919 May: exhibition at Galerie Bernheim-Jeune. Antoinette begins posing.

Summer and autumn: Issy.

November–December: exhibits at the Leicester Galleries, London.

1920 Early summer: visit to London then a few weeks in Etretat, Normandy.

Works on the ballet *Le Chant du rossignol* by Diaghilev. Constant travelling from Nice to Monte Carlo to consult Diaghilev on the project.
Publication of *Cinquante dessins par Henri Matisse* supervised by the artist. Exhibition of his recent 1919–20 works at Galerie Bernheim-Jeune.

1921 Summer: Etretat.
Autumn: back in Nice, taking an apartment on Place Charles Félix. From now on, half the year in Nice and the other half in Paris until the 1930s. The painting *Odalisque au pantalon rouge* is bought by the state for the Musée du Luxembourg. Henriette Darricarrère begins posing.

1922 Focuses on lithography. Begins work on *Large Seated Nude*, completed in 1925.

1923 Many of his paintings are preceded by charcoal drawings.

1924 Exhibitions, notably at the Brummer Galleries, New York, and in Copenhagen.

1925 Visits Italy. Is made 'Chevalier de la Légion d'Honneur'. Exhibition at Galerie des Quatre Chemins, Paris, on the occasion of their publication of W. George's book on Matisse's drawings.

1927 Awarded First Prize at the Carnegie International Exhibition in Pittsburgh. Exhibition of drawings and lithographs at Galerie Bernheim-Jeune.

1929 Concentrates on numerous drypoints, prints and lithographs.

1930 Leaves for Tahiti via New York and San Francisco, visiting the Barnes Foundation at Merion, Pennsylvania, as well as Miss Etta Cone in Baltimore. Commissioned by Albert Skira to illustrate Mallarmé's poems.
Important retrospective at Galerie Thannhauser in Berlin. Exhibition of sculpture at Galerie Pierre, Paris.
December: returns to the US.

1931 Series of important retrospectives in Paris (Galerie Georges Petit), Basel (Kunsthalle), New York (The Museum of Modern Art), the last two including numerous drawings. Concentrates on the illustration to Mallarmé. Accepts Dr Barnes's commission to paint murals for the walls of the Foundation. Shows 46 sculptures at the Brummer Galleries, New York.

1932 Completes the first version for the Barnes mural. Begins work on a second version after an error in the dimensions. Publication of Mallarmé's *Poésies*, with 29 etchings. Exhibition at Pierre Matisse Gallery, New York, of the 50 drawings chosen by Matisse for the 1920 publication *Cinquante dessins*.

1933 Installs the second version of the murals in the Barnes Foundation.
Holiday in Italy (Venice and Padua).

1934–35 Focuses on the series of engravings for *Ulysses* by James Joyce.

1935 Makes a design for Beauvais Tapestry. Mme Lydia Delectorskaya, Matisse's secretary, begins acting as his assistant and model.

1936 Exhibition of Matisse's recent works at Paul Rosenberg's gallery, Paris. Special issue of *Cahiers d'art* includes an important series of ink drawings by Matisse. Exhibits at the Leicester Galleries, London.

1937 Massine invites him to design the scenery and costumes for the ballet *Rouge et noir* by the Ballets Russes of Monte Carlo. Participates in the exhibition *Maîtres de l'art indépendant* at the Petit Palais, Paris.

1938 Moves to the hotel Le Régina in Cimiez, near Nice. First *gouache découpée* (cut-out), a medium which he had previously used in preliminary works for Barnes decoration.

1939 Summer: works at Hôtel Lutétia in Paris.

September: leaves Paris after declaration of the Second World War.

October: returns to Nice. Special issue of *Cahiers d'art*, illustrating a series of his charcoal drawings.

1940 Stays until the spring at the Hôtel Lutétia, then moves to boulevard Montparnasse.

May: moves to Bordeaux, then to Ciboure (near Saint-Jean de Luz). Legal separation from Madame Matisse.

1941 Begins illustrating *Florilège des amours* by Ronsard.

Spring spent in hospital in Lyons recovering from two intestinal operations. Works in bed on a series of drawings, *Thèmes et variations* (continuing through 1942). Exhibition of his drawings and charcoals at Galerie Louis Carré, Paris.

1942 Exchanges paintings and drawings with Picasso. Works on the illustrations for *Poèmes* by Charles d'Orléans. Louis Aragon visits.

1943 Air raid at Cimiez.

June: moves to villa 'La Rêve' in Vence. Publication of *Thèmes et variations* preceded by the text 'Matisse en France' by Louis Aragon. Begins the paper cut-outs for *Jazz*.

1944 Participates in the Salon d'Automne exhibition in celebration of the Liberation. Illustrations for Baudelaire's *Les Fleurs du mal*.

1945 Summer: returns to Paris.

Series of exhibitions, including important retrospective at the Salon d'Automne. Recent drawings at Pierre Matisse Gallery in New York, then at Galerie Maeght in Paris.

1946 Illustrates the letters of Marianna Alcaforado. A documentary film shows Matisse working.

1947 Publication of *Jazz* (Tériade), and of *Les Fleurs du mal*, illustrated by Matisse.

1948 Retrospective at the Philadelphia Museum of Art. Begins designs and decorations for the Dominican Chapel at Vence, and a figure of St Dominic for the church at Assy. Publication of *Florilège des amours* by Ronsard.

1949 Returns to the hotel Le Régina in Cimiez. Exhibition of cut-outs at Pierre Matisse Gallery, New York. Exhibition at the Musée National d'Art Moderne, Paris. Retrospective in Lucerne, Musée des Beaux-Arts.

1950 Exhibition at Galeries des Ponchettes, Nice, and at the Maison de la Pensée Française, Paris. Publication of *Poèmes* by Charles d'Orléans with lithographs by Matisse. Receives highest prize at the 25th Venice Biennale.

1951 25 June: consecration of the chapel at Vence.

Matisse retrospective at The Museum of Modern Art, New York. Publication of Alfred Barr's monograph *Matisse, His Art and His Public*. Works on cut-outs and large brush drawings.

1952 Inauguration of the Musée Matisse at Le Cateau-Cambrésis. Exhibition of recent drawings and the *Blue Nude* series at Galerie Maeght, Paris.

1953 Exhibition of cut-outs at Galerie Berggruen and of sculpture (organized by the Arts Council) at the Tate Gallery, London, and the Curt Valentin Gallery, New York.

1954 3 November: Matisse dies in Nice and is buried at Cimiez.

MAJOR EXHIBITIONS CONTAINING SCULPTURE

1906 19 March–7 April. *Exposition Henri Matisse*. Paris, Galerie Druet (3 sculptures).

1908 1 October–8 November. *Société du Salon d'Automne*. Paris, Grand Palais des Champs Elysées (13 bronzes and works in plaster).

1908–09 December–January. *Henri Matisse*. Berlin, Paul Cassirer.

1910 February–March. *Les Indépendants*. Prague, Manes (4 sculptures).

1910–11 8 November–15 January. *Manet and the Post-Impressionists*. London, Grafton Galleries (8 bronzes).

1912 14 March–6 April. *An Exhibition of Sculpture (the first in America) and Recent Drawings by Henri Matisse*. New York. The Little Galleries of the Photo-Secession (6 bronzes, 5 works in plaster, 1 terracotta).

 5 October–31 December. *Second Post-Impressionist Exhibition*. London, Grafton Galleries (8 bronzes).

1913 15 February–15 March. *International Exhibition of Modern Art*. New York, The Armory of the Sixty-ninth Infantry (1 sculpture).

 14–19 April. *Exposition Henri Matisse: tableaux du Maroc et sculptures*. Paris, Galerie Bernheim-Jeune (13 sculptures).

1915 20 January–27 February. *Henri Matisse Exhibition*. New York, Montross Gallery (11 scultures).

1928 Venice, XVI Biennale (6 bronzes).

1930 *Exposition de peintures et de sculptures de Henri Matisse*. Paris, Galerie Pierre (16 sculptures at least).

 15 February–19 March. *Henri Matisse*. Berlin, Galerie Thannhauser (19 bronzes).

1931 5 January–7 February. *Sculpture by Henri Matisse*. New York, The Galleries of Joseph Brummer (46 sculptures. 25 works shown subsequently at the Arts Club of Chicago, 13–28 March).

 9 August–15 September. *Henri Matisse*. Basel, Kunsthalle (16 sculptures).

 3 November–6 December. *Henri Matisse Retrospective Exhibition*. New York, The Museum of Modern Art (11 bronzes).

1943 19 October–13 November. *Bronzes by Degas, Matisse, Renoir*. New York, Buchholz Gallery (12 sculptures).

1948 *Henri Matisse. Retrospective Exhibition of Paintings, Drawings and Sculpture*. Organized in collaboration with the artist. Philadelphia Museum of Art (19 sculptures).

1949 9 July–2 October. *Henri Matisse*. Lucerne, Musée des Beaux-Arts (38 bronzes).

1950 5 July–24 September. *Henri Matisse. Chapelle, peintures, dessins, sculptures*. Paris, Maison de la Pensée Française (51 bronzes).

1951 20 November–15 December. *Sculpture by Painters*. New York, Curt Valentin Gallery (12 sculptures).

1951–52 13 November–13 January. *Henri Matisse*. New York, The Museum of Modern Art. Travelling exhibition to Cleveland, Chicago and San Francisco (28 bronzes).

1953	9 January–22 February. *An Exhibition of the Sculpture of Matisse and 3 Paintings with Studies*. London, Tate Gallery, organized by the Arts Council of Great Britain (48 bronzes).
	10–28 February. *The Sculpture of Henri Matisse*. New York, Curt Valentin Gallery (38 sculptures).
	6 November–6 December. *Henri Matisse: Sculpturer, Malerier, Farveklip*. Copenhagen, Ny Carlsberg Glyptotek (45 sculptures). Most works were subsequently shown in Oslo, Rotterdam, Ottawa and Houston.
1954	*Modern Utlāndsk Konst, Ur Svenska Privatsamlingar*. Stockholm, Nationalmuseum (22 bronzes).
	September. *Cézanne till Picasso*. Liljevachs, Konsthall (17 sculptures).
1955	1–30 November. *Matisse Bronzes and Drawings*. Boston, Museum of Fine Arts (46 sculptures).
1956	*The Bronze Reliefs 'Nu de dos' by Matisse*. London, Tate Gallery (4 sculptures).
1957	4–23 September. *Henri Matisse, Apollon*. Stockholm, Nationalmuseum (43 bronzes). Known subsequently as the Theodor Ahrenberg Collection, the exhibition travelled to Lund, Helsinki, Liège, Zürich and Gothenburg. When shown in Zürich at the Kunsthaus with loans from the Estate and Swiss private collections, the complete sculptures were assembled.
1960	4–6 July. *Forty-nine Bronzes by Matisse – The Property of Mr and Mrs Theodor Ahrenberg of Stockholm*. London, Sotheby and Co. (for sale).
1961	11 July–11 September. *Henri Matisse*. Albi, Musée Toulouse-Lautrec (63 bronzes).
1966	5 January–27 February. *Henri Matisse Retrospective*. Los Angeles, UCLA Art Gallery. Shown subsequently in Chicago and Boston (47 bronzes).
1968	*Matisse*. London, Hayward Gallery (8 sculptures).
1969	12 June–12 July. *Henri Matisse–Sculpture*. London, Victor Waddington (16 bronzes).
1970	April–September. *Henri Matisse, exposition du centenaire*. Paris, Grand Palais (28 bronzes).
	10 October–29 November. *Matisse. En Retrospektiv udstilling*. Copenhagen, Statens Museum for Kunst (21 sculptures).
1972	24 February–8 May. *The Sculpture of Matisse*. New York, The Museum of Modern Art. Shown subsequently in Minneapolis and Berkeley (69 sculptures).
1974	*Henri Matisse – sculptures*. Nice, Musée Matisse (68 sculptures).
1975	29 May–7 September. *Matisse, dessins, sculpture*. Paris, Musée National d'Art Moderne. Centre Georges Pompidou (69 sculptures).
	29 September–29 October. *Henri Matisse, dessins et sculpture*. Brussels, Palais des Beaux-Arts.
1978–79	26 October–30 January. *Matisse in the Collection of The Museum of Modern Art*. New York, The Museum of Modern Art (16 sculptures).
1982–83	15 October–16 January. *Henri Matisse*. Zürich, Kunsthaus (10 bronzes). Shown subsequently in Düsseldorf.

SELECT BIBLIOGRAPHY

This bibliography includes only those works which discuss sculptures as well as the major monographs on the artist. For a more complete list of references, see the catalogue Matisse, dessins, sculpture, *Musée National d'Art Moderne, Centre Georges Pompidou, Paris, 1975.*

ARAGON, Louis. *Henri Matisse. Roman.* Paris, 1971, 2 vols (English edition: *Henri Matisse. A Novel.* London, 1972).

Arts Magazine. New York, May 1975. Special issue with articles by D. Ashton, P. Larson, L. Lyons, F. Trapp, J. Cowart, J.D. Flam. New York, May 1975. Also June 1975, with an article by J.H. Neff.

BALTIMORE. The Baltimore Museum of Art. *The Cone Collection.* 1955 (revised edition 1967).

BARR, Alfred. *Matisse, His Art and His Public.* New York, 1951 (with bibliography; reprinted London, 1975).

DIEHL, Gaston. *Henri Matisse.* Paris, 1954.

ELDERFIELD, John. *Matisse in the Collection of The Museum of Modern Art.* New York, 1978 (with bibliography).

ELSEN, Albert. 'The Sculpture of Henri Matisse', series of four articles, *Artforum.* Los Angeles, September–December 1968.

———. *The Sculpture of Henri Matisse.* New York, 1972.

ESCHOLIER, Raymond. *Matisse ce vivant.* Paris, 1956.

FLAM, Jack D. 'Matisse's *Backs* and the Development of his Painting', *Art Journal.* London, XXX, 4, summer 1971.

——— . *Matisse on Art.* London, 1973 (reprinted 1978).

FOURCADE, Dominique. *Henri Matisse. Ecrits et propos sur l'art.* Paris, 1972.

——— . 'Autres propos de Henri Matisse', *Macula.* Paris, no. 1, 1976.

FOURNET, C. 'Matisse sculpteur', *France, Art Press International.* Paris, July 1979.

GOLDWATER, Robert. 'The Sculpture of Matisse', *Art in America.* New York, March–April 1972.

GOWING, Lawrence. *Matisse, 1869–1954.* London, 1968.

———. *Henri Matisse.* London, 1979.

GUEGUEN, Pierre. 'Sculpture d'un grand peintre', *XXème siècle.* Paris, no. 4, 1983.

GUICHARD-MEILI, Jean. *Henri Matisse, son oeuvre, son univers.* Paris, 1967.

HAMILTON, George H. *Painting and Sculpture in Europe, 1880–1940.* Harmondsworth, 1967.

HUTTINGER, B., and U. Linde. *Henri Matisse, Das Plastische Werk.* Zürich, 1959 (introduction to catalogue).

KRAMER, Hilton. 'Matisse as a Sculptor', *Bulletin, Museum of Fine Arts, Boston.* Vol. LXIV, no. 336, 1966.

LASSAIGNE, Jacques. *Henri Matisse.* Geneva, 1966.

LEYMARIE, Jean. *Henri Matisse. Grand peintre.* Paris, 1967.

LICHT, Fred. *Sculpture, Nineteenth and Twentieth Centuries.* London, 1967.

Los Angeles, UCLA Art Gallery. *Henri Matisse Retrospective.* 1966 (with contributions by Jean Leymarie, Herbert Read and William S. Lieberman).

———, County Museum of Art. 'Five Heads of Jeannette by Matisse', *Bulletin.* XIX, I, 1968–69.

MONOD-FONTAINE, Isabelle. 'La Donation Jean Matisse', *Revue du Louvre.* Paris, vol. 30, no. 3, 1980.

New York, The Museum of Modern Art. *The Sculpture of Henri Matisse.* 1972 (introduction by Alicia Legg).

Paris, Grand Palais. *Henri Matisse. Exposition du Centenaire.* 1970 (introduction by Pierre Schneider).

Paris, Musée National d'Art Moderne, Centre Georges Pompidou. *Matisse, dessins, sculpture.* 1975 (with bibliography).

———, Musée National d'Art Moderne, Centre Georges Pompidou. Isabelle Monod-Fontaine, *Oeuvres de Henri Matisse, 1869–1954,* 1979.

POULAIN, Gaston. 'Sculpture d'Henri Matisse', *Formes.* Paris, no. 9, 1930.

PURRMANN, Hans. *Henri Matisse.* Paris, 1938.

SCHNEIDER, Pierre. 'Matisse's Sculpture: The Invisible Revolution', *Art News.* New York, March 1972 (text reprinted in *Critique.* Paris, May 1974).

SPEYER, James A. 'Twentieth Century European Painting and Sculpture', *Apollo.* London, September 1966.

SYLVESTER, David. 'The Sculptures of Matisse', *The Listener.* London, vol. 49, no. 1248, 29 January 1953.

TUCKER, William. *Henri Matisse Sculpture.* London, 1969 (introduction to catalogue).

———. 'The Sculpture of Matisse', *Studio International.* London, July–August 1969.

———. 'Four Sculptors, part 3: Matisse', *Studio International.* London, September 1970.

———. *The Language of Sculpture.* London, 1974.

———. 'Matisse's sculpture: the grasped and the seen', *Art in America.* New York, vol. 63, July–August 1975.

WATKINS, Nicholas. *Matisse.* Oxford, 1977.

WHEELER, Monroe. *Catalogue of Forty-nine Bronzes by Matisse* (sale of the Ahrenberg Collection). Sotheby and Co., London, July 1969.

NOTES TO THE TEXT

Chapter 1 (pp. 9–17)

1 'Moi j'ai fait de la sculpture comme un peintre. Je n'ai pas fait de la sculpture comme un sculpteur.' (Georges Charbonnier, 'Entretien avec Henri Matisse', *Le Monologue du peintre*, vol. 2, Paris, 1960. Dominique Fourcade, *Henri Matisse. Ecrits et propos sur l'art*, Paris, 1972.)

2 'C'était toujours pour organiser. C'était pour ordonner mes sensations, pour chercher une méthode qui me convienne absolumment.... C'était toujours en vue d'une possession de mon cerveau, d'une espèce de hiérarchie de toutes mes sensations qui m'aurait permis de conclure.' (Matisse, in conversation with Pierre Courthion, quoted by Jean Guichard-Meili in *Henri Matisse, son oeuvre, son univers*, Paris, 1967; *Matisse*, New York, 1967.)

3 'Croyez vous que la photographie puisse produire des oeuvres d'art?' – 'La photographie peut fournir les documents les plus précieux qui soient, et personne ne peut contester son intérêt de ce point de vue. Faite par un homme de goût, une photographie aura une apparence d'art. Mais je crois que le style des photographies est sans importance, elles seront toujours frappantes, parce qu'elles nous montrent la nature, et tous les artistes y trouveront un monde de sensations.' ('Statement on Photography', *Camera Work*, no. 24, New York, October 1908. Jack D. Flam, *Matisse on Art*, London, 1973.)

4 'Matisse and Impressionism', *Androcles*, no. 1, February 1932. *Two Negresses* was included in the 1931 retrospective organized by The Museum of Modern Art, New York.

5 'J'ai aminci et mis en rapport les formes de telle façon que le mouvement soit complètement compréhensible de tous les points de vue.' (Alfred Barr, *Matisse, His Art and His Public*, New York, 1951.)

6 'Je me considère comme ayant fait des progrès, quand je constate dans mon travail un détachement de plus en plus évident du soutien du modèles.... Je voudrais bien pouvoir m'en passer tout à fait un jour – je ne le pense pas car je n'ai pas assez cultivé la mémoire des formes ... je sais suffisamment comment est fait un corps humain – le modèle est pour moi un tremplin – c'est une porte que je dois enfoncer pour accéder au jardin dans lequel je suis seul et si bien.' (Louis Aragon, 'La grande songerie', *Henri Matisse. Roman*, Paris, 1971.)

Chapter 2 (pp. 18–23)

1 'Il était d'ailleurs normal qu'une entreprise qui tendait à refaire l'inventaire plastique du monde extérieur – et ce fut là le but du cubisme à ses débuts – ait fait appel à la sculpture pour suppléer aux faiblesses de la peinture quant à la figuration du volume.' (*Les Sculptures de Picasso*, Paris, 1948.)

2 'Un tableau fait avec de petits cubes'. Quoted in Louis Vauxcelles, preface to exhibition catalogue, *Les Fauves et l'atelier de Gustave Moreau*, Paris, 1934.

3 'C'était une époque où nous nous sentions pas emprisonnés dans des uniformes et ce que l'on pouvait découvrir d'audace et de nouveauté dans le tableau d'un ami appartenait à tous.' ('Matisse Speaks', interview with Tériade in *Art News Annual*, New York, no. 21, 1952. Dominique Fourcade, *Henri Matisse. Ecrits et propos sur l'art*, Paris, 1972. Jack D. Flam, *Matisse on Art*, London, 1973.)

4 Letter from Braque to Daniel-Henry Kahnweiler, in Nadine Pouillon and Isabelle Monod-Fontaine, *Braque dans les collections du Musée National d'Art Moderne*, Paris, 1982.

5 'Parlent de peinture avec acharnement.' (Daniel-Henry Kahnweiler, *Juan Gris, sa vie, son oeuvre, ses écrits*, Paris, 1946.)

6 'Le combat contre la déliquescence de l'impressionnisme.' 'L'investigation du plan ... chez les cubistes repose sur la réalité ... elle doit faire appel à l'imagination.' 'C'est l'imagination qui donne au tableau espace et profondeur. Les cubistes faisaient accepter de force à l'imagination du spectateur un espace rigoureusement défini entre chaque objet.' ('Matisse Speaks', interview with Tériade in *Art News Annual*, New York, no. 21, 1952.)

7 'Le changement qui s'opère à partir de 1910 ne fait qu'accentuer cet éclectisme dans les moyens. C'est la sculpture qui domine, au point de départ de cette évolution. Une nouvelle fois, entre 1911 et 1913, les peintures de Picasso se révèlent les copies de sculptures imaginaires.' (*Les Sculptures de Picasso*, Paris, 1948.)

8 'La surface n'est plus simplement rugueuse, mais se troue de creux profonds, se bossue de saillies, comme si Picasso avait voulu douer son bronze d'une lumière créée, comme un tableau. Ce n'est plus la forme de la tête qui est figurée,

mais l'objectivation de la lumière sur cette tête.' (*Les Sculptures de Picasso*, Paris, 1948.)

9 'Picasso jusque là avait bouleversé la figuration, c'est à dire les modalités de la représentation du réel sensible dans la peinture. Il en est venu maintenant à détruire jusqu'à la *Figura*, l'ensemble des éléments qui constituent la forme d'un corps, l'image. . . . Que se passe-t-il quand l'image n'est plus là, que la forme de la figure a disparu? Eh bien, çà fonctionne. Le cerveau rétablit les corrélations indispensables.' (Pierre Daix and Joan Rosselet, *Le Cubisme de Picasso*, Neuchâtel, 1979; *Picasso: The Cubist Years 1907–16*, London, 1979.)

10 'Ce qui constitue la nouveauté éclatante de ces reliefs dans la sculpture européenne, c'est le fait que le volume "opaque" (si je puis dire) se trouvait crevé. La forme de ces verres, de ces instruments de musique n'est *décrite* nulle part en sa continuité, mais n'acquiert celle-ci que dans l'imagination créatrice du spectateur.' (Daniel-Henry Kahnweiler, *Les Sculptures de Picasso*, Paris, 1948.)

11 *The Sculpture of Henri Matisse*, New York, 1972. This is the most complete and fully documented study of Matisse's sculpture.

Chapter 3 (pp. 24–33)

1 'Une peinture d'intimité.' (Matisse, 'Notice biographique', *Formes*, no. 1, January 1930.)

2 'Ce que je poursuis avant tout, c'est l'expression . . . l'expression est dans toute la disposition de mon tableau: la place qu'occupent les corps, les vides qui sont autour d'eux, les proportions, tout cela y a sa part.' (Matisse, 'Notes d'un peintre', *La Grande Revue*, vol. 52, 25 December 1908. Jack D. Flam, *Matisse on Art*, London, 1973.)

Chapter 4 (pp. 34–42)

1 'Mes tableaux s'établissent par combinaisons de taches et d'arabesques . . . oeuvres de caractère surtout décoratif . . . commence à se faire place une expression plus creusée, établie par plans, en profondeur, une *peinture d'intimité* qui est celle de l'époque actuelle.' ('Notice biographique', *Formes*, no. 1, January 1930.)

2 'When I realized that I would see that light every morning, I could not believe my good fortune.' ('Quand j'ai compris que chaque matin je reverrais cette lumière, je ne pouvais croire à mon bonheur.') (Quoted by Georges Salles in his preface to the exhibition catalogue, *Henri Matisse*, Nice, 1950.)

3 'Des qualités nouvelles . . . que j'avais dû brider depuis longtemps, des saveurs de peinture savoureuse'. Matisse is here describing a similar change of twenty years earlier, in a letter to Théodore Pallady written in the winter of 1940. (Barbu Brezianu, *Secolul 20*, Bucharest, no. 6, 1965. Dominique Fourcade, *Henri Matisse. Ecrits et propos sur l'art*, Paris, 1972.)

4 'Demeures nouées, tressées, tissées, brodées et patinées.' 'Leur nudité semble protégée par le velours herbu des parois et la frange des palmes: ils se glissent hors de leurs demeures, comme ils se dévêtiraient de géants peignoirs d'autruche. Joyaux de ces écrins duveteux, les corps possèdent des modelés affinés et des tonalités rehaussées par l'éclat des fards et des peintures'. (*Tristes tropiques*, Paris, 1955.)

5 'Ce qui m'interesse le plus, ce n'est ni la nature morte, ni le paysage, c'est la figure. C'est elle qui me permet le mieux d'exprimer le sentiment pour ainsi dire religieux que je possède de la vie.' ('Notes d'un peintre', *La Grande Revue*, vol. 52, 25 December 1908. Jack D. Flam, *Matisse on Art*, London, 1973.)

6 'Hommage plénier à la splendeur féminine offerte et déployée en tous sens dans l'espace tactile qu'elle engendre.' (Preface to the exhibition catalogue *Henri Matisse, sculptures*, Nice, 1974.)

7 'Mes modèles, figures humaines, ne sont jamais des figurantes dans un intérieur. Elles sont le thème principal de mon travail. Je dépends absolument de mon modèle que j'observe en liberté, et c'est ensuite que je me décide pour lui fixer la pose qui correspond le plus à *son naturel*. Quand je prends un nouveau modèle, c'est dans son abandon au repos que je devine le pose qui lui convient et dont je me rends esclave.' ('Notes d'un peintre sur son dessin', *Le Point*, Paris, no. 21, July 1939. Jack D. Flam, *Matisse on Art*, London, 1973.)

8 'Une peinture architecturale . . . l'élément humain . . . paraît devoir être tempéré, sinon exclu.' (Letter to Alexander Romm, 14 February 1934, quoted in Jack D. Flam, *Matisse on Art*, London, 1973.)

9 'Les tons locaux des choses n'étaient pas changés, mais leur résultante, dans la lumière du Pacifique, me procurait une sensation semblable à celle que j'ai éprouvée en regardant à l'intérieur d'une grande coupe d'or.' (Matisse, quoted in Louis Aragon, *Henri Matisse. Roman*, Paris, 1971.)

10 *Matisse in the Collection of The Museum of Modern Art*, New York, 1978.

11 *The Sculpture of Henri Matisse*, New York, 1972.

Chapter 5 (pp. 43–48)

1 'Dessins noirs filiformes qui décorent les murs tout en les laissant très clairs. Il en résulte en ensemble noir sur blanc, dans lequel le blanc domine.' ('La chapelle de Vence', *France-Illustration*, Christmas 1951.)

2 'Découper à vif dans la couleur me rappelle la taille directe des sculpteurs'. (*Jazz*, Paris, 1947.)

3 'La technique de la statuaire est appliquée à la substance de la peinture. L'artiste taille dans un bloc qui n'est plus grès ou marbre, mais chromatisme. Il s'impose ainsi une exigence très onéreuse car la couleur ne se prête pas du premier coup au traitement sculptural.... Il s'oblige à conférer le volume à une matière qui, moins que les supports du pinceau ou du crayon, adombrant ne serait-ce que le souvenir d'un contour, n'est apte à en porter les traductions accoutumées. Il lui faut imaginer un langage pour en dire encore les poids et les mesures.' ('Le tailleur de lumière', *Verve*, Paris, 1958, vol. IX, nos 35–36.)

4 'La moindre distraction pendant le tracé d'un trait entraîne involontairement une légère pression des doigts sur la page et influence le trait malencontreusement.' (Matisse, 'Comment j'ai fait mes livres', *Anthologie du livre illustré par les peintres et sculpteurs de l'Ecole de Paris*, Geneva, 1946.)

5 'Sans beauté particulière, ni valeur marchande, mais rassemblés dans le but de se voir inspirer par eux dans ses propres recherches.' (Georges Duthuit, in a letter to Jean Laude, 18 June 1958, quoted in Jean Laude, *La Peinture française 1905–40 et l'art nègre*, Paris, 1968.)

6 'Les articulations, poignets, chevilles, genoux et coudes doivent montrer qu'elles sont à même de soutenir les membres.... Il est préférable de mettre l'accent sur l'articulation plutôt que ne pas l'exprimer avec assex de vigueur. Surtout il faut veiller à ne pas couper le membre aux articulations, mais au contraire à intégrer les articulations aux membres dont elles font partie. N'introduisez pas de vides préjudiciables à l'ensemble, par exemple entre le pouce et les doigts côte à côte. Exprimer par des rapports de masse, et des grands mouvements de lignes en corrélation.' ('Notes by Sarah Stein', in Alfred Barr, *Matisse, His Art and His Public*, New York, 1951.)

PHOTOGRAPHIC ACKNOWLEDGMENTS

M. Bérard, nos 1, 26a, 50, 63, 66; Prudence Cuming, nos 8, 9; Jacqueline Hyde, nos 37a, 58; Los Angeles County Museum of Art, five heads of Jeannette and nos 44, 44a, 45a, 46, 46a, 47, 47a, 48a; Eric Pollitzer, no. 3; T. E. Rogers, nos 61, 61a; Conrad Ronkowski, nos 28, 28a, 28b, 28c; Studio Malaisy, no. 7; Rodney Todd-White, no. 25a; Malcolm Varon, no. 13.